CHARLESTON
THEN & NOW

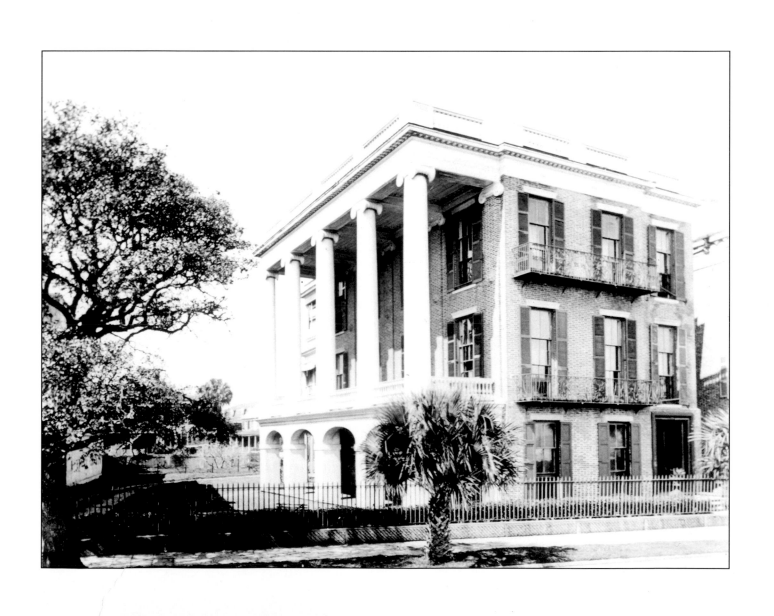

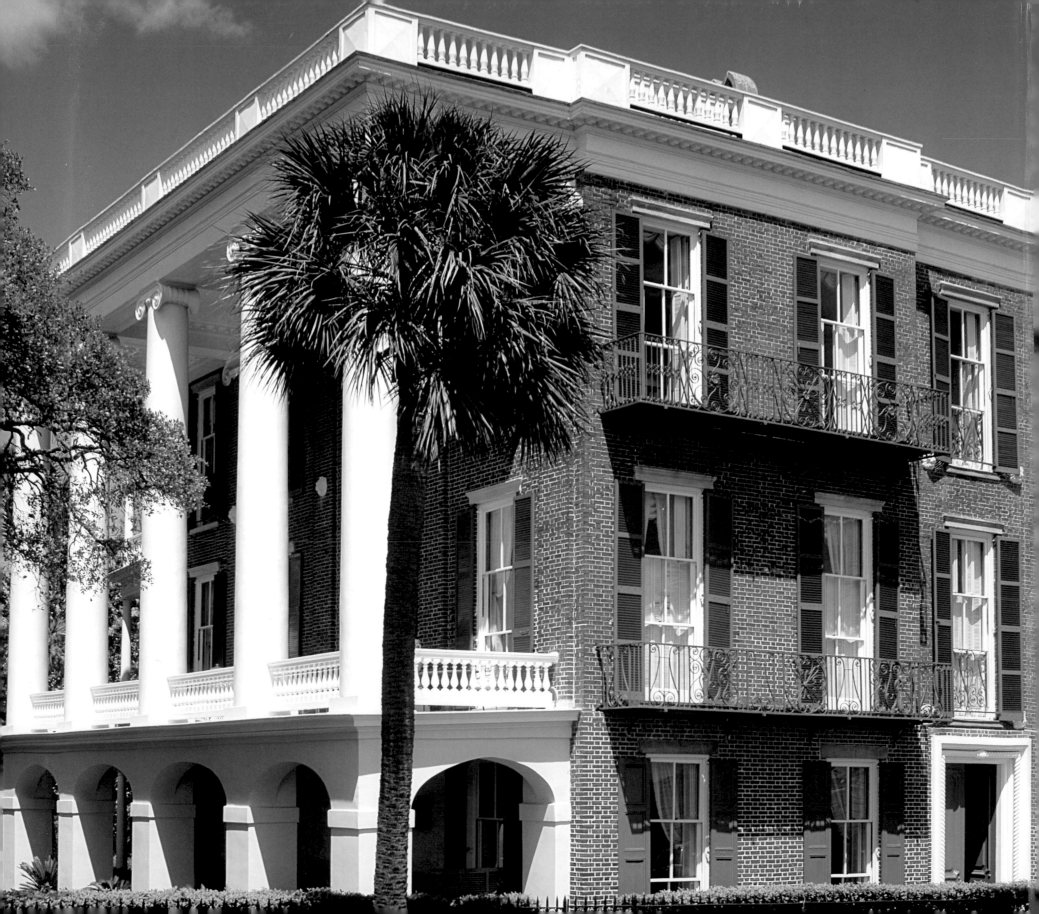

CHARLESTON THEN & NOW

W. CHRIS PHELPS

THUNDER BAY
P·R·E·S·S

San Diego, California

Thunder Bay Press
An imprint of the Advantage Publishers Group
10350 Barnes Canyon Road, San Diego, CA 92121
www.thunderbaybooks.com

Produced by Salamander Books,
an imprint of Anova Books Company Ltd.,
10 Southcombe Street, London W14 0RA, U.K.

Library of Congress Cataloging-in-Publication Data

Phelps, W. Chris.
 Charleston then & now / W. Chris Phelps.
 p. cm.
 Includes index.
 ISBN-13: 978-1-59223-486-8
 ISBN-10: 1-59223-486-0
 1. Charleston (S.C.)--Pictorial works. 2. Charleston (S.C.)--History--Pictorial works. I.
Title: Charleston then and now. II. Title.

F279.C443P48 2005
975.7'91--dc22

 2005052974

Printed and bound in China

5 6 7 8 9 12 11 10 09 08

Acknowledgments:

In a work dealing with photographic history one must rely on many repositories to gather the necessary
materials. There are numerous archives and museums that assisted me in producing this work; however, I
would be remiss if I did not show my extreme gratitude to Dr. Eric Emerson, Director of the South Carolina
Historical Society, and Mike Coker, in charge of the society's photographic reproductions. The great
majority of the historical photographs in this work were provided by the society.

In addition, many thanks must be extended to Sharon Bennet of the Charleston Museum and Joyce Baker
of the Gibbes Museum of Art, both of whom graciously provided archival photographs of their respective
buildings. Tracey Todd of Middleton Place Foundation and Amanda Kirkpatrick of Drayton Hall
Plantation were also very kind in allowing me to use photographs of these two wonderfully preserved
historic plantation structures. Thanks also to Tony Youmans, who provided historical information about
the Old Exchange Building, and Joan Quinn, who provided information about the Cooper River Bridges.

This work could not have been produced without the help of my good friend and Charleston author and
historian Mike Brown, who helped me compile and organize my notes and research. More valuable
assistance in the way of allowing me to take time off from familial activities was generously provided by my
wife Aimee and our three children, Tucker, Addie-Belle and Lucy Phelps.

INTRODUCTION

Charlestonians are a proud people to be sure, for they have 335 years of lineage, heritage, and history of which to be proud. A quaint illustration to help the reader better understand the undying affection Charlestonians have for their beloved city is that for centuries they have boasted that the two rivers that hold fast their peninsula city, the Cooper to the east and the Ashley to the west, come together in Charleston Harbor to form the Atlantic Ocean.

Charleston, South Carolina, with its sprawling live oaks, cobblestone streets, and magnificent waterfront mansions, is considered by visitors from all points of the compass to be the epitome of the antebellum American South. This belief was hammered home to the world thanks largely to Margaret Mitchell and her epic novel-turned-film, *Gone with the Wind*.

Charleston's history stretches back into the antiquity of the United States, to the late seventeenth century, when English colonists arrived from the Caribbean island of Barbados and settled the area in the spring of 1670. The new settlement was originally named Charles Towne in honor of King Charles II. The English newcomers established Charles Towne several miles upriver from the city's present location in what was considered to be a more defensible location. Today, this original site, known as Charles Towne Landing, is preserved as a South Carolina state park.

In the years between 1670 and 1680, many of Charles Towne's early inhabitants began populating a peninsula several miles downstream and closer to the Atlantic Ocean. This peninsula—whose tip they referred to as White Point because of the accumulated sand and large mounds of oyster shells left by local Indians—was lodged between the Ashley and Cooper rivers, named by the English in honor of the coastal surveyor Lord Anthony Ashley Cooper.

Charles Towne was effectively reestablished on this peninsula around 1680. Due to harassment by hostile Indian tribes, as well as threats of invasion by the Spanish and French, a defensive wall was erected, making it one of only three walled cities in North America.

By the 1770s, however, a new threat was brewing: disenchantment with English control over the Colonies. The fourth-largest city in the Colonies behind New York, Boston, and Philadelphia, Charles Towne was by far the wealthiest of the four, and played a major role in the American Revolution. Several of the city's sons were actors in the first real American drama. Edward Rutledge and Pierce Butler were signers of the Declaration of Independence, and John Rutledge (Edward's brother), along with Charles Cotesworth Pinckney, were signatories of the United States Constitution.

The next great act in Charleston's history was, unfortunately, a starring role in the greatest American catastrophe to date, the Civil War. During the decades leading up to the Civil War, Charleston differed from the rest of the South in that "King Cotton" was actually "King Rice," a crop better suited for cultivation in the rich, fertile soils surrounding Charleston. In either case, large-scale cultivation of these crops required slave labor. In addition to agriculture, the domestic slave trade was a major element in Charleston's economy; thus, as the Northern states shifted to the free labor system, a great chasm grew between the North and the South. Charleston, perhaps the most outspoken proponent of slavery, was dubbed by many in the North as the "Home of Slavery."

On December 20, 1860, South Carolina seceded from the Union, inaugurating fratricidal war. The official ordinance of secession was signed in Charleston, and the first shots of the conflict were fired in Charleston Harbor against Union-held Fort Sumter, four miles from the city's waterfront. Following the four-year conflict, Charleston was left in ruin. An accidental fire had swept across the city in December of 1861, and this devastation was compounded by a siege, accompanied by an unprecedented long-range bombardment from the entrance of the city's harbor. Charlestonians endured the combined siege and bombardment, which lasted 545 days (second in length only to the German bombardment of Leningrad in World War II), from August of 1863 until the city's evacuation in February of 1865.

For the remainder of the nineteenth century, Charleston valiantly struggled through Union occupation (which lasted from 1865 to 1876), economic depression, a series of hurricanes and tornadoes, and a major earthquake in 1886. Collectively, these disasters solidified the Northern public's belief that Charleston was paying for her past sins of embracing the institution of slavery and instigating a conflict that resulted in the deaths of over 600,000 Americans.

Fortunately for the city, a "regentrification," or preservation movement, the first of its kind in the country, commenced in the late nineteenth century. This undertaking owed a lot to the female members of Charleston society who wanted to return their city to its splendorous antebellum grandeur. This movement slowly saved numerous businesses and homes from the wrecking ball. As a result, over the last ninety years, Charleston's once proud, majestic lower districts have slowly been restored.

Today, Charleston is the fourth-largest container port in the United States, growing every year in order to accommodate the world's largest vessels. The city boasts several colleges and universities, increasing its status as a mecca for higher education. Hand in hand with both education and industry, Charleston has grown from a peninsula city into a sprawling metropolis, extending north and south along the Atlantic seaboard and also inland. Consistently voted the "Most Polite City in America," Charleston proudly boasts the largest historic district in the United States as well as the largest collection of antique architecture in the country. History and tourism now mesh seamlessly with modern business and industry to create a look and atmosphere like no other city in America.

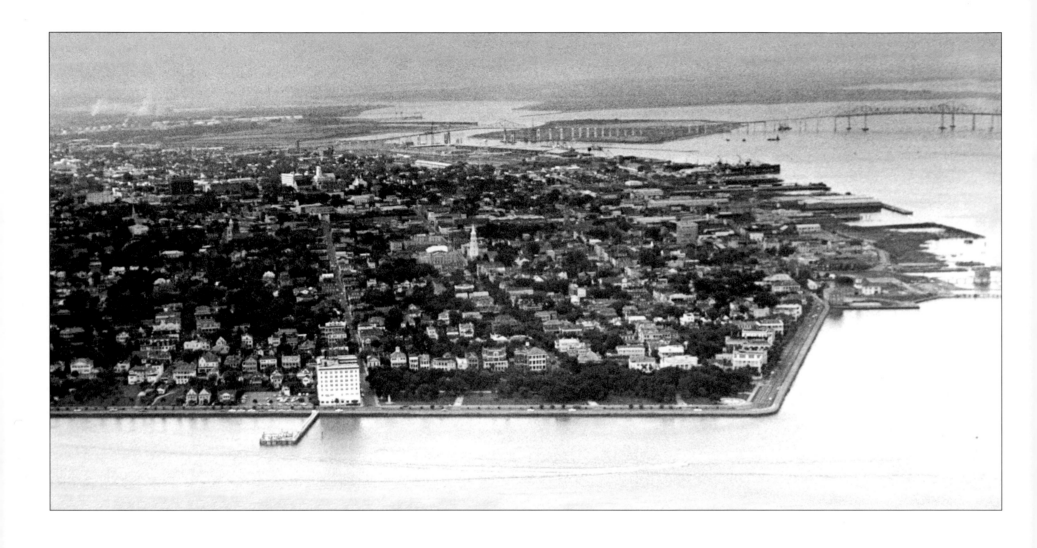

This photograph shows the Charleston Peninsula in the early 1960s. To the right is the Cooper River, and below is the Ashley River. Also on the right is the two-mile-long Cooper River Bridge—completed in 1929 and later renamed the Grace Memorial Bridge in honor of Mayor John P. Grace. The bridge was built for a number of reasons, one being convenient access for Charlestonians to the new bustling town of Mount Pleasant and the beautiful beaches of Sullivan's Island beyond. But the primary reason was that the War Department and the Navy had relocated the old naval station from Beaufort and Port Royal, sixty miles south, to Charleston in 1901. Thus, the bridge had to provide upriver access for large naval vessels, which required that the bridge have a 1,000-foot horizontal clearance. Also of great importance and visible in the center of Charleston's historic district is the white steeple of St. Michael's Episcopal Church at the intersection of Meeting and Broad streets.

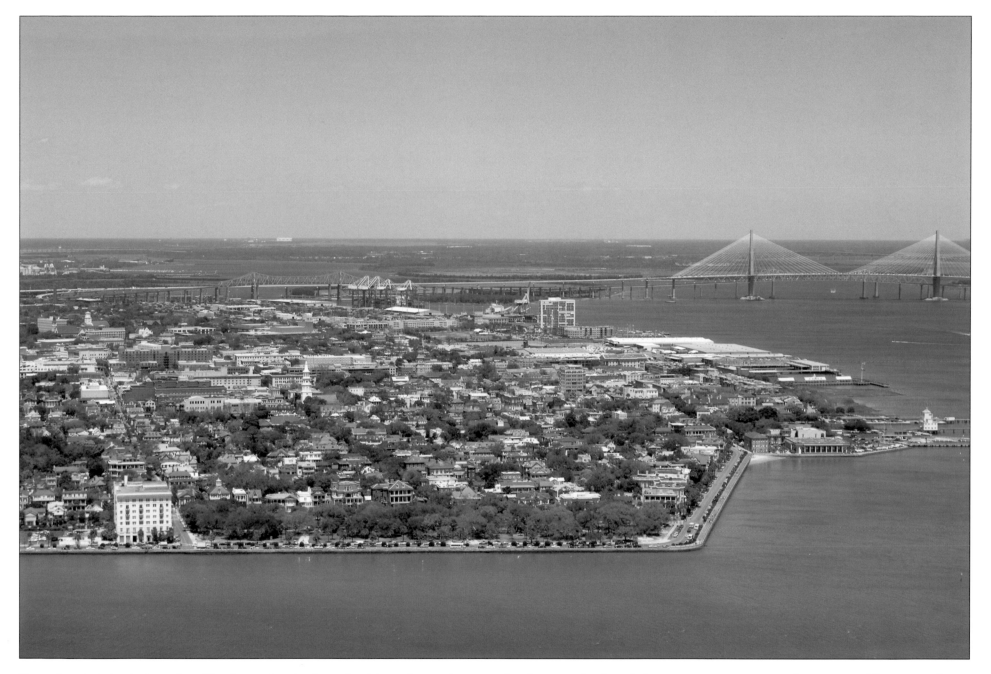

From the air it is obvious that Charleston has both evolved into the modern age and managed to conserve its historic beauty. Much of the peninsula looks the same, though one cannot miss the fact that the accommodation for incoming and outgoing vessels has been redeveloped into a massive container port, which has been moved a considerable distance up the Cooper River and has become the fourth-largest container port in the country. The town of Mount Pleasant in the 1960s has grown exponentially to become the city of Mount Pleasant today; the Grace Memorial Bridge is no longer the only access to it.

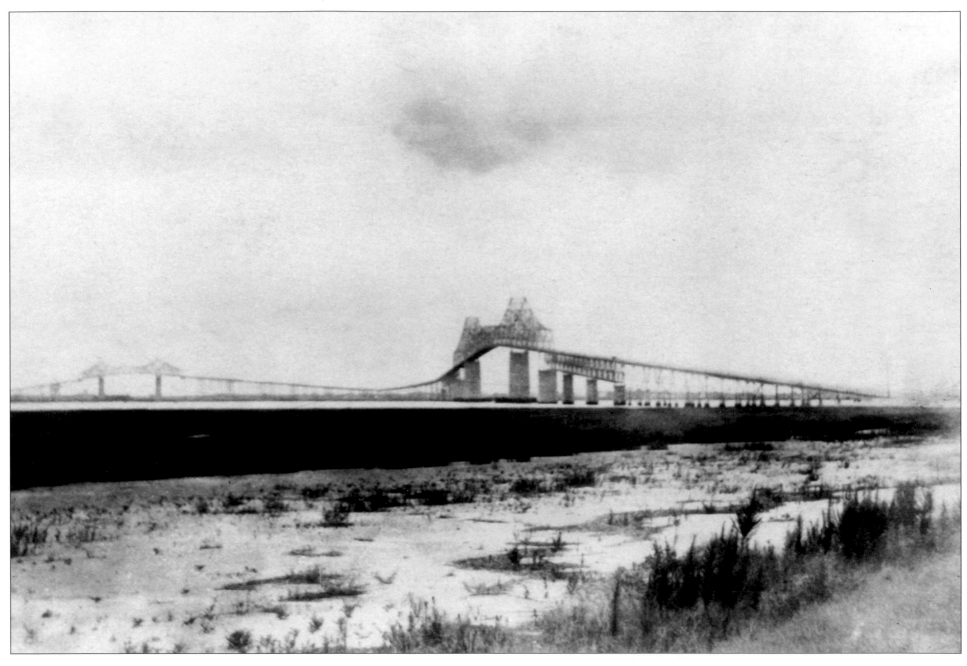

This ghostly photograph of the old Grace Bridge, headed toward Charleston, was taken from the Mount Pleasant side of the Cooper River. A curious, yet important, feature of this photograph can also be seen in the photograph on page 6: concrete pilings, barely visible near the point where the Grace Bridge meets the Charleston Peninsula. These post and lintel supports were for the new Cooper River bridge, named the Silas N. Pearman Bridge after the state's commissioner of highways. The Grace Bridge was considered inadequate in 1957, and construction of the new bridge began three years later, allowing more automobile traffic to cross between Charleston and Mount Pleasant.

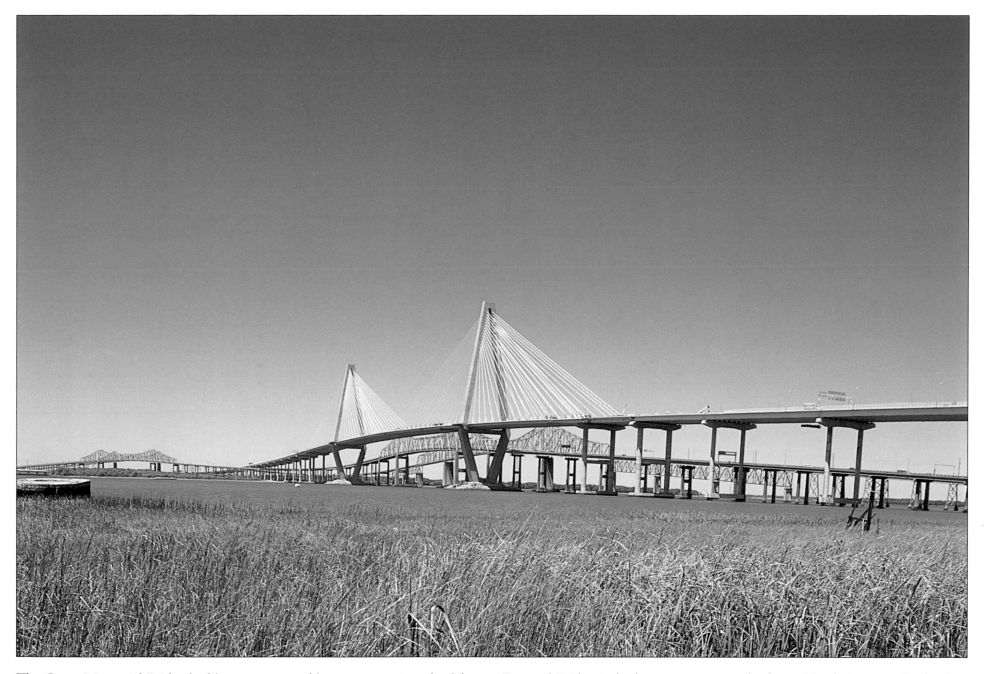

The Grace Memorial Bridge had been augmented by its companion, the Silas N. Pearman Bridge, in the 1960s. Today, however, both bridges are no longer considered structurally acceptable and were replaced in 2005 by the massive Arthur Ravenel Jr. Bridge, a beautiful cable-stayed suspension bridge. The Ravenel Bridge is the longest suspension bridge in North America. Both of the towers that support the bridge are 570 feet tall, with a vertical clearance of 186 feet from the river's surface. Four lanes wide, with walking and biking paths on either side, the bridge's main span stretches a distance of 1,546 feet.

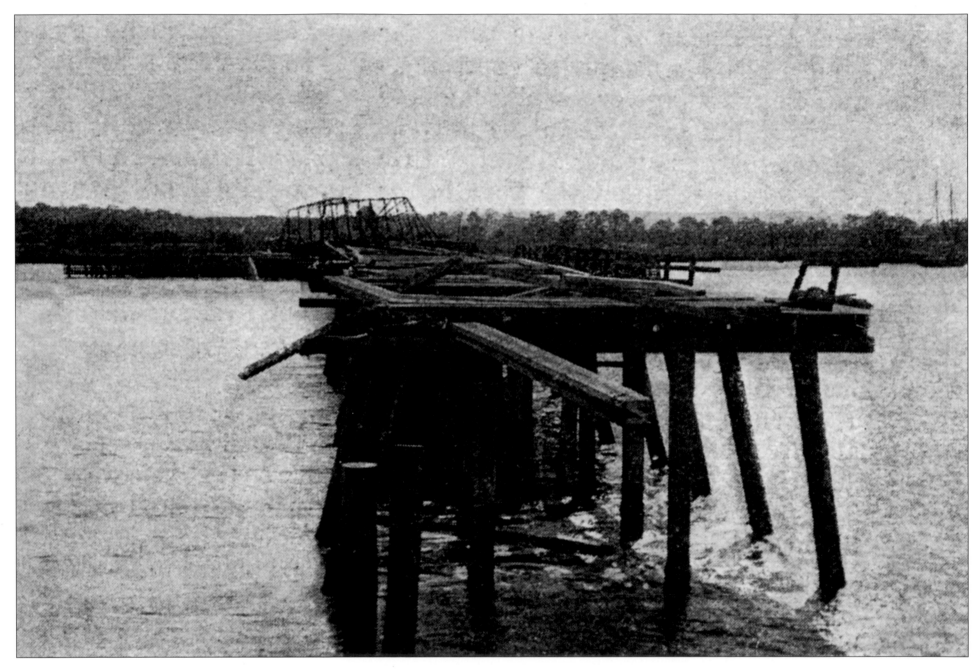

What appears to be hardly more than a disorganized pile of lumber supported by a few pilings above the water is all that remained of the Ashley River Bridge following the hurricane of 1911. Hurricanes are a simple fact of life along the southern Atlantic coast. As the churning storms press down on the ocean below, they spread before them "surge walls" of water. In this case, a powerful surge wall forced its way up the Ashley River, steamrolling everything in its path, including the Ashley River Bridge. The first bridge over the river was built in 1808, replacing the old ferry systems, and it was eventually turned into a toll bridge with turnstiles at both ends. The old Ashley River Bridge was burned in 1865 as Confederate forces evacuated Charleston. Nearly a quarter of a century passed before this "New Bridge," as it was dubbed, was built as a toll bridge.

In 1921, the county purchased the New Bridge and removed the toll. In 1926, a new concrete bridge was constructed as the Ashley River Memorial Bridge to commemorate the men from Charleston who served in World War I. A combination of federal and local funds enabled construction of the Memorial Bridge. From this vantage point, one can see that an even more modern bridge was eventually needed to accommodate passage back and forth from the suburb of St. Andrews and the peninsula. Visible to the right is a marina allowing dockage to the newly built condominiums and town houses overlooking the Ashley. This complex was built on the site of the old city garbage dump and landfill.

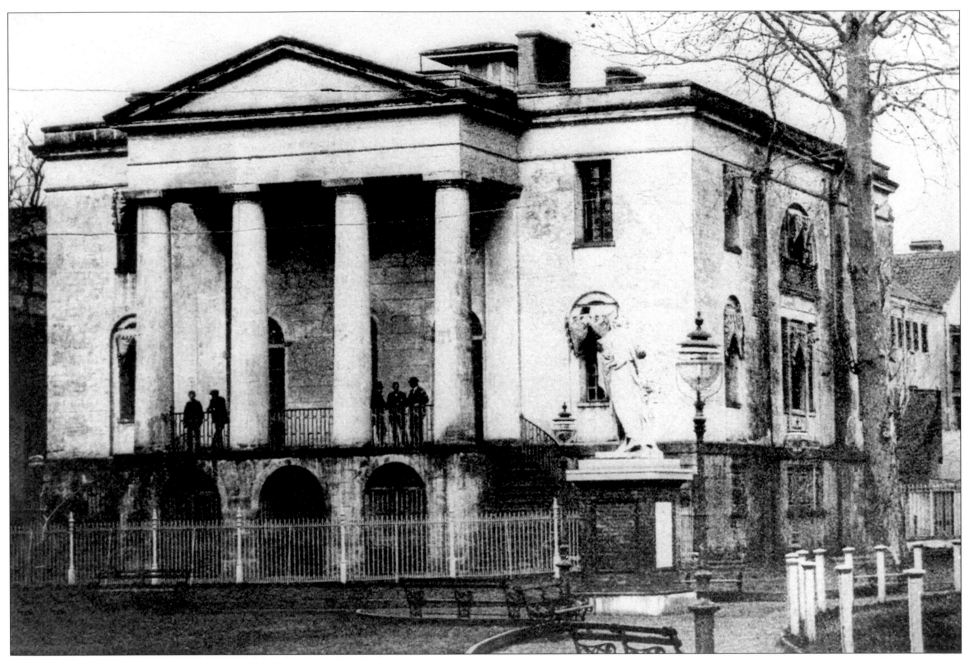

Established in 1818, Washington Square, named after George Washington, is situated in the center of the historic district at the intersection of Meeting and Broad streets and is the oldest city park in Charleston. Initially, it was surrounded on all sides by the houses of Meeting Street, Broad Street, the cobblestoned Chalmers Street, and a small, long-since-vanished street known as the "Beef Market." When the city purchased the land for a park, the houses were torn down and the park was officially established as City Hall Park, since City Hall was situated in the southwestern corner of the square. The fence and formal wrought-iron gates were added in 1824. This previously unpublished photograph shows the "Fireproof Building" sometime between 1865 and 1886, when an earthquake damaged the structure. It can be dated by the sloping, symmetrical "open arms" staircase, which were replaced after the quake by modern square staircases with landings on either side.

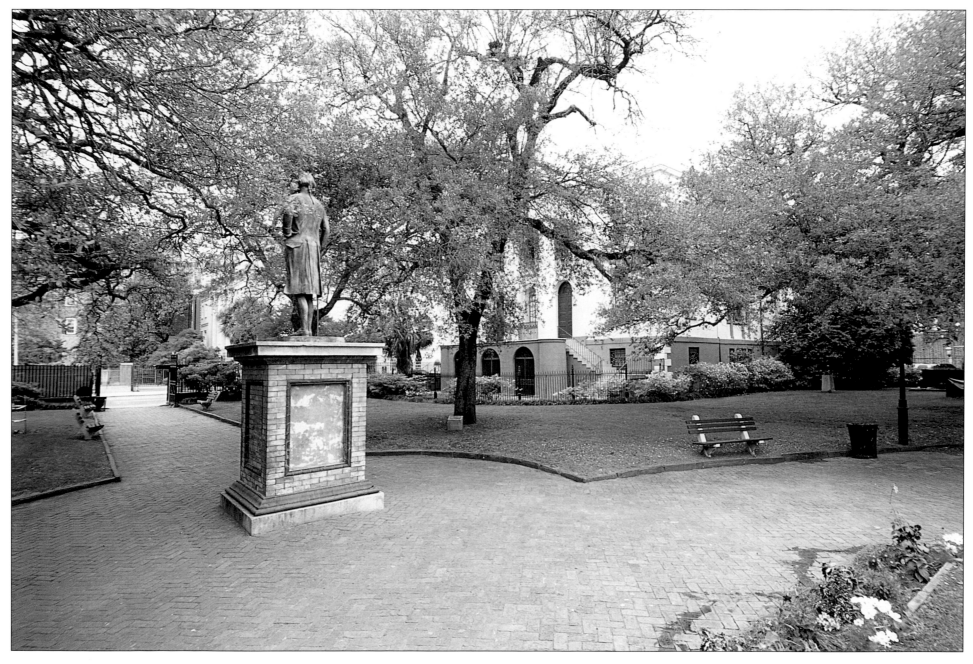

The structure was designed to protect the city's records from fire by Robert Mills, as Charleston had suffered four "Great" fires throughout its history, the largest having been in 1861. In the 1940s, Charleston County leased two floors of the Fireproof Building and modified some of the interior to house the collections of the South Carolina Historical Society (SCHS). During the 1960s, exterior modifications were made, including changing the color back to its original appearance, and the last county office—that of the coroner— was moved. In the 1970s, air-conditioning, new wiring, and humidity controls were introduced, and in the 1980s the building was finally transferred into the ownership of the SCHS. From 2000 to 2002, the building's exterior underwent extensive refurbishing. Today, visitors and historians alike can perform their research in a comfortable environment.

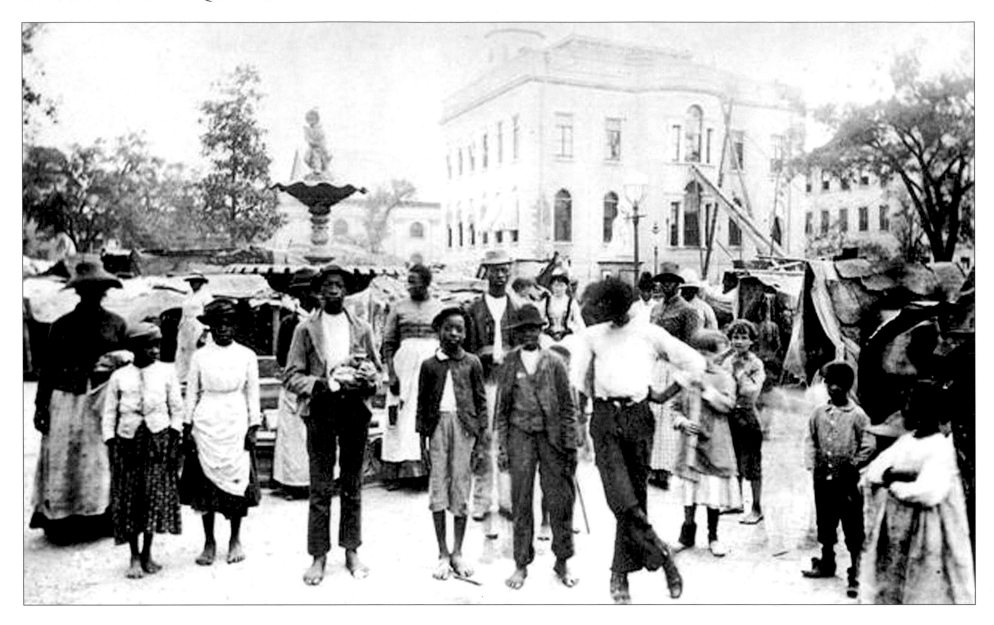

Charleston sits atop the Woodstock Fault, the second-largest fault in the country, and the city experiences a multitude of minor tremors every year, which has resulted in the placement of a seismograph in City Hall's council chambers. Aside from the regular tremors, most of which are undetectable to residents, the city has suffered two major earthquakes: one in the 1680s and the destructive earthquake of 1886. The 1886 quake struck on Tuesday, August 31, at nine in the evening, and is estimated to have measured almost 8.0 on the Richter scale. Countless buildings were severely damaged. Human casualties were relatively minor, but families were forced to evacuate their homes and live in tent cities like this interracial one in Washington Square. The tents themselves were often made from carpets or bedsheets, and many were furnished with all the comforts of home, including furniture.

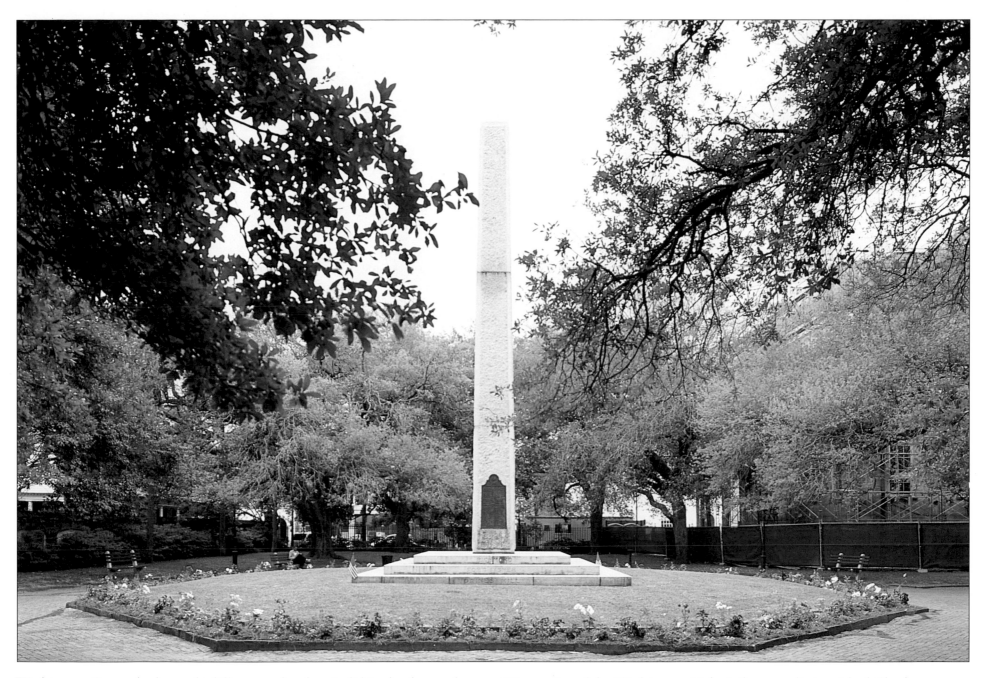

Washington Square looks vastly different today than it did in the days and weeks following the 1886 earthquake. The most visible change is that the fountain, seen in the background of the previous photograph, has been replaced by the forty-five-foot gray granite obelisk commemorating the Civil War service of the Washington Light Infantry, a distinguished Charleston military organization. The Washington Light Infantry served in most of the major battles in Virginia, led by the famous General Robert Edward Lee, from the beginning until the end of the Civil War.

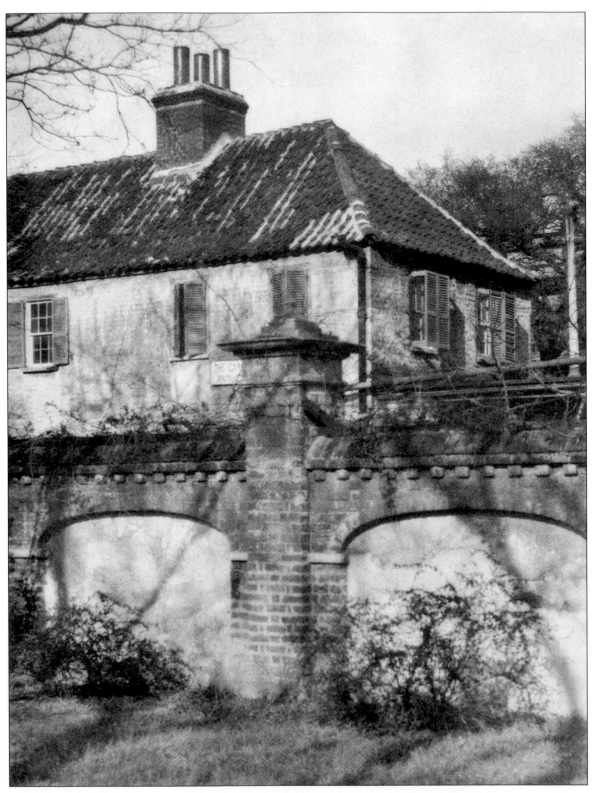

Viewable over the eastern wall of Washington Square is the kitchen house of the Daniel Ravenel House. Daniel Ravenel was descended from Daniel Ravenel of France, a wealthy planter and merchant who was born in the early 1600s. The lot was acquired in 1710 by Isaac Mazyck, a French Huguenot immigrant, and was given to his daughter in 1749. A wooden house appears to have been built on the lot originally, but it was destroyed by a fire in 1796, and the pictured structure was erected between 1796 and 1800 and was owned by Daniel Ravenel. Detached kitchen houses were a standard feature in early Charleston because fires often originated in buildings where cooking fires burned practically all day. It was hoped that a certain amount of distance between the main house and the kitchen would prevent a fire from spreading to the principal dwelling. In the late nineteenth and early twentieth centuries, outbuildings—like this kitchen house—together with servants' quarters and stables, were often connected to the main house to create what appears to the modern visitor to be extremely long, narrow houses.

Eighteenth- and nineteenth-century kitchen houses have long since been replaced with modern indoor kitchens, with all the convenient and safe amenities imaginable. Thus, such outbuildings from another era have been converted into rental properties and condominiums, as is the case with the Daniel Ravenel House today. This house is the only home in Charleston owned continuously by the same family for nearly three hundred years.

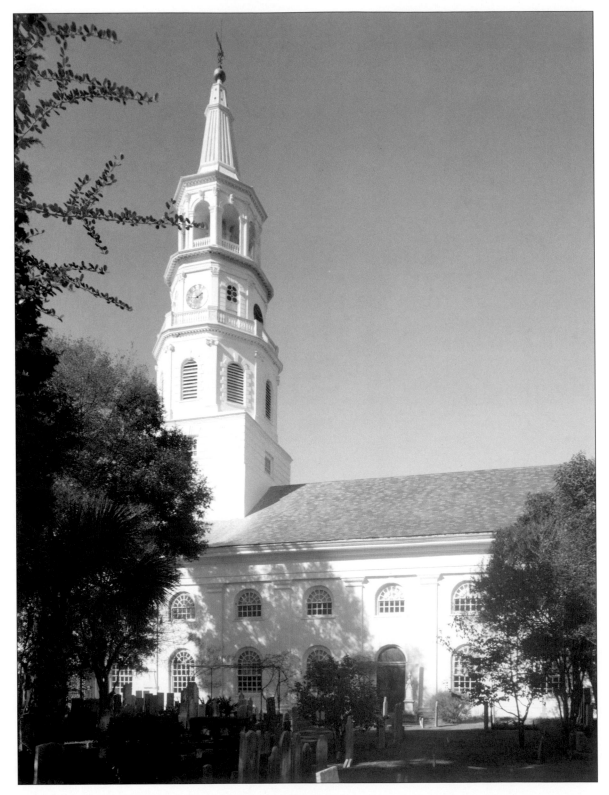

On the southeastern corner of Meeting and Broad streets, across from Washington Square, stands St. Michael's Episcopal Church, the oldest existing church structure in Charleston. Sitting on the site of the old St. Philip's Church (the oldest congregation in the city), St. Michael's cornerstone was laid in 1752 and parishioners began to worship there in 1761. Its spire rising 186 feet into the sky, St. Michael's steeple was used as an observation post to spot fires for nearly 150 years and then for monitoring the advance of the British in 1780 and Union forces throughout the Civil War. Though popular history has it that St. Michael's steeple was painted a dark color to eliminate it as a nighttime target for Union shellfire, other records indicate it may have been painted a dark brown color in the 1850s to match the rest of the church. In any event, many Civil War photographs clearly show a darkened steeple. The resilient structure survived the 545-day Union bombardment from 1863 to 1865, and though it was also heavily damaged by the 1886 earthquake, it remains today as perhaps the most recognized symbol of Charleston.

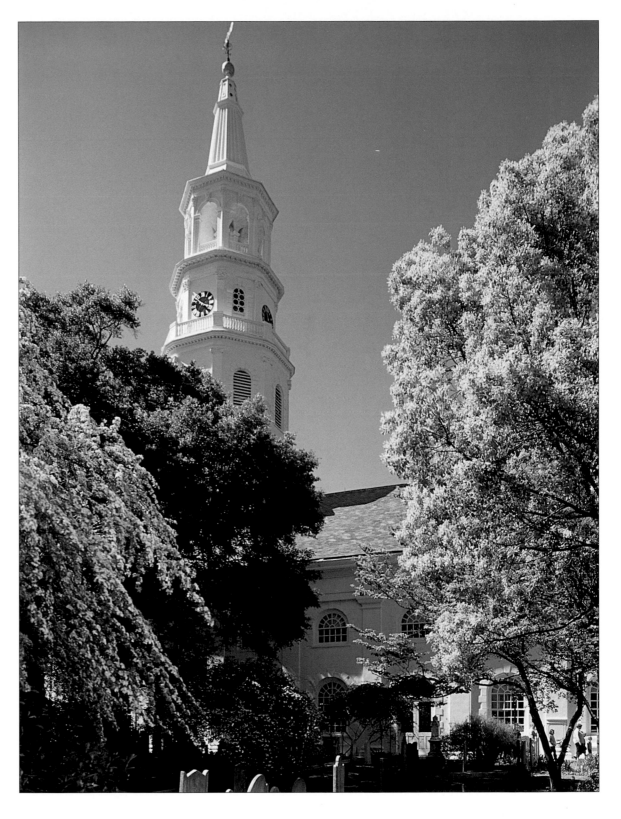

St. Michael's stands today as practically the same structure as it was when constructed. Although the Civil War and the 1886 earthquake heavily damaged the church, it was in both cases restored and refurbished to its eighteenth-century beauty as quickly as possible. In 1989, Hurricane Hugo damaged the exterior of the church, but repairs were completed within several years. In 1993, the Ainsworth Thwaites clock—considered to be the oldest Colonial tower clock in the country—was fully restored, and in 1994 the original John Snetzler organ was refurbished and restored to its original condition.

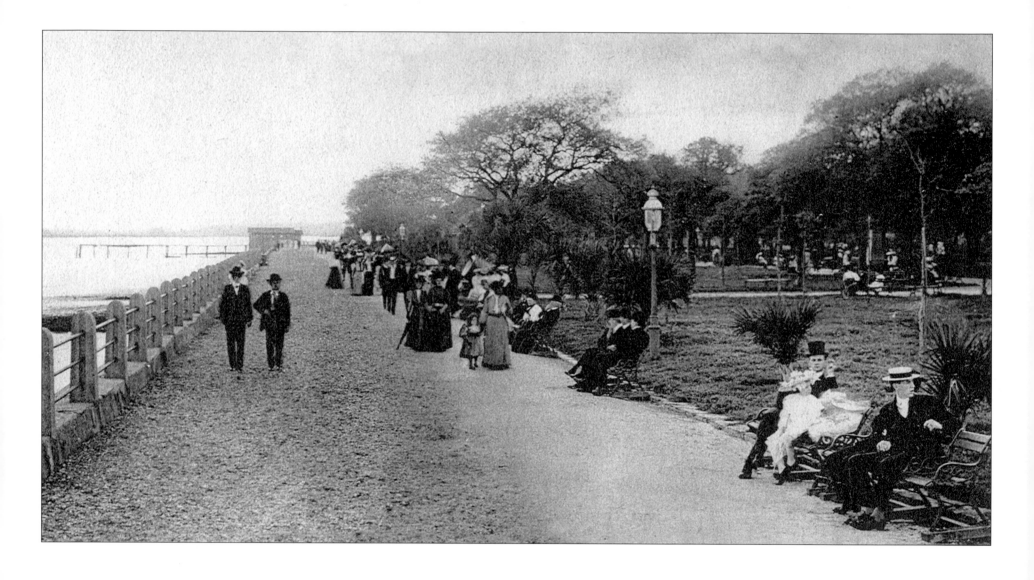

East Battery begins at Battery Park and runs roughly north with the Cooper River, Charleston Harbor, and the Atlantic Ocean on its eastern side. As early as the 1830s, the city began purchasing land in order to build a "public pleasure ground" for the city's residents. Originally, the city wanted to purchase land along East Battery Street to extend the park along the seawall; however, funding was not available and lots along East Battery were sold off.

In addition, a desire to run the park along the southern edge of the peninsula was ultimately put on hold due to the Civil War. In this late-nineteenth-century photograph, one can see where East Battery turns westward, running along the Ashley River. Though economic depression still held the city in its grip, this obviously did not deter the citizens of Charleston from enjoying the park's original purpose.

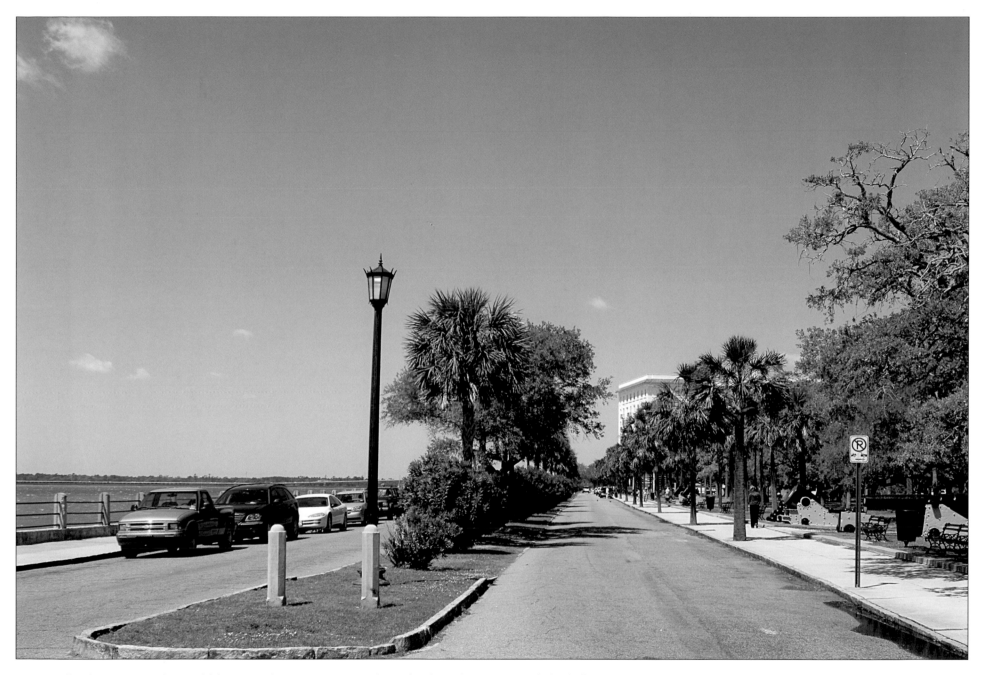

Eventually the promenade would be turned into Murray Boulevard, a lengthy street lining the Ashley River. Before the full length of the boulevard could be constructed, forty-seven acres of mud flats, from White Point to the western end of Tradd Street, had to be filled and an extension of the battery retaining wall was built to hold back the river. Andrew Buist Murray, a Charleston orphan who became a successful businessman and philanthropist, footed the bill for approximately 50 percent of the project, which stretched over a mile in length. To modern visitors, this section of Charleston's waterfront appears to be the wealthiest district in the city, though it is not the most architecturally rich or diverse. The majority of the large homes along Murray Boulevard were built in the twentieth century.

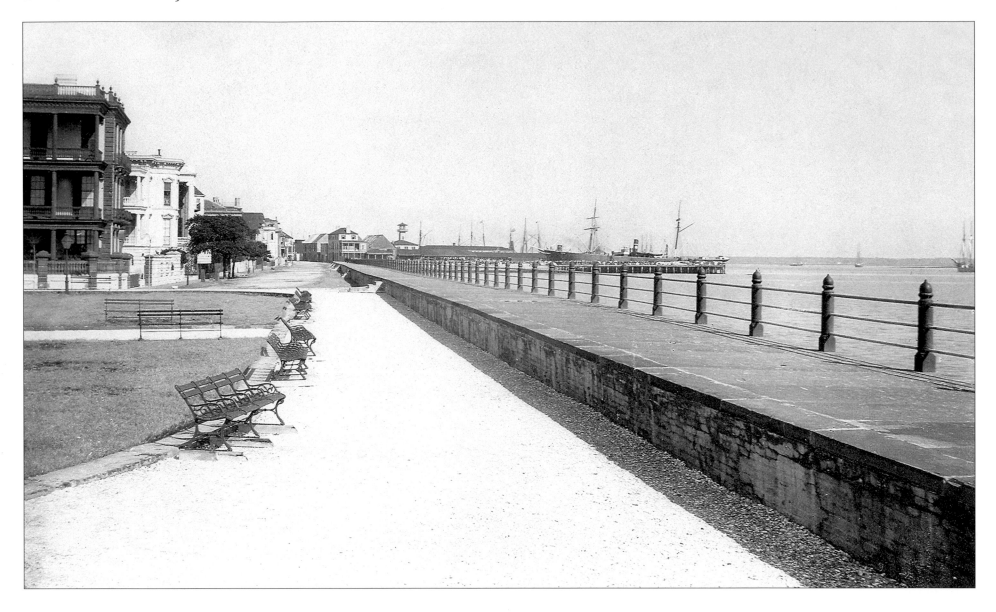

Looking north in this 1880s photograph, one sees the celebrated High Battery Wall. South of the walled city was originally marshland, so an earthen wall was erected and then ultimately replaced with a more substantial seawall. For nearly two hundred years, Charlestonians have enjoyed the promenade down the wall because of its majestic view of the harbor and its cool summertime breezes. To the left foreground is the home of the French Huguenot Louis D. DeSaussure, which dates roughly to the late 1850s; the 1840s home of John

Ravenel, another Huguenot; and beyond that, the enormous white columns of the 1838 house built by William Roper. The antebellum homes age progressively as one strolls north along the High Battery Wall, until reaching the Edmonston-Alston House (not visible in this photograph), built in 1828. Looking to the right of the wall, in the distance can be seen a number of masts and smokestacks of vessels docked along the Cooper River wharves, a sign of economic recovery.

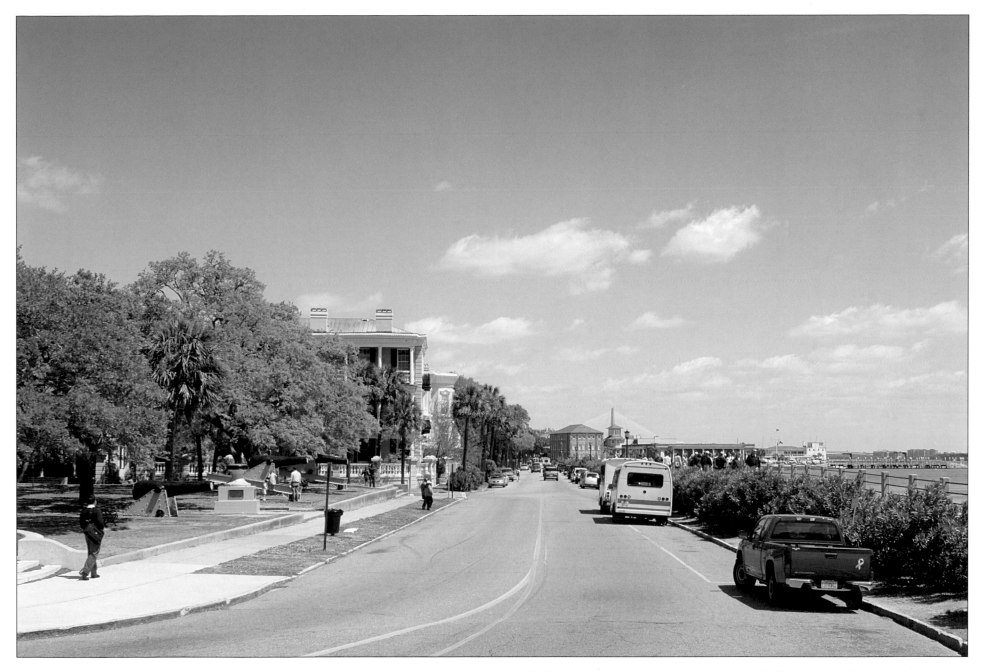

In the wake of a devastating series of hurricanes in the late nineteenth century, the seawall at right was strengthened and elevated. In contrast to the earlier image, one can see that East Battery has long since been turned into a modern traffic thoroughfare, which bends to the west and becomes Murray Boulevard. After the photo on the opposite page was taken, three Civil War cannons—two of which defended Charleston while the third, a Union Dahlgren gun, assaulted it—were placed in the park seen on the left to mark the position of the three-gun Battery Ramsay, which overlooked the harbor approaches to the city. Judging by the growth of the sprawling live oaks, it is obvious that the park has recuperated over the past century.

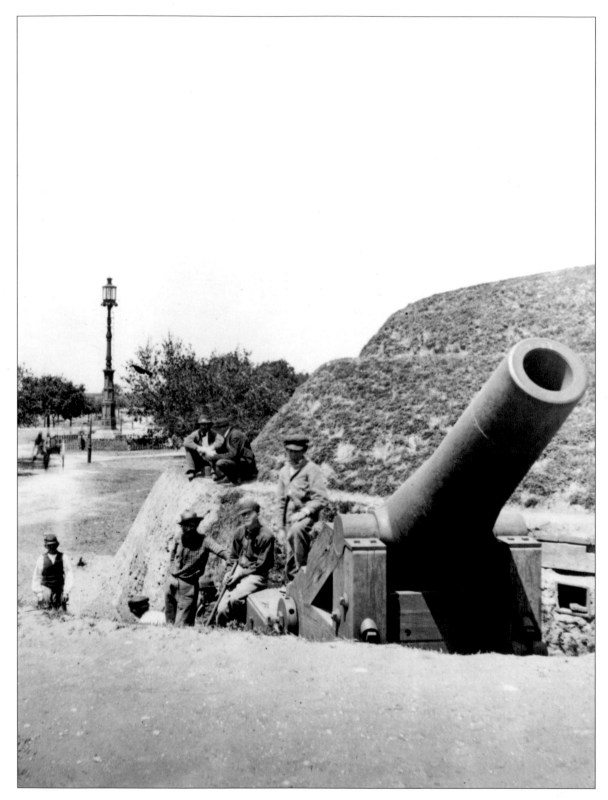

This Civil War image shows a ten-inch Columbiad smoothbore cannon, one of three heavy guns in Battery Ramsay overlooking the harbor. Many of the wartime batteries surrounding Charleston Harbor were laid out by General Robert E. Lee in his short stint as commander in Charleston. Subsequent commanders, including General Pierre Beauregard, continued to build batteries and other defenses in compliance with Lee's plan to "give the enemy a warm reception" should they enter the harbor through the narrow, mile-wide channel, which served as the front door to Charleston. A tall-oil navigational light, used to guide peacetime vessels and wartime blockade runners into the harbor, can be seen behind the gun.

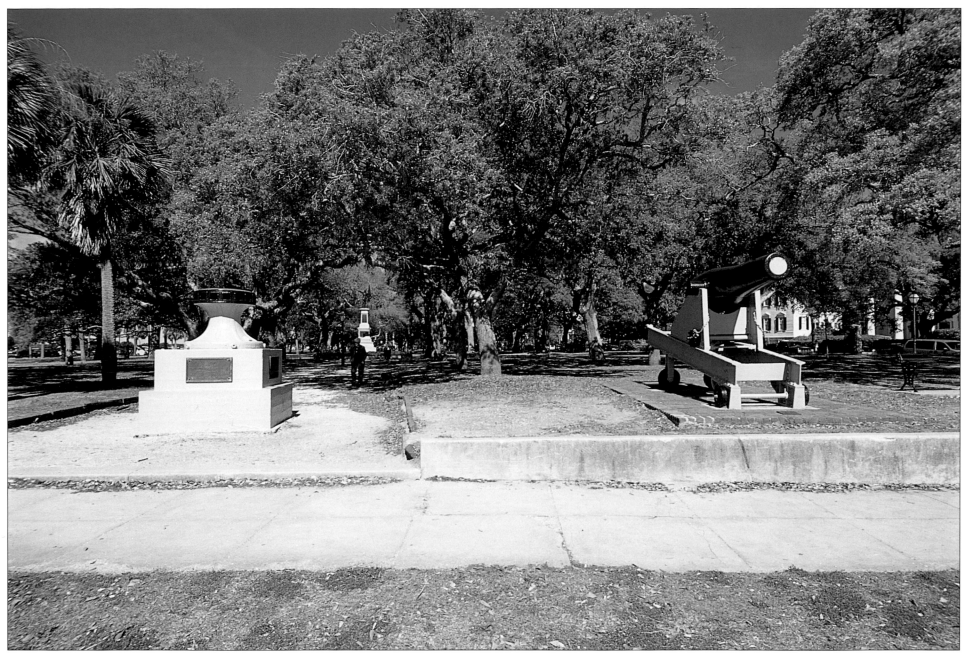

A curious sight for most visitors is the capstan of the USS *Maine*, seen here in the foreground. After the *Maine* mysteriously blew up in Havana's harbor in 1898, initiating the Spanish—American War, her salvaged remnants were distributed throughout the country. Looking through the park where the old navigational light once stood, today the Sergeant William Jasper monument, commemorating the June 28, 1776, battle of Sullivan's Island, stands shaded by live oak trees. This celebrated American victory, fought several days before the Declaration of Independence was signed, pitted the soldiers of Fort Sullivan (now Fort Moultrie), a hastily constructed fortification of sand and palmetto logs, against the full might of the British Navy under Admiral Sir Peter Parker. During the fighting, the flagstaff of the Second South Carolina Regiment was shot in two by British cannon fire. Without a moment's hesitation, Sergeant Jasper braved the fire to refasten the flag atop the fort and shouted, "Let us not fight without a flag!"

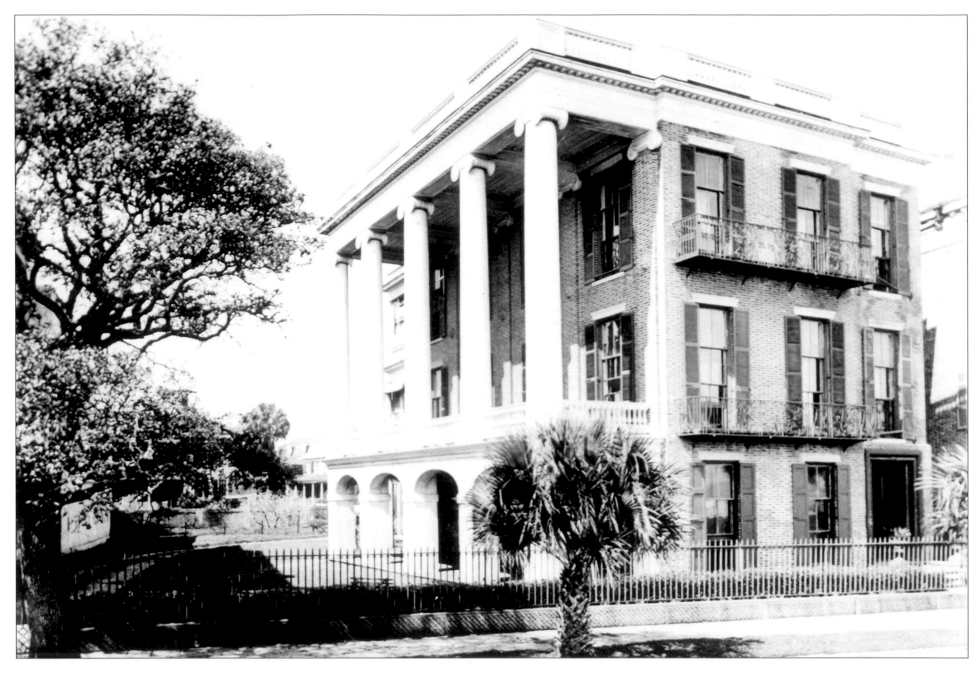

Three doors up East Battery stands the Greek Revival mansion of William Roper with its enormous white Ionic columns visible to all vessels entering the harbor. The city had intentions of creating White Point Gardens northward along this section of East Battery; however, a financial panic in 1837 convinced supporters of this plan to sell off the land. Several doors down, at the intersection of East and South Battery, a massive English Blakely rifle was placed in a battery that literally sat in the middle of the intersection. This gun, which weighed several tons and was capable of firing a projectile of 600 pounds, was blown up by the evacuating Confederate forces during the night of February 17–18, 1865. The explosion heavily damaged several homes in the area and lobbed a giant piece of the gun tube into Roper's attic. In 1877, Rudolph Siegling, publisher of the *Charleston News and Courier*, purchased the structure and had his initials placed over the front door.

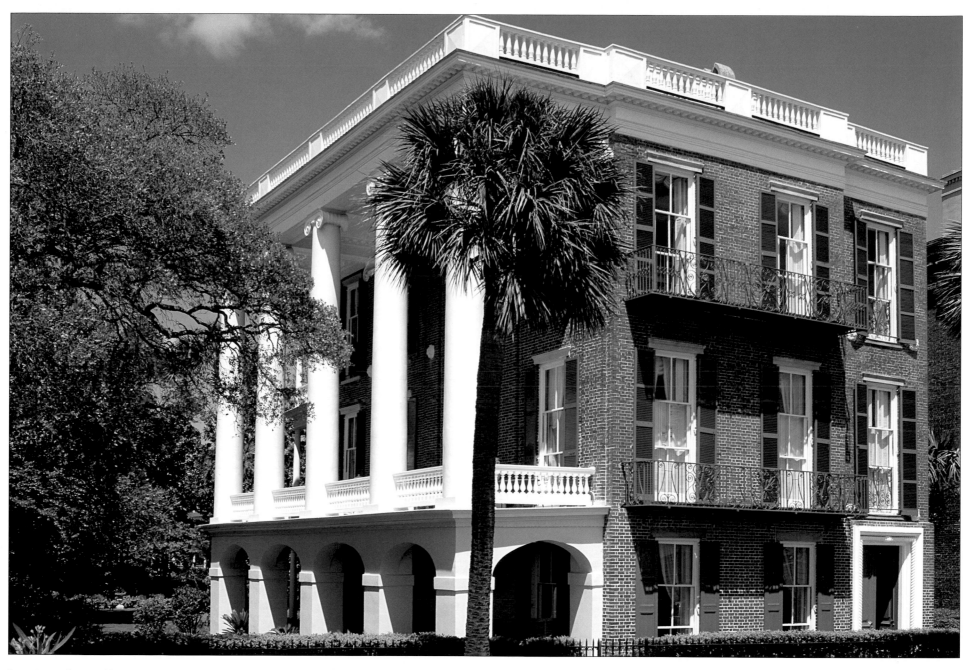

In 1929, the William Roper House was purchased by Solomon Guggenheim, the New York millionaire and patron of the arts. His widow sold the house in 1952 to Drayton Hastie, owner of Magnolia Gardens, who in turn sold it in 1968 to Richard Jenrette, chief executive officer of the New York investment firm Donaldson, Lufkin, Jenrette. Jenrette still owns the home today and uses it to entertain distinguished visitors and lovers of classical architecture, including Prince Charles of Wales.

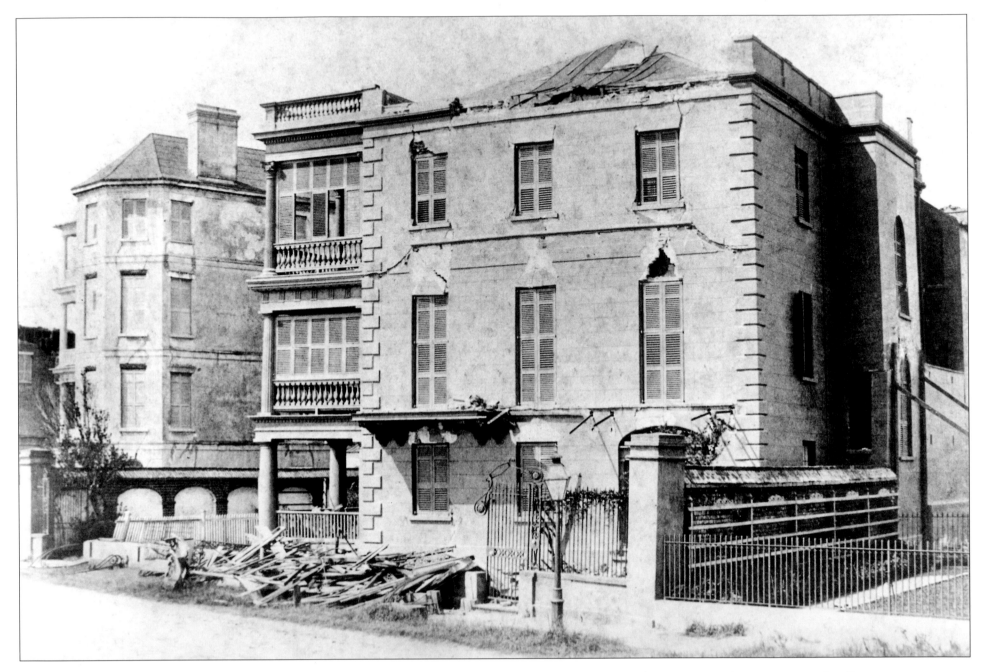

In this photograph, the celebrated Edmonston-Alston House appears all but destroyed by the 1886 earthquake. Built in 1828 by Scottish merchant and wharf owner Charles Edmonston, who hailed from the Shetland Islands, the house was purchased and renovated in 1838 by the prosperous rice planter Charles Alston. Notice that on the roof of the Greek Revival home there is a board covering the chimney hole. The chimney swayed from the shock of the quake, eventually breaking free from the structure and collapsing across the parapet, which contained the Alston coat of arms. This falling debris removed the cast-iron balcony on the second floor, which in turn collapsed to the ground, destroying the iron fence in front of the house. One can also see cracks in the stucco around the third-floor windows and the support beams on the right side of the structure.

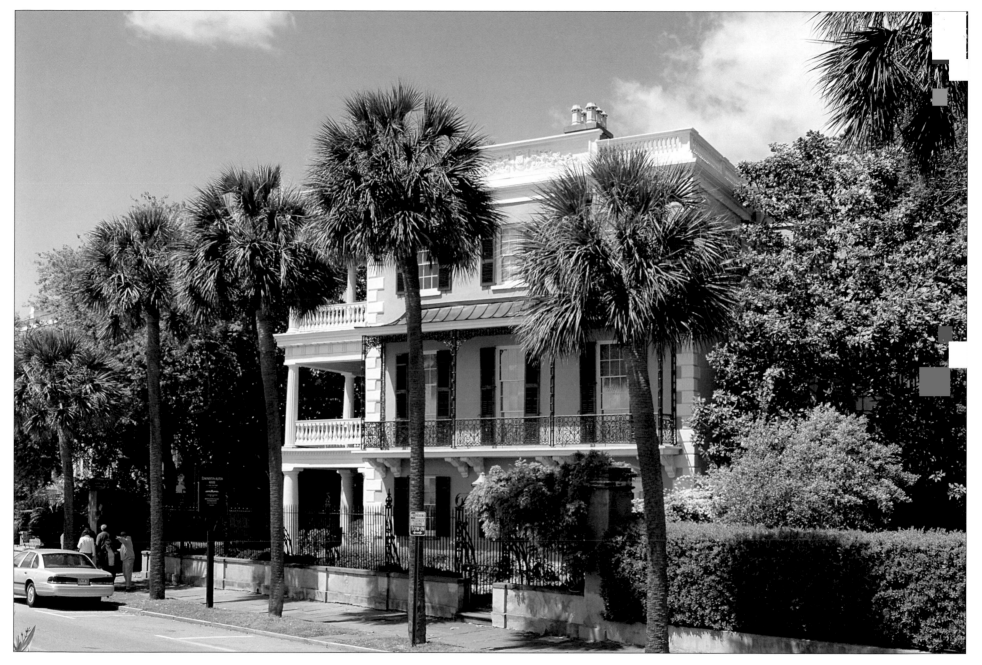

The Edmonston-Alston House has remained in the Alston family since 1838. The Alstons have been responsible for keeping and preserving the family furniture and belongings, which is why this house contains the largest collection of heirlooms original to the family than any other museum house. Up to 90 percent of the furnishings in the home belonged to the Alstons prior to 1850. The rear carriage house, which now serves as a bed-and-breakfast, was completely renovated, with the interior designed by Martha Stewart, who was the very first guest to stay in the house. During Hurricane Hugo in 1989, the first floor of the house was flooded with over three feet of water, which left behind nearly a foot of mud. Today, the third floor of the house is occupied by the Alston family, while the first two floors are open for tours.

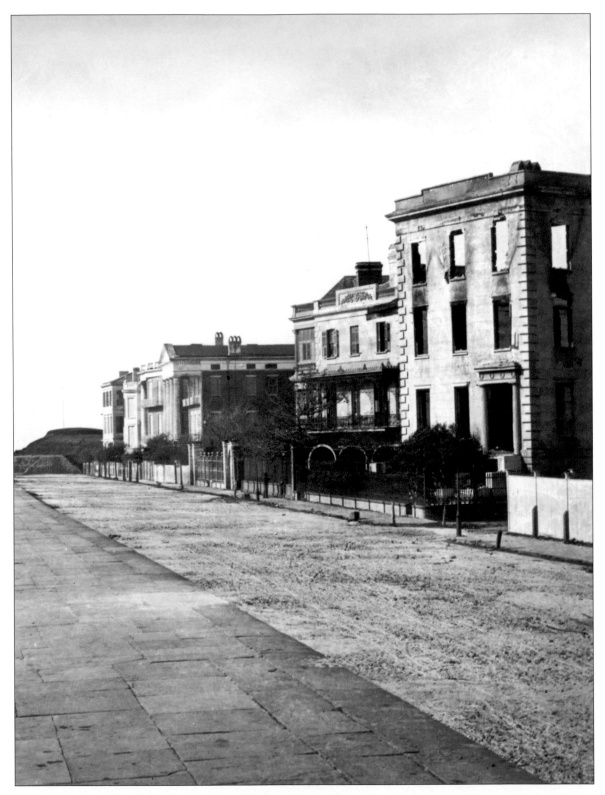

Looking south along East Battery, with the harbor to the east, this Civil War photograph, taken by a Northern photographer shortly after Charleston fell, clearly illustrates a small portion of damage inflicted by the 545-day bombardment of the city. Because these homes were closer to the Union guns and near the lower tip of the peninsula, the majority of enemy shells passed over them. However, the Daniel Heyward House, seen here on the right, has been shelled and burned out. Colonel Daniel Heyward was a wealthy rice planter. Shortly after this image was taken, the ruins toppled. Though the Edmonston-Alston House next door seems to have survived intact, its front steps and rear stable house were damaged by shells. Immediately after the Union occupation, the weeds and brush—in many cases waist and chest high—that choked this depopulated part of the city were quickly removed from the streets, and the shell craters were filled in. The Union troops, primarily from New England, were unaccustomed to coastal diseases spread by mosquitoes that found safe haven in the brush and water-filled shell craters.

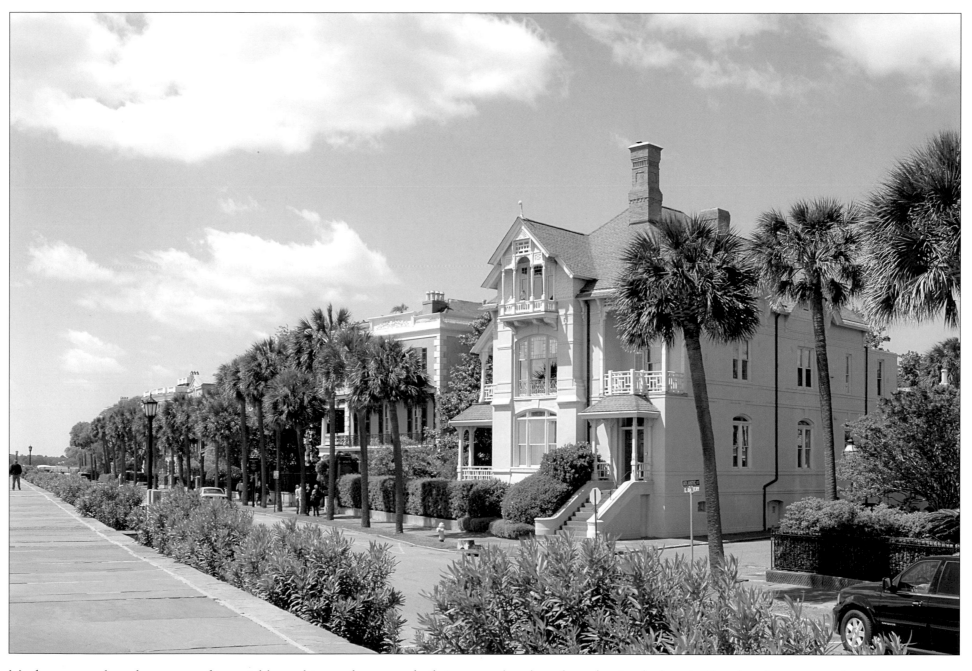

Much more modern than many of its neighbors, this new home was built in 1885 by Charles Drayton, owner of the Drayton Hall plantation on the upper Ashley River, to replace the Daniel Heyward House. Drayton followed the path of many former planters by shifting from the large-scale production of crops, which was no longer feasible after the Civil War, to the mining of phosphate from the riverbed marl. The phosphate was used as a key ingredient in making fertilizer. The Drayton home was considered to be quite out of style for a Charleston mansion in that it incorporated a unique combination of both medieval and Chinese influences.

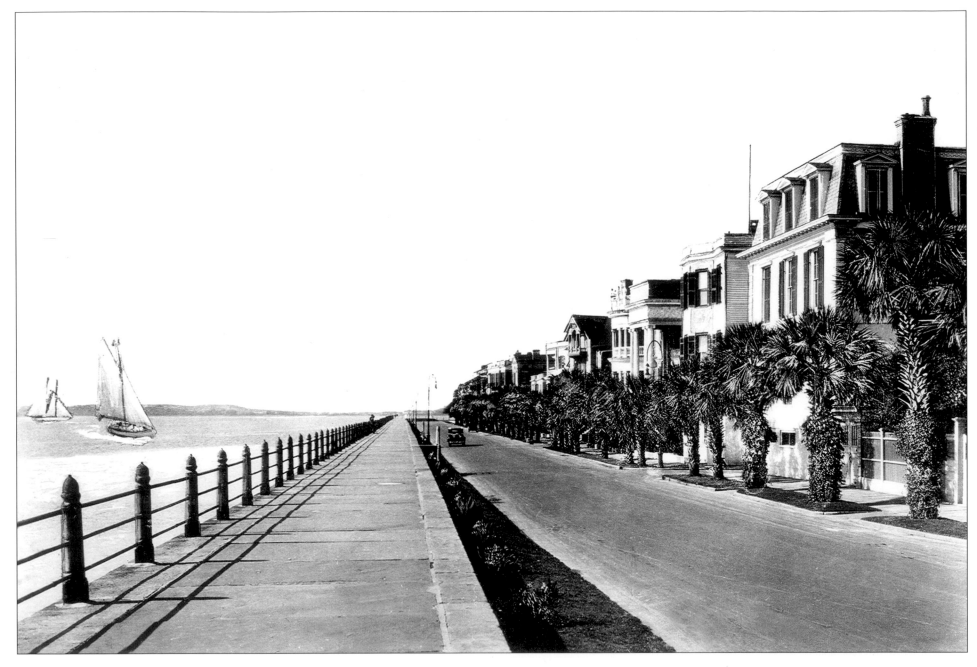

An early twentieth-century view of a stretch of East Battery reveals a relative amount of healing to the area after the bombardment it suffered during the Civil War. For example, the Daniel Heyward House (seen on page 30 as a burned-out shell) has been replaced by the Charles Drayton House, barely visible to the right of the automobile. Not only was this area a casualty of the Civil War but is also vulnerable to the damage that can be caused by storms. This is the purpose of the high Battery Wall, seen to the left, that still affords some protection from surge walls of water generated by storms. However, its other primary use, then and now, is to provide visitors with a stroll down the oleander-lined walkway.

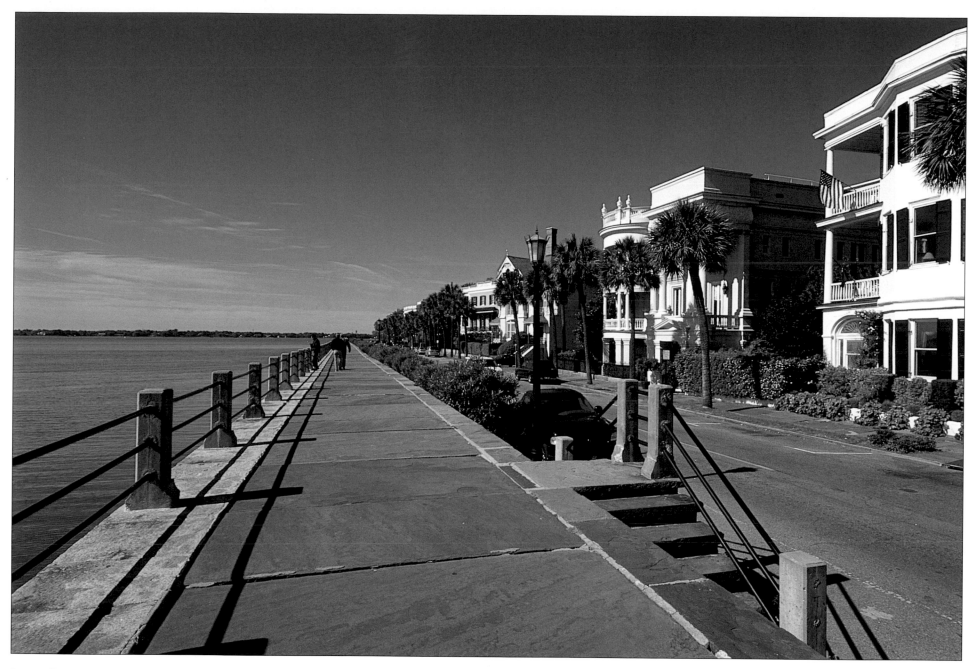

Regardless of the taller, more structurally sound seawall, the stately homes along East Battery suffered greatly decades later due to the impact of Hurricane Hugo, when a surge wall of water fifteen feet high rolled over the wall. The eye of the great storm passed over the Charleston Peninsula at midnight on September 21, 1989, with winds reaching 135 miles an hour. Hurricane Hugo caused the deaths of twenty-six people and ultimately cost six billion dollars in damage.

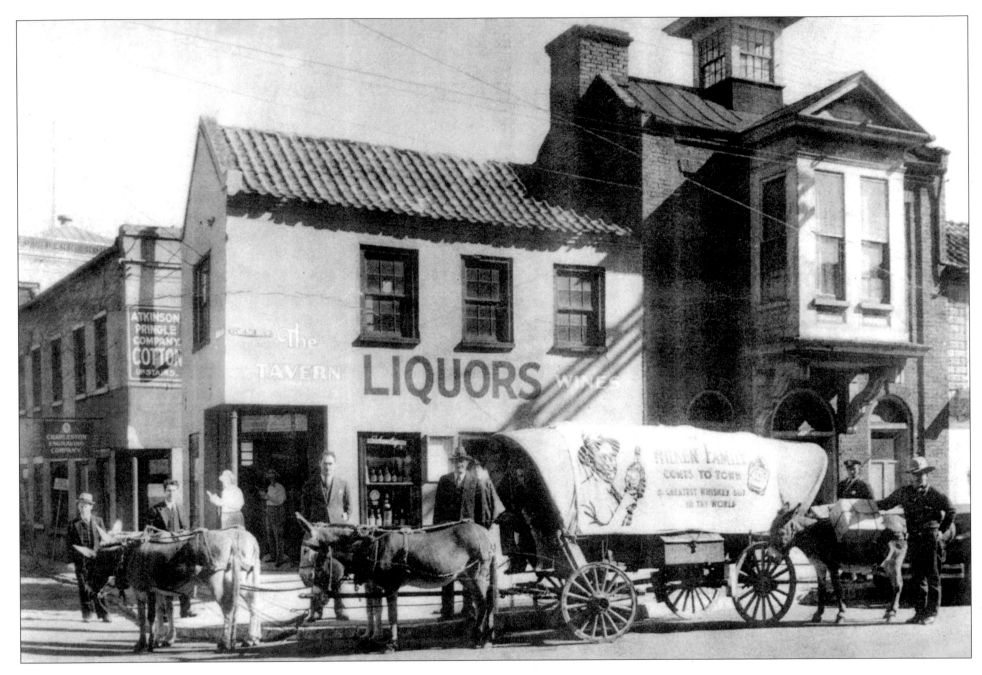

Further up East Bay, and just a few yards south of where Broad and East Bay streets intersect, sits Coates Row, supposedly the oldest commercial building in Charleston, possibly dating back to 1718. Equally interesting is that the Tavern Liquors, seen here on the left, is considered to be the oldest tavern in the country, possessing receipts from the 1850s. Originally, the Tavern was on the waterfront and served drinks and generated lively debates and general discussions among its clientele: seafaring men. Over time, taverns gave way to fashionable coffee houses serving "syrup of root," or "Turkish gruel," as the drink was sometimes termed. However, drinks such as rum and whiskey were still served. The photo appears to have been taken in the early 1920s, before Prohibition, as evidenced by the mule-drawn liquor delivery wagon seen in front of the Tavern.

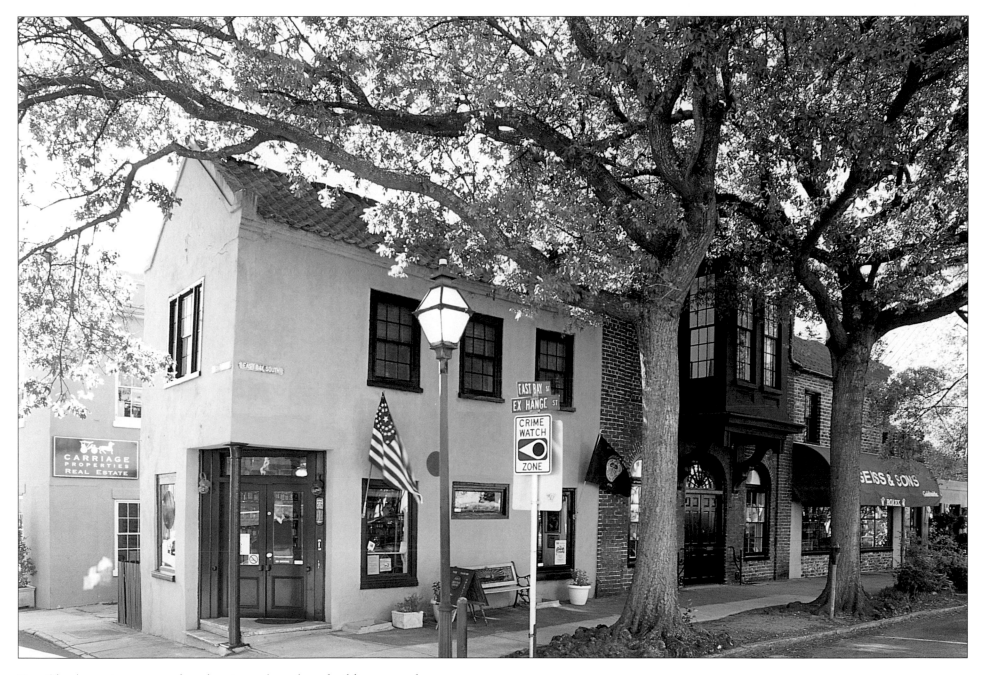

Few Charlestonians remember the time when these buildings were known as Coates Row. The Tavern remains firmly planted at what is today the corner of East Bay and Exchange streets, to the right. The buildings along Exchange Street are mostly old warehouses converted into law offices and fashionable restaurants. To the right of the Tavern, the connected buildings offer antiques and fine jewelry.

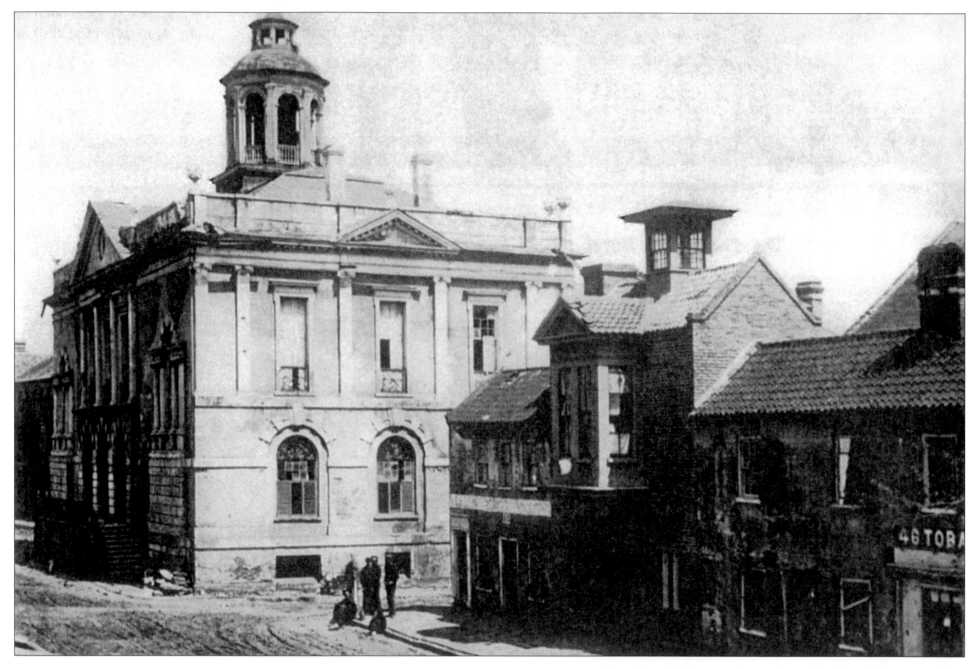

The Old Exchange and Customs House was built around 1770, pressed against the Cooper River and built atop the site and foundation of the Court of Guard, a much older structure that incorporated a semicircular bastion known today as the Half-Moon Battery. Practically all official dignitaries—including George Washington, who visited Charleston for several weeks in 1791—were entertained in the Exchange. The Old Exchange was the last building erected by the British prior to the American Revolution, and its two staircases projected out into the intersection of Broad and East Bay streets. These were ostensibly removed for traffic reasons. On the northern side of the building, the domestic slave trade thrived as an outdoor process until 1856, when the sale of slaves was forced inside private auction houses. This was due largely to the fact that England and France had freed their slaves decades before, so men and women aboard ships docking at the Cooper River wharves were appalled and offended by the outdoor sales.

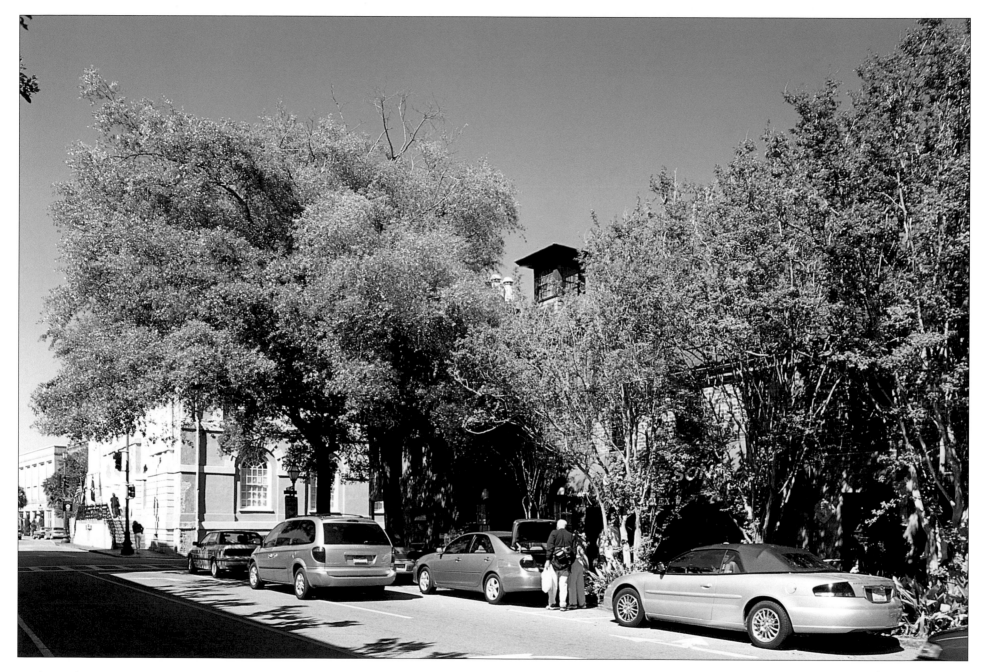

In the early twentieth century, the Old Exchange was slated to become a gasoline station. Efforts by the Rebecca Motte Chapter of the Daughters of the American Revolution to purchase the property were put on hold during World War I, when it was used as the headquarters of General Leonard Wood. They were finally able to purchase the property in 1921. In 1924, they replaced the roof and restored the ironwork on the west elevation. In 1943, the building was used as the headquarters for the Coast Guard's

Coastal Pickets. It was during this time that a new stairway to the upper floor was created by removing a large section of the original floor in the Great Hall. In the 1950s, the building was rented to a fencing school, and in the 1970s, the Old Exchange Commission was established to lease and renovate the property, the latter having been done at a cost of $1.9 million. Since the 1980s, however, exterior structural problems have made further renovations necessary.

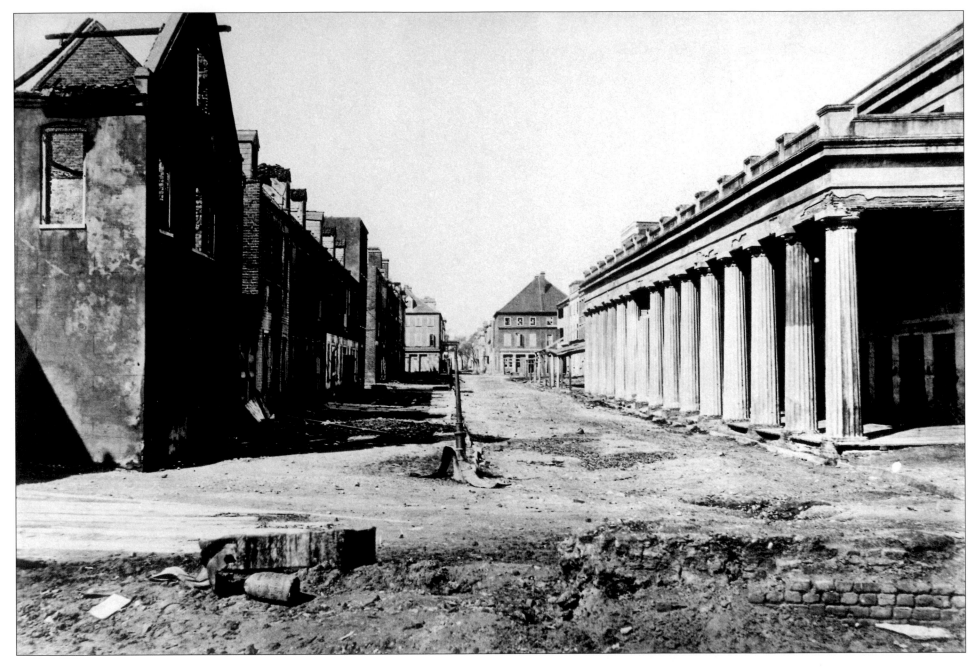

To the east of East Bay Street, about a block north of the Old Exchange, runs Vendue Range, a short street to the waterfront. The street's name is derived from the auctioneers whose businesses lined the street. In addition, the street was lined with houses belonging to the merchants and auctioneers, many of whom were of French descent. The photographer who took this shot showing the destruction of the Civil War had to stand with his back on the edge of the Cooper River in order to take the picture. Behind him is hardly more than a few feet before he would either fall into the water or fall onto a ferryboat headed across the river to Mount Pleasant. The building immediately to the left has been shelled out, and, opposite this, one of the columns along the colonnade has been struck by a shell, creating a gap in the building's architectural rhythm. East Bay Street runs perpendicular to Vendue Range and is visible in the background.

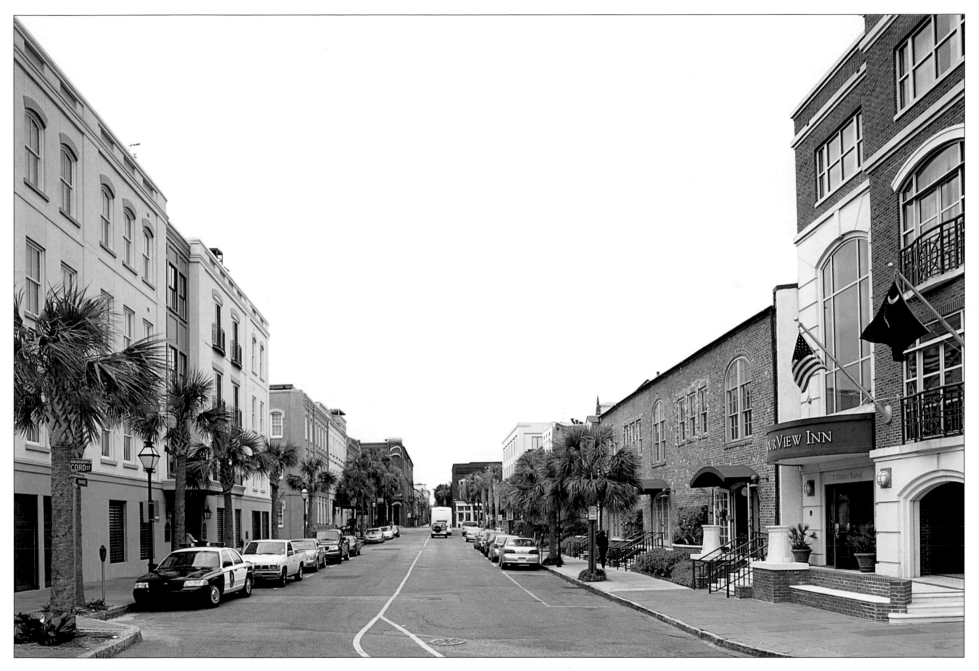

The person who took the photo opposite would not have to worry about falling backward into the Cooper River today, as an additional hundred yards of land—Waterfront Park—were developed after Hurricane Hugo and would catch his fall. Immediately after the Civil War, a vastly different view of this area would seem almost inconceivable. On the right, where the colonnades once stood, are the Charleston Harbour View Inn, the Griffin Pub, and the Anchorage Inn; across the street is a series of modernized buildings, including the fashionable Vendue Inn.

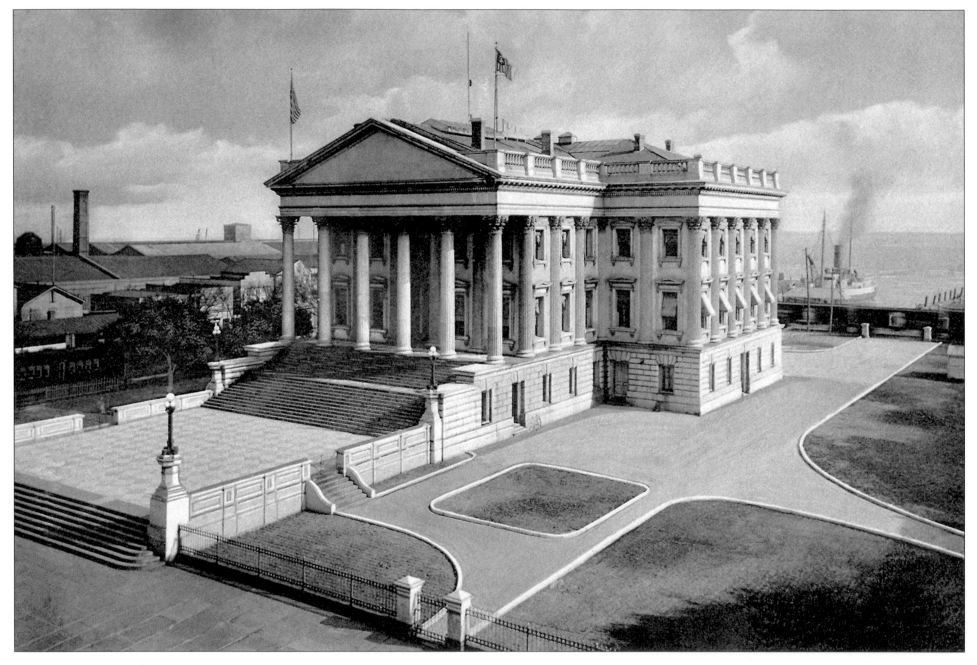

North of Vendue Range, on East Bay Street, the United States Custom House dominates the landscape. In 1848, Congress set aside money to fund the construction of a new customshouse, and one year later a piece of property known as Fitzsimmons Wharf was purchased, on which the new structure would be built. The wharf sat atop the location of Craven's Bastion, an ancient city fortification whose remains were discovered while excavating the foundation. An architect was chosen in 1850, but the project stalled in 1861, partly because many of the workmen had gone off to war, including the chief engineer of construction, who joined the famous "Charleston Battalion" of infantry. By 1863, Union shelling had shut the work down completely, and it was not to be resumed until after the war. The United States Custom House for the Port of Charleston was finally completed in 1879.

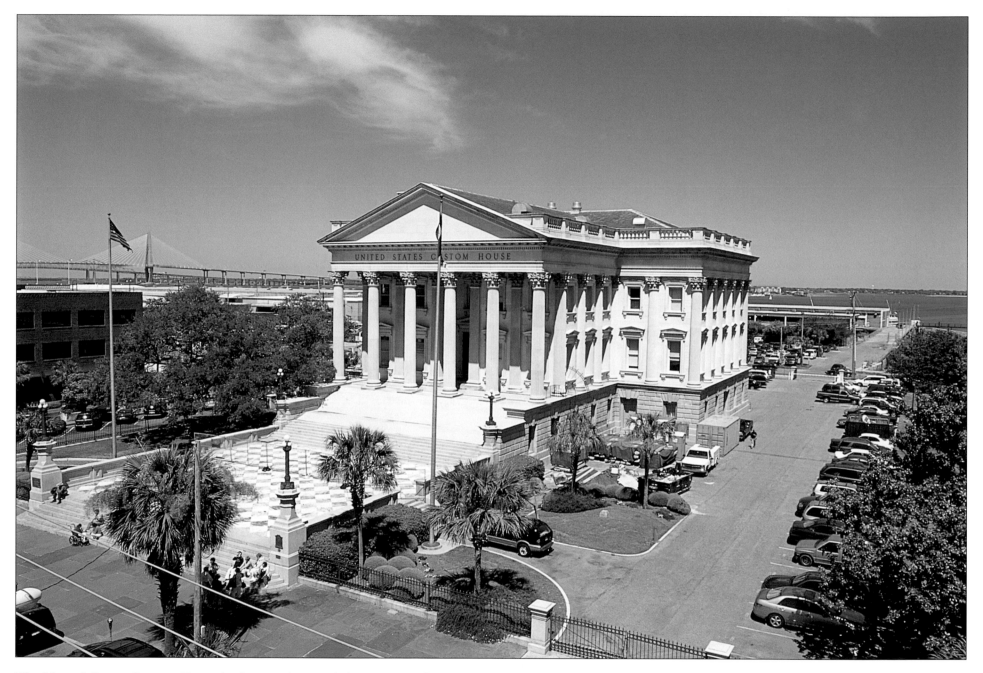

The United States Custom House looks exactly as it did in 1879. Today, however, the steps of the building allow the Custom House to serve many purposes. Each year, visitors and residents alike throng to its Cooper River side, where the steps serve as a grandstand for Spoleto and musical events during the African American Moja Arts festival. The federal government intended to demolish it until preservation-minded Charlestonians convinced the government of its historical and architectural significance.

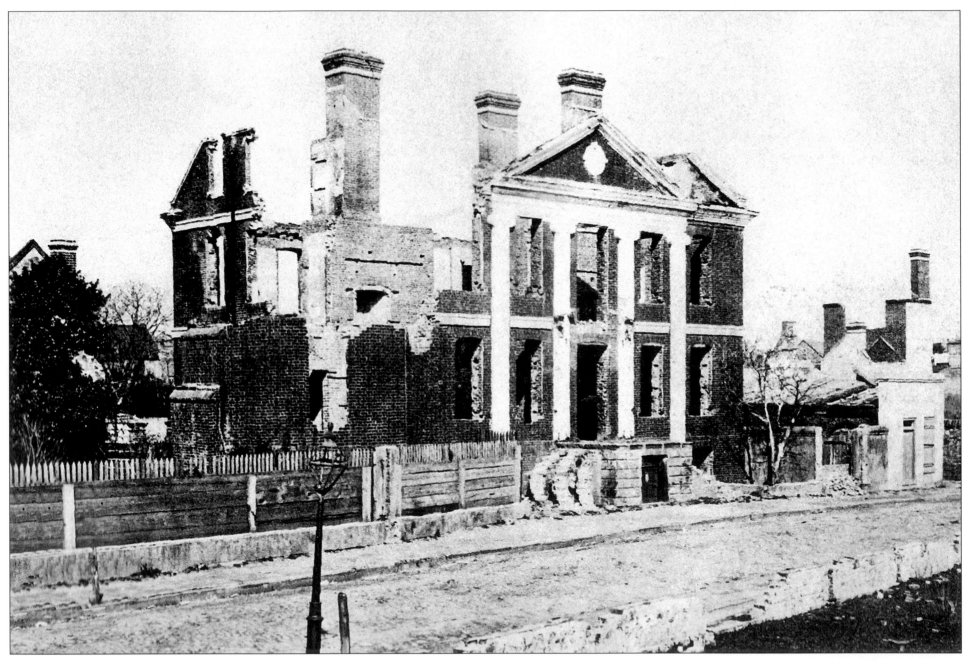

On East Bay, just north of the City Market, is the site of one of the first architectural casualties of a devastating fire that broke out in December 1861. This was by far the largest fire in Charleston's history and simply one of the worst disasters to strike the city. Pictured here are the ruins of the Pinckney Mansion, built between 1745 and 1769 by Charles Pinckney, a notable politician—one-time attorney general and chief justice of the early colony— and father of Charles Cotesworth Pinckney, a signatory to the United States Constitution. Pinckney moved his family to a smaller home nearby and rented his home to Governor James Glenn, forever attaching the title of Governor's Mansion to the structure. The burned-out mansion was later heavily damaged by Union shellfire and was eventually torn down.

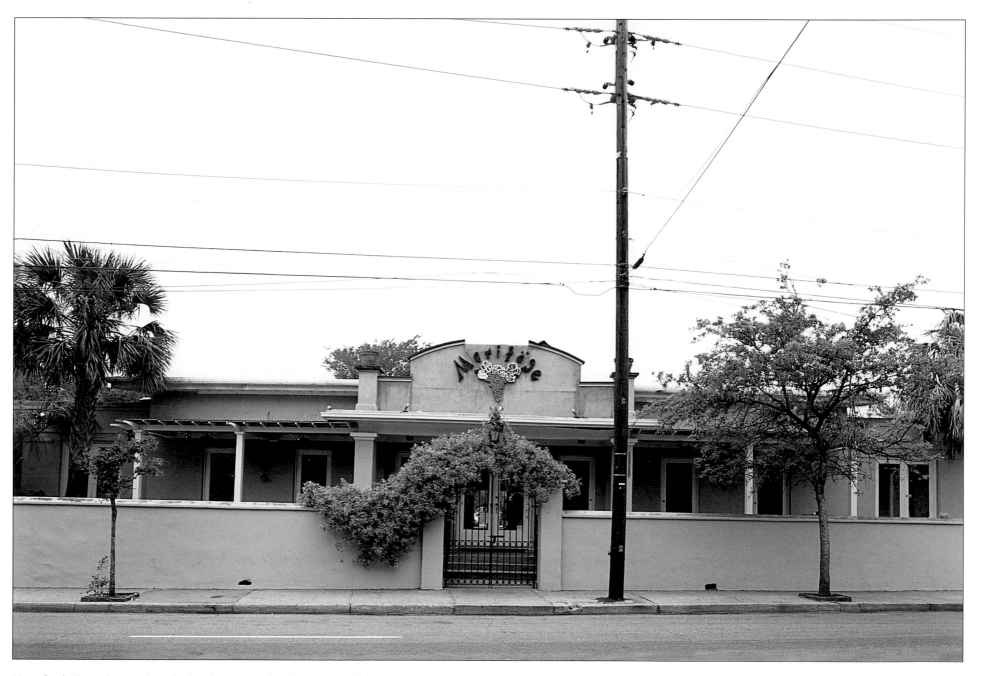

Very little has changed with this lot since the Governor's Mansion graced its landscape. However, as Charleston has changed to a tourism market so have its businesses. In modern times, a series of restaurants have occupied the lot, the latest being the Meritage, a popular tapas restaurant. Across the street from this structure is the large warehouse complex of the South Carolina Ports Authority.

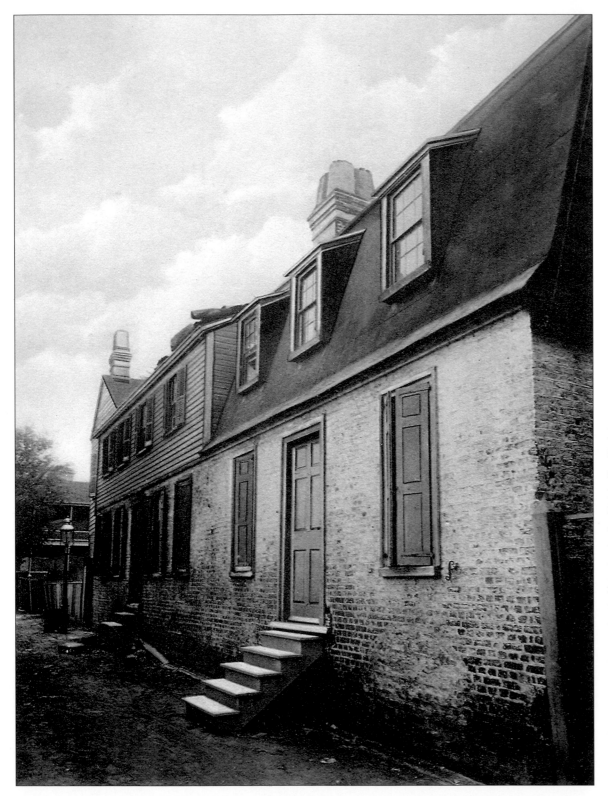

Most Colonial cities have a Bay Street and a Church Street. Church Street, like East Bay, Meeting, and King streets, was one of the streets laid out in the original town plan for Charleston. Originating near present-day Water Street, Church Street was eventually bridged over the creek around 1739, creating what many commonly referred to as "Church Street Extension" or "Continued," which was little more than a pathway southward to White Point. Just north of the creek ran Stoll's Alley, named after Julius Stoll, a blacksmith who purchased a house in the alley as early as 1759. Houses were built as early as 1746, when the alley was known as Pilot's Alley because harbor pilots occupied many of the houses in it due to its close proximity to the waterfront. Peter Trezevant became a resident of the alley in 1826. In the post-Civil War era, the alley was populated by poor residents. Mrs. George Canfield purchased and renovated many of these houses in the early twentieth century. At this time, the alley was bricked and a Union shell was uncovered in the excavations.

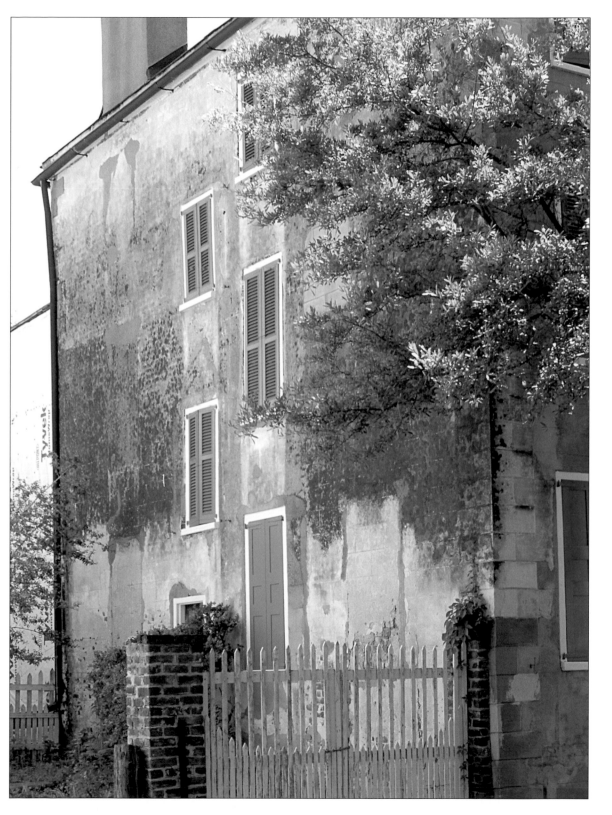

Today, Stoll's Alley provides a perfect example of why visitors return to Charleston year after year. Once you think you've seen it all, you turn a corner and discover a neat, tidy little alley like Stoll's. No longer a slum, Stoll's Alley tucks away numerous small houses of the past overflowing with beautiful gardens. The Trezevant House, while in somewhat of a state of disrepair is currently being renovated.

Like Stoll's Alley, Longitude Lane (which actually runs latitudinally) is also a small lane connecting East Bay Street and lower Church Street. It is believed that rice was first cultivated in Charleston in the area between Longitude Lane and Tradd Street, one block north. Yet other records have recently indicated that rice exportation from nearby plantations began earlier, in 1694. As with many streets, alleys, and lanes along the waterfront, it is believed that Longitude Lane was once a small, marshy inlet. Over the years, these inlets were filled with anything from ships' ballast stones to trash.

During early twentieth-century renovations, two cannons from the American Revolution were discovered buried in the lane. One of the guns is believed to have been buried there to avoid being captured by the British occupiers of Charleston from 1780 to 1782. The other cannon is believed to be a British gun and was reinterred on Queen Street, where its muzzle can be seen sticking out of the sidewalk and pointing skyward. Thanks to continued restoration efforts over the past hundred years, Longitude Lane is no longer a leery side street off the waterfront.

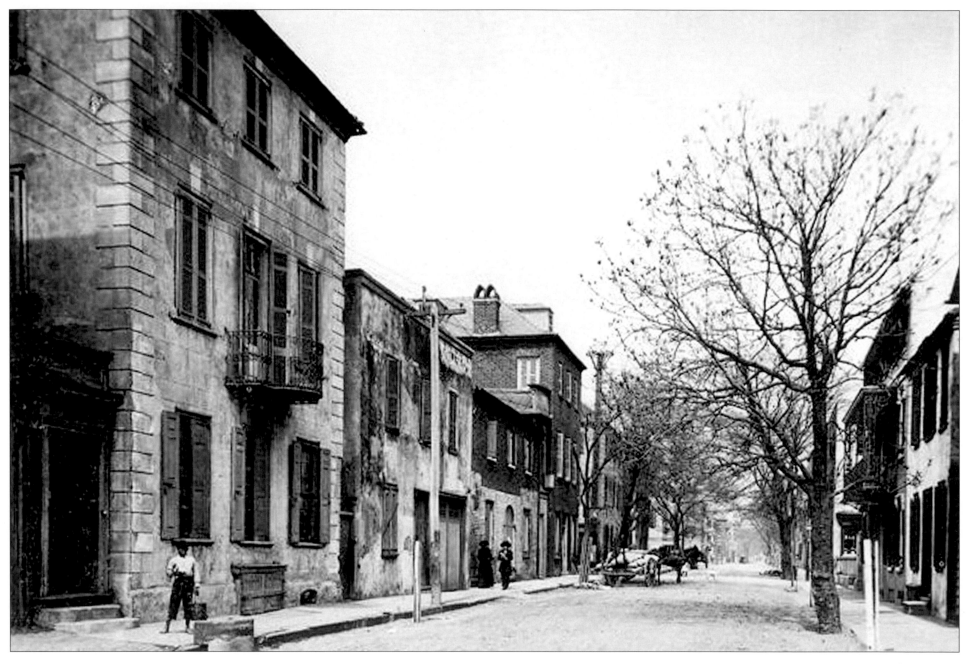

The lower neighborhoods of Charleston were in a distressed condition following the Civil War, the 1886 earthquake, and economic depressions in the late nineteenth century. Visible on the left, with the little boy standing in front, is the Colonel Robert Brewton House, considered to be the oldest example of the "single house" in Charleston, dating to the 1720s. When Brewton built this house, Church Street was a beautiful, thriving street, as opposed to this image of neglect. The single house—to this day the most common architectural style in Charleston—was perhaps a direct descendant of the long, narrow English "unit house" that became a necessity following London's devastating fire of 1666. This style was altered as the English established sugar plantations on the island of Barbados, which, like London and Charleston, had little room for larger homes.

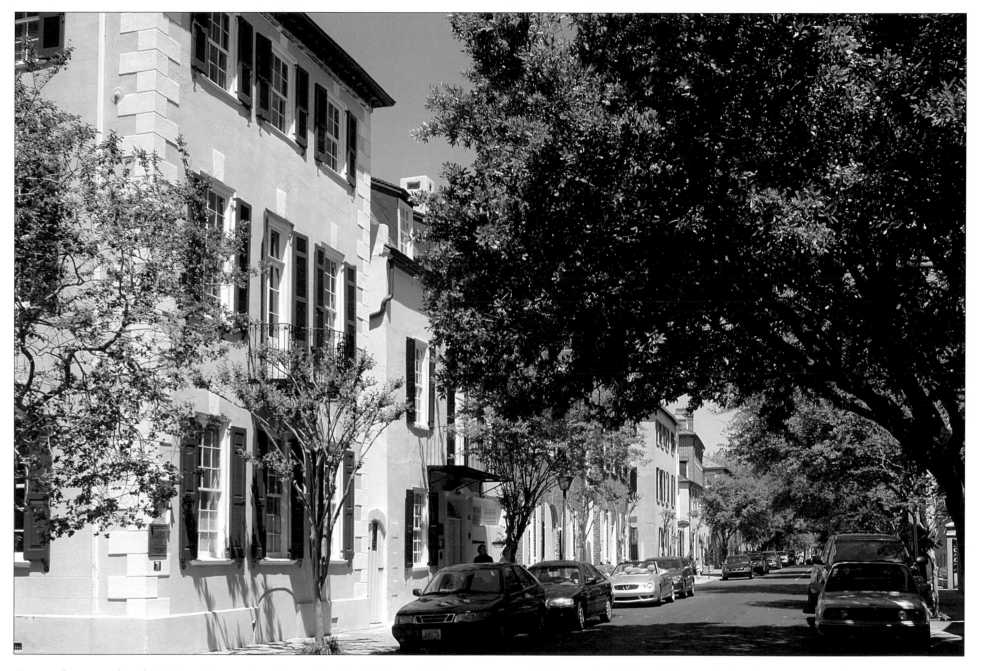

Across the street lived DuBose Heyward, author of the book *Porgy*, which was transformed by George Gershwin into the first American opera, *Porgy and Bess*. In the 1920s, Heyward described this neighborhood as "mixed best," with poor blacks and whites living among each other. With the advent of the automobile, quaint confinement to a neighborhood became a thing of the past. This stretch of Church Street is clearly a rejuvenated area open to residents and visitors alike, as well as foot, bike, and automobile traffic. The Colonel Robert Brewton House stands proudly, returned to its original beauty, and still serves as a private residence.

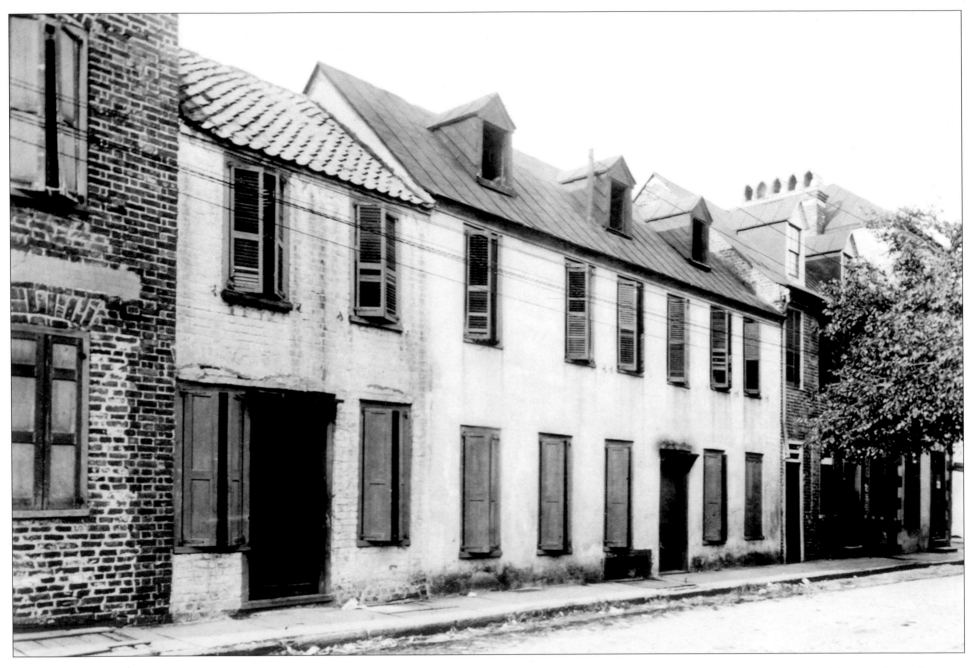

Just north of the Brewton House is the intersection of Church and Tradd streets. Tradd Street was supposedly named after Robert Tradd, the first child born in the new colony. This is the only street in the city where one can see across the peninsula from the Cooper River to the Ashley River. Tradd Street also appears to be in a distressed condition. This view looks east to the corner at Church Street. Most notable in this image is the building on the right, which was built by John Bullock or perhaps by his widow, Mary, around 1718. Bullock later gave the two-and-a-half-story structure to his daughter, who married Colonel Robert Brewton.

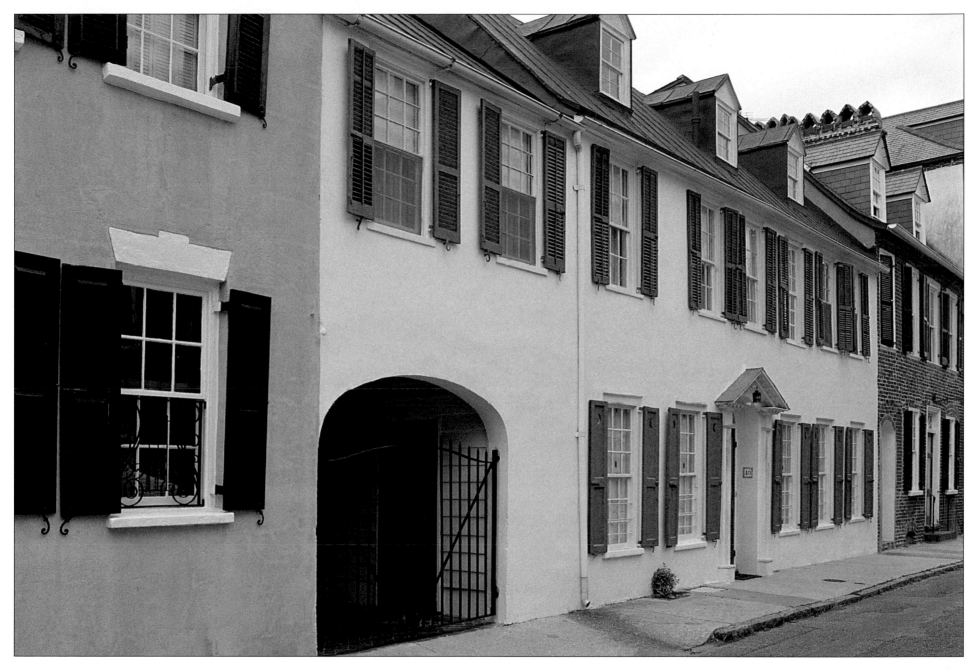

Artist Elizabeth O'Neill Verner, one of Charleston's most prolific artists during the 1920s and 1930s—a period sometimes known as the "Charleston Renaissance"—used the home as her studio beginning in 1938. In her drawings, etchings, and dry points, Verner protrayed typical scenes of the local area, such as churches, homes, and views of the city market. She was largely famous for her etchings and lived into her nineties, using the studio space until her death in 1979. Since that time, her former home has been converted into an art gallery.

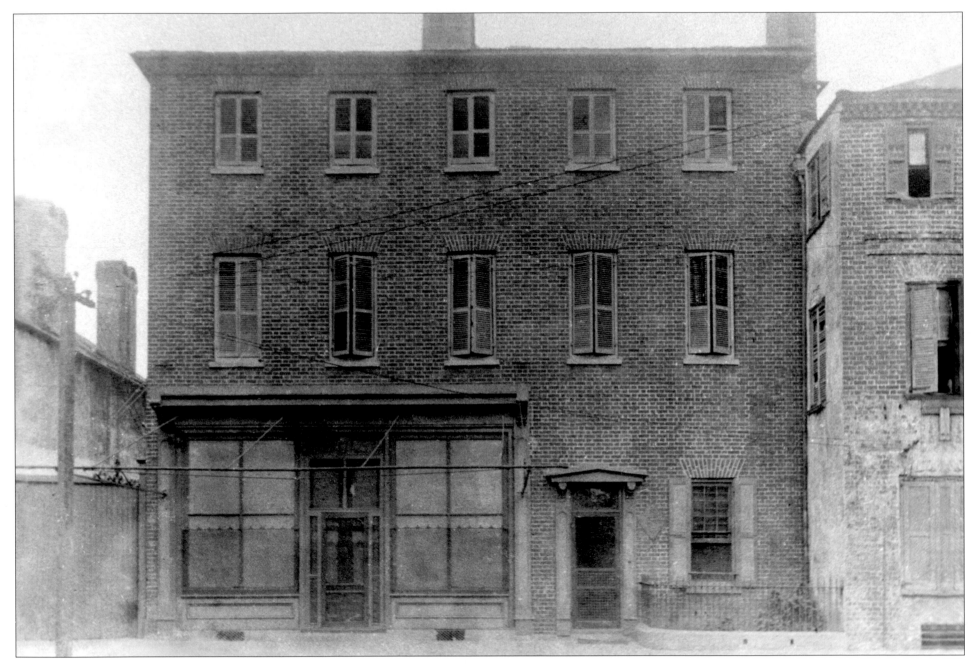

Just around the corner of Church and Tradd streets, and half a block north of the Colonel Robert Brewton House, sits the Heyward-Washington House. Daniel Heyward built this classic Georgian double-fronted house in 1773, and soon his son Thomas Heyward—a member of the Second Continental Congress and a signer of the Declaration of Independence—moved in with his wife, Elizabeth Mathews Heyward.

The "Washington" in the name comes from President George Washington's visit to Charleston in 1791, during which time he used this house as his residence. This photograph shows the Heyward-Washington House nearly a hundred years later, when a portion of the structure was converted into a bakery with a glass storefront.

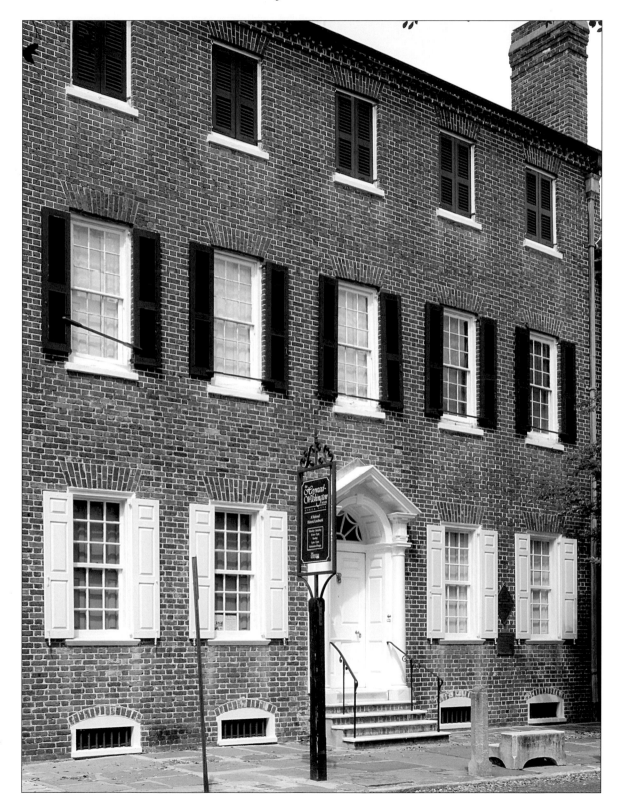

The bakery occupied the Heyward-Washington House from 1880 until 1920. The Charleston Museum purchased the property in 1929 and restored the house, opening it in 1930 as Charleston's first tour home. Milbey Burton, a curator of the Charleston Museum and a celebrated author and historian, lived with his wife in the house until he died in the 1970s. His wife died there in 1990. Today the carriage house is used by the Society of Cincinnati, an age-old organization comprised of the direct descendants of George Washington's military staff during the Revolution.

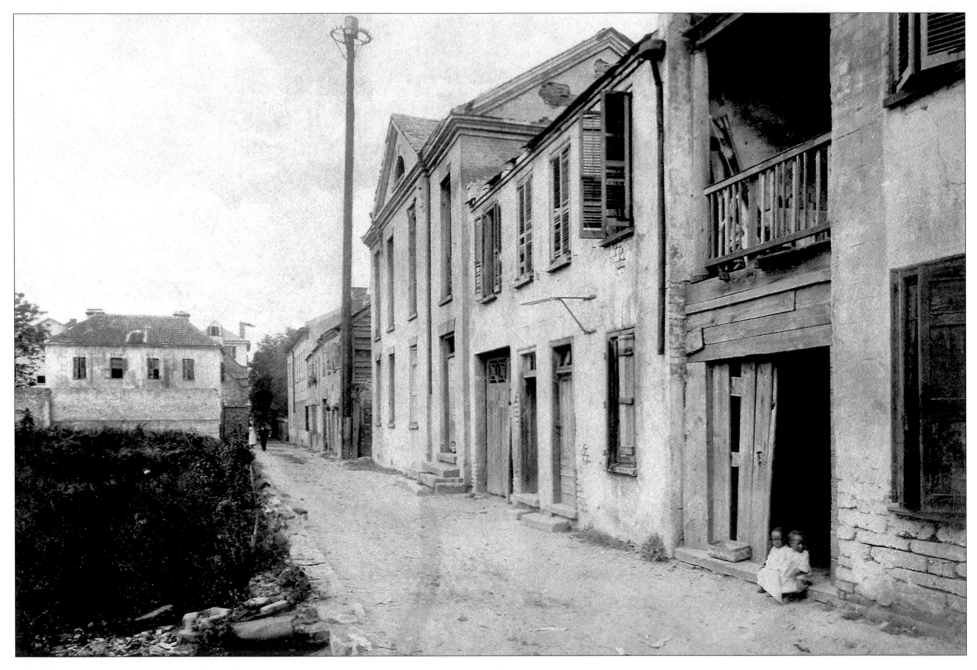

Half a block north of the Heyward-Washington House is St. Michael's Alley, which runs a short distance westward behind the famous landmark to Meeting Street. This view of the alley provides more evidence of the depressed conditions of Charleston's landscape in the late nineteenth century. The vacant lot to the left was once the site of the Charleston Hydraulic Cotton Press Company, which was partially destroyed by Union shellfire in the early morning hours on Christmas Day, 1863. Also destroyed or damaged in the fire were the Burkes Stationery store at the nearby intersection of Church and Broad streets, and several homes along St. Michael's Alley. Following the Civil War, the alley was partially covered by a gabled roof, and the vacant lot to the left contained a large industrial complex.

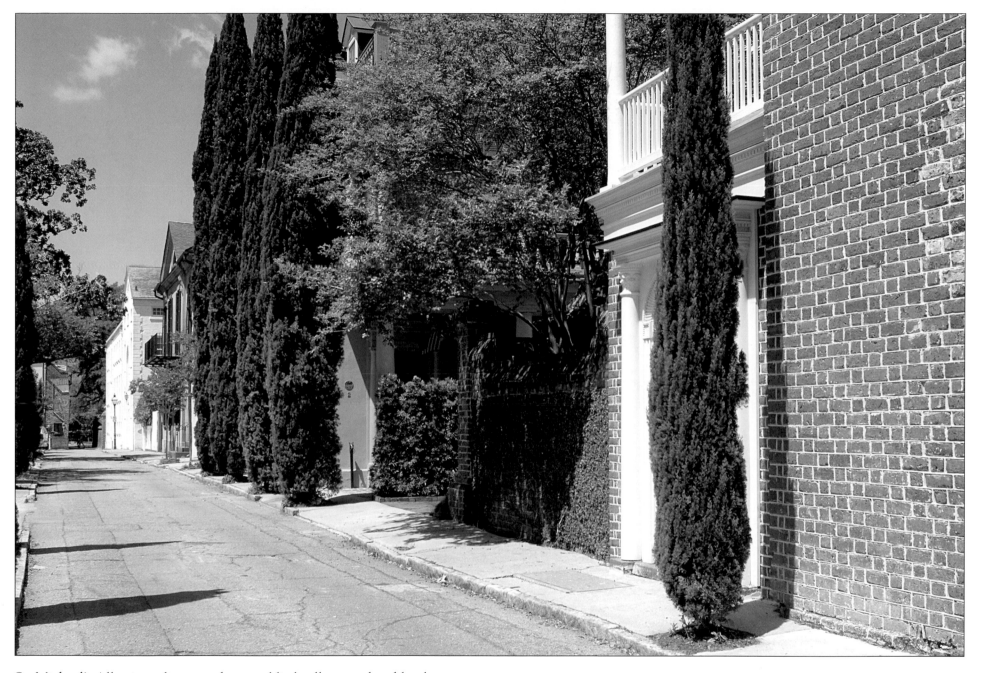

St. Michael's Alley is no longer a depressed little alley populated by the poor. Indeed, most of the oldest surviving buildings lining the alley have been converted into fashionable residences prized for their privacy, as they are tucked away from the hustle and bustle of the city's business district half a block north on Broad Street. The vacant lot seen on the left in the opposite photograph is now a parking lot for area residents.

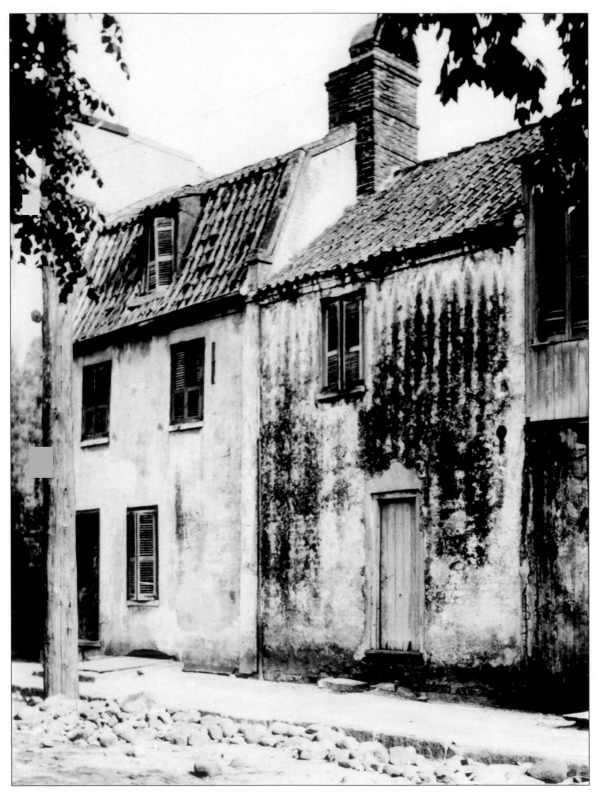

After crossing Broad Street northward, Church Street crosses Chalmers Street, the longest of Charleston's six remaining cobblestoned streets. Probably the two most interesting and important structures on Chalmers are the Pink House, pictured here, and the Old Slave Mart. Recent findings indicate that the Pink House is probably the oldest structure in Charleston, built by John Breton in the 1690s. Built of Bermuda coral stone, a soft stone that hardens with time, the structure also retains the original terra-cotta roof tiles, supposedly fashioned in a curved shape by bending each tile over the workman's thigh. Chalmers was a red-light district, also known as "Mulatto Alley," lined with bordellos frequented by sailors. The house probably became a tavern early on, as determined by the huge fireplace that was no doubt used for cooking large amounts of food for hungry sailors. This is very unusual, since most Charleston houses had a separate kitchen house designed to limit the size of an accidental cooking fire. Also distinctive is that the house has a gambrel roof. It remained a tavern for much of its early existence but deteriorated considerably after the Civil War and was not renovated until the 1930s.

The late nineteenth century saw the Pink House slip into decay. In the 1930s, salvation came when two wealthy New Yorkers bought and repaired the structure. In 1946, the building was purchased by Harry McInvail and was turned into a small publishing house and then an art gallery with studio space. It remained occupied in this capacity until 1956, when attorney Frank H. Bailey fully renovated the small dwelling again. The Baileys were responsible for placing the electrical and telephone lines under the slate sidewalk along Chalmers Street. In 1994, the Pink House reopened again as an art gallery and is owned by Mr. Bailey's widow.

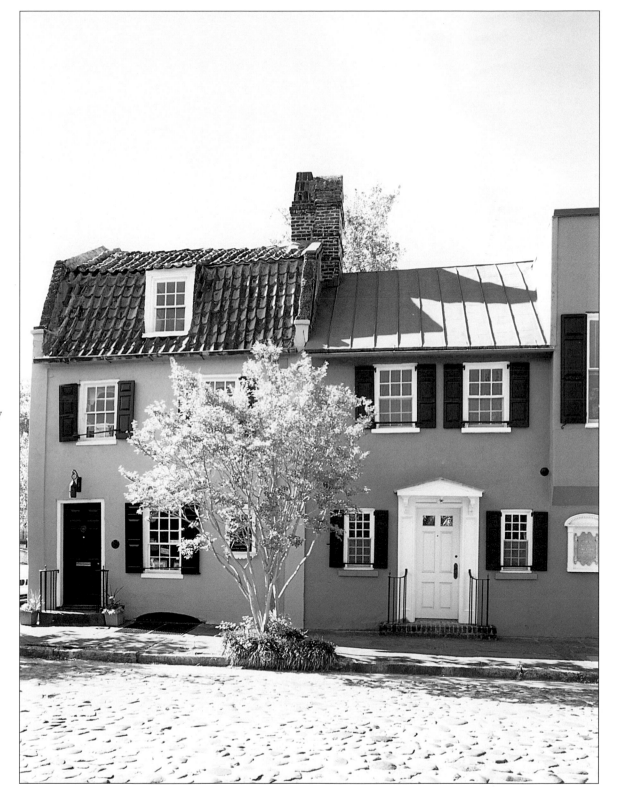

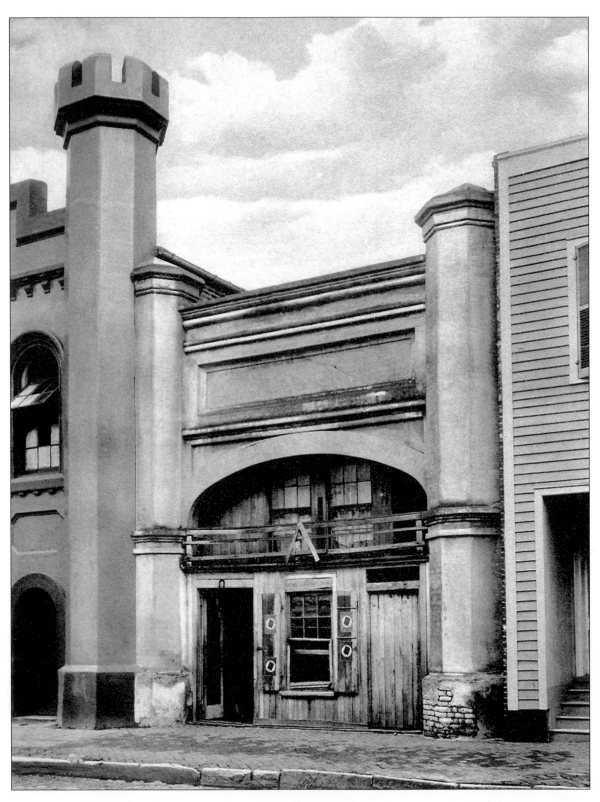

When outdoor slave auctions were eliminated, the process was moved indoors, particularly in the area of Church and Chalmers streets, known today as Charleston's French Quarter. The Old Slave Mart on Chalmers, the last of its kind in Charleston, was built around 1859 and was used to auction cattle and farming implements as well as slaves. Known as Ryan's Mart, the property extended one block north to Queen Street, where a four-story tenement served as a detention house, or barracoon. The property was erected by Z. B. Oaks, who received bureaucratic permission to insert large wooden trusses into the walls of the German Fire Insurance Company next door, so as to build a "shed" under which to auction goods and slaves. This shed had large octagonal columns on each side and an iron gate fronting Chalmers Street. Approximately twenty years later, after the Civil War, the building was transformed into a tenement house but deteriorated until it was renovated in the early twentieth century.

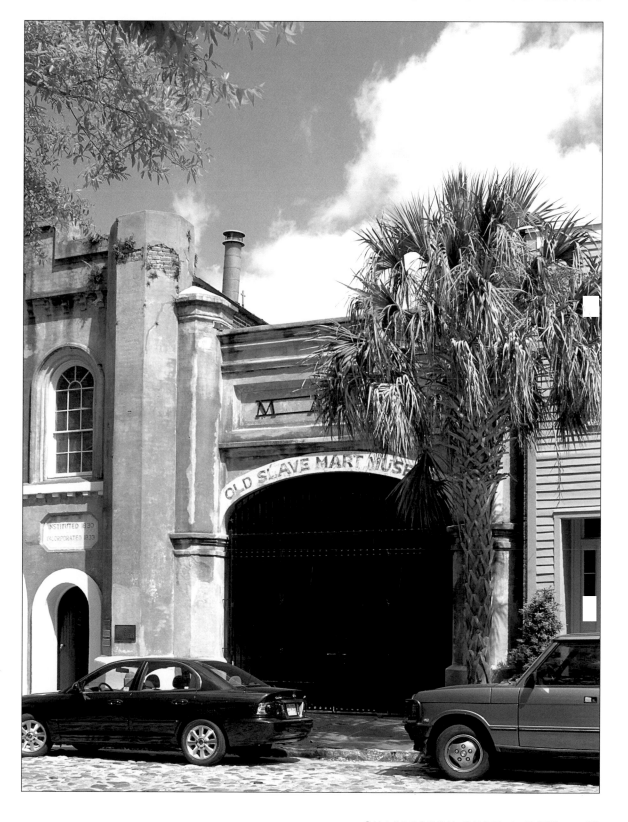

Until 1916, Ryan's Mart was a tenement. In 1927, it became Earl Fisher's Auto Repair Shop, after which it was transformed by Miriam B. Wilson in the 1930s into a privately owned museum of African American art and history. For a time afterward, the museum was operated by the Miriam B. Wilson Foundation; however, for much of the twentieth century the building was inactive. In 1988, the city bought the structure for $200,000. Today the city owns the Old Slave Mart, and with the help of the South Carolina African American History Council, the building was completely renovated at a cost of $720,000 and will soon become one of the most important African American museums in the country.

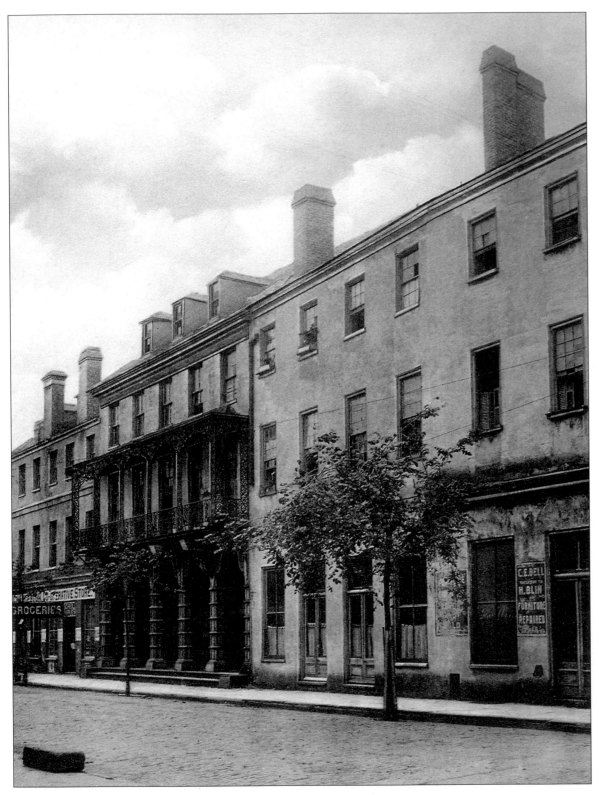

On Church Street, around the corner from the Old Slave Mart, sits the Dock Street Theatre. Established on the corner of Church and Queen (originally called Dock) streets, the first theater on the site was built in the 1730s and was referred to as "little more than a barn." Its first play was *The Recruiting Officer*, which debuted in 1736. Between that time and 1809, at least three other theaters were built on the site. In 1809, the Planter's Hotel was constructed there, and it soon became *the* hotel in Charleston. Indeed, the hotel was such a hotbed of activity that it had to be renovated in the 1830s. As was the case with many other structures in town, Civil War shellfire damaged the building to the point where one individual described it as "thoroughly used up." For the remainder of the nineteenth century, the usable space in the building was shared by tenements, a secondhand store, and grocery store, as seen in this circa 1900 photograph.

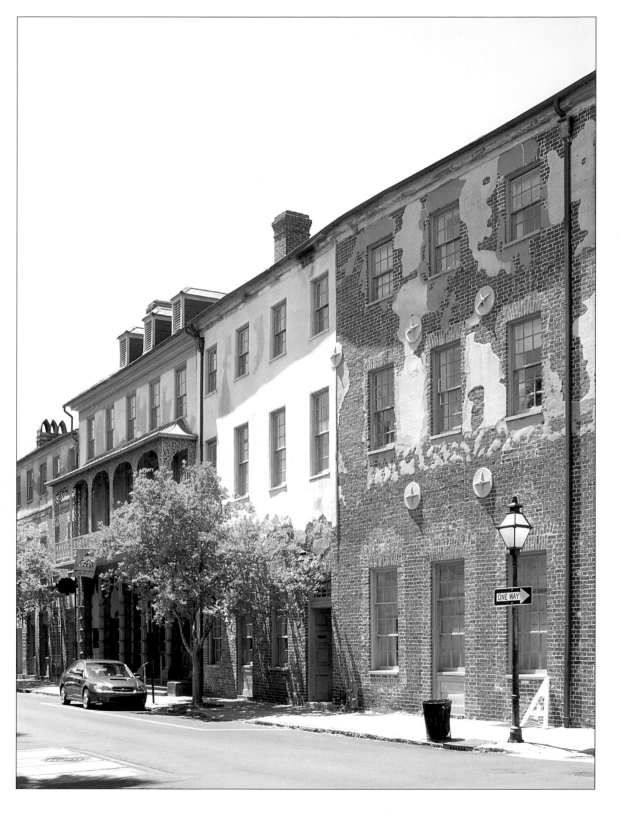

Oddly, the Great Depression saved the theater, in that the Works Progress Administration gave federal funds to renovate the dilapidated building into a theater again. On November 26, 1932, the Dock Street Theatre reopened with a revival of its very first play, *The Recruiting Officer*. During the renovation, the courtyard of the old Planter's Hotel was transformed into the actual theater. Virtually unchanged since the 1930s, the building is now owned by the city.

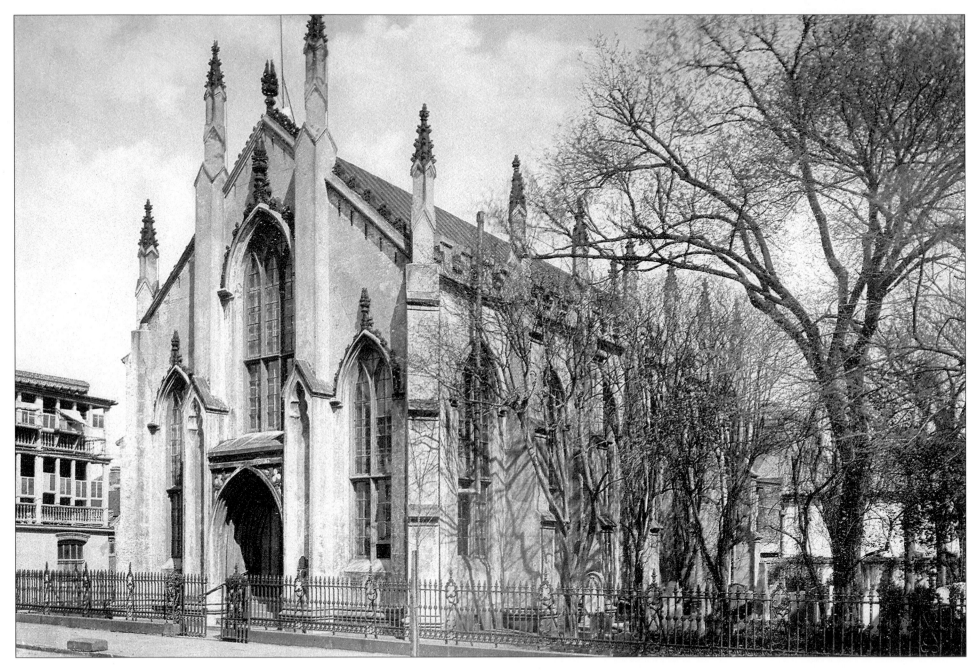

Across the street from the Dock Street Theatre stands the French Huguenot Church, the only operational Huguenot church in the country. The church seen here is the third Huguenot church built on the site. Driven out of their country by Catholic persecution, French Protestants erected the first church in 1687, and the structure survived until the fire of 1796, when the church was purposefully destroyed to create a firewall. The second church was a brick building sitting on a high basement. The congregation dwindled and revived, and the present Gothic Revival–style church was built in the 1840s. The Union bombardment blew out both gabled ends of the church, but it was repaired shortly thereafter.

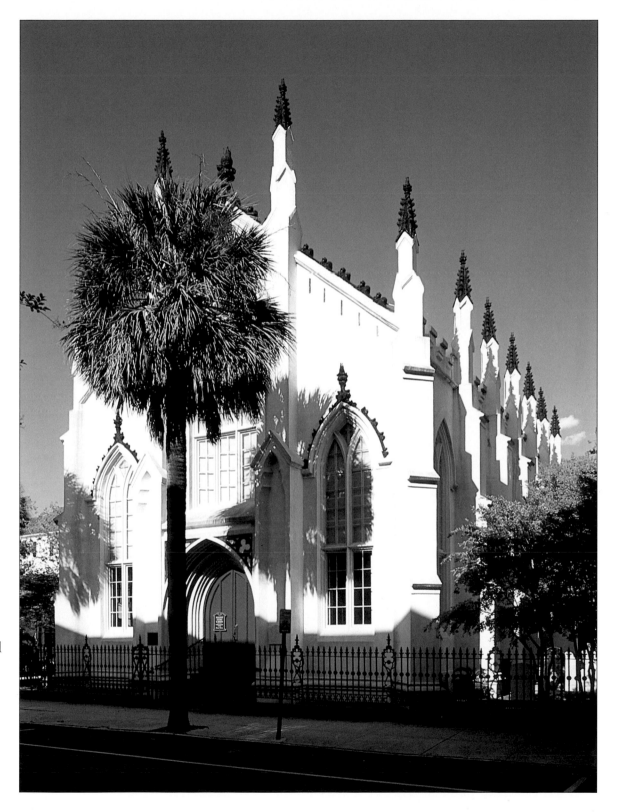

For much of the nineteenth century, the French Huguenot Church was closed. Although it was repaired after the Civil War and other catastrophes of that century, the first real modern restoration was to the church's ancient organ in 1967. Regular services have been held since 1982, after the church had been largely inactive since the 1950s. The church thrives today and remains a treasure to its members and visitors from all over the world.

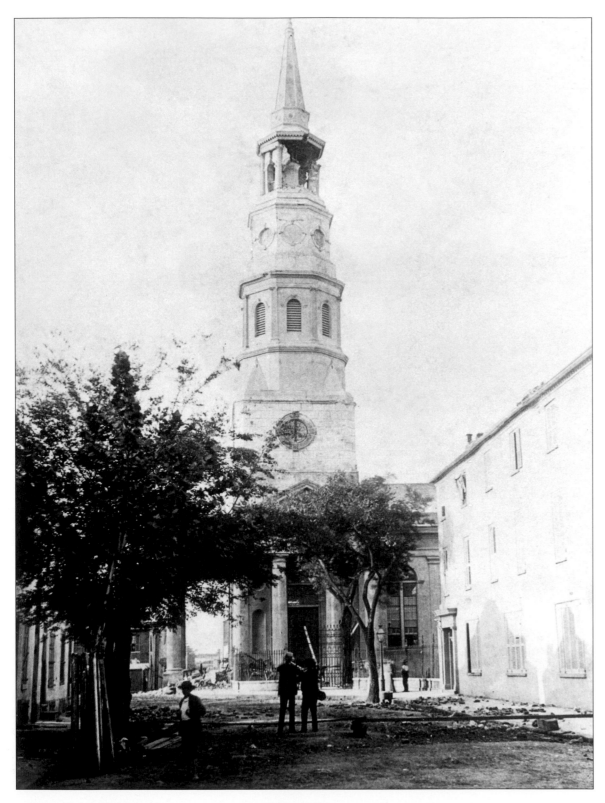

If one stands in the middle of Church Street, between the Dock Street Theatre and the Huguenot Church, looking north, one would be awestruck by the impressive brown steeple of St. Philip's Church. In this previously unpublished 1886 photograph, it is obvious that the earthquake was not kind to the church. Other quake photographs show the cap of the steeple supported by wooden beams. This shot, however, must have been taken immediately afterward, considering the unremoved rubble, awed onlookers in the street, and the unsupported steeple cap. St. Philip's is the oldest Anglican congregation in Charleston, having built a church on the corner of Meeting and Broad streets where St. Michael's, a derivative of St. Philip's congregation, now stands. The second St. Philip's Church was built on its present site—a higher, dryer piece of land—but was destroyed in the fire of 1835. The present structure was rebuilt by 1838. No less than ten shells struck the steeple during the Union bombardment. One shell passed through the cap of the steeple, traveled onward several blocks, and landed in the Pavilion Hotel, the present-day site of the King Charles Best Western hotel.

St. Philip's, like St. Michael's, had one of the tallest steeples in Charleston. In addition, St. Philip's was also used to spot fires throughout the city. But after the Civil War and the development of the city's modern fire departments, the steeple was called to a different use and became known as the "lighthouse church" because of the light installed in the steeple, which was used to help guide ships to port. The federal government actually maintained this light well into the twentieth century. Like so many other churches in Charleston, St. Philip's donated its bells during the Civil War to be converted into cannons. On July 4, 1976, new bells were placed in the steeple, which was then heavily damaged by Hurricane Hugo in 1989. Draped in scaffolding into the early 1990s, St. Philip's has now been restored to its original beauty.

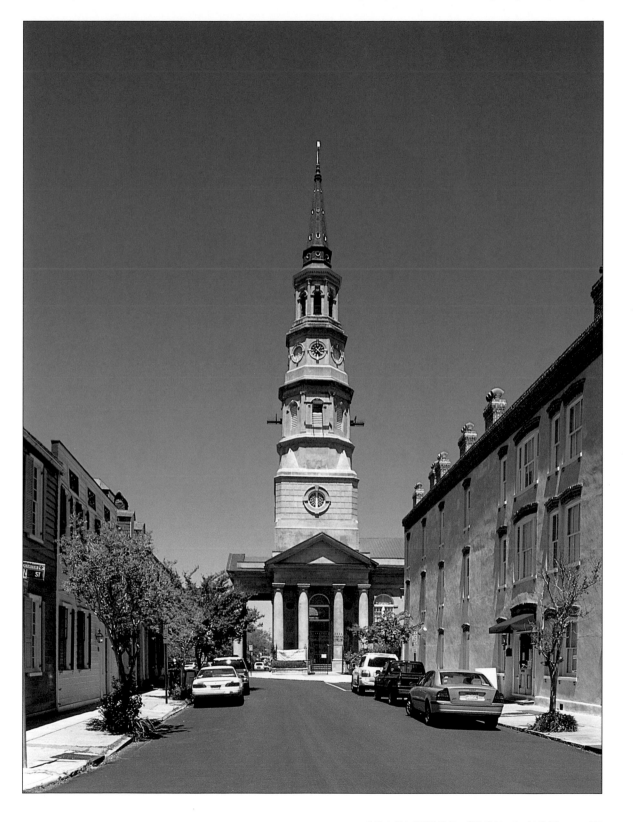

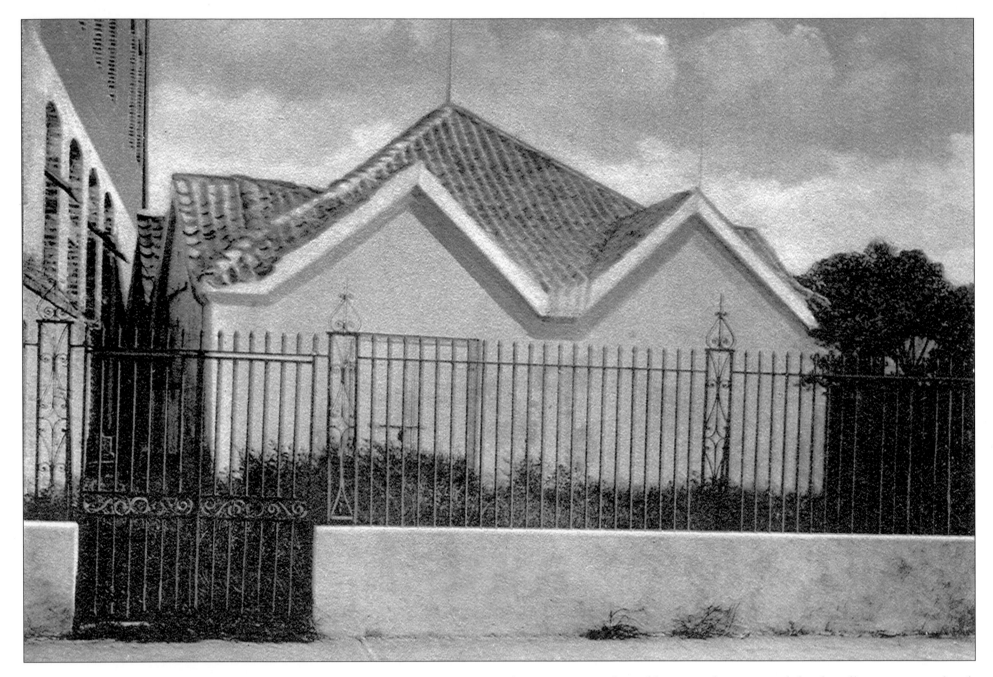

Just north of St. Philip's Church is Cumberland Street, running east to west. Cumberland roughly follows the path of the northern wall of the fortified eighteenth-century settlement. Perhaps the most important structure on Cumberland is the Old Powder Magazine, completed in 1713 and, much later, the first building in Charleston to be restored for its historical significance. Placed near the northern wall of the city, in a region considered to be safe from enemy attack, and boasting thirty-six-inch brick walls, it was considered a valuable military structure. It was condemned in 1770 but was again used during the American Revolution until a British shell burst within thirty feet of the magazine. Subsequently, iron beams were used to support its heavy hipped roof and, with the construction of other magazines in the western part of the city, it was used for a time as a warehouse.

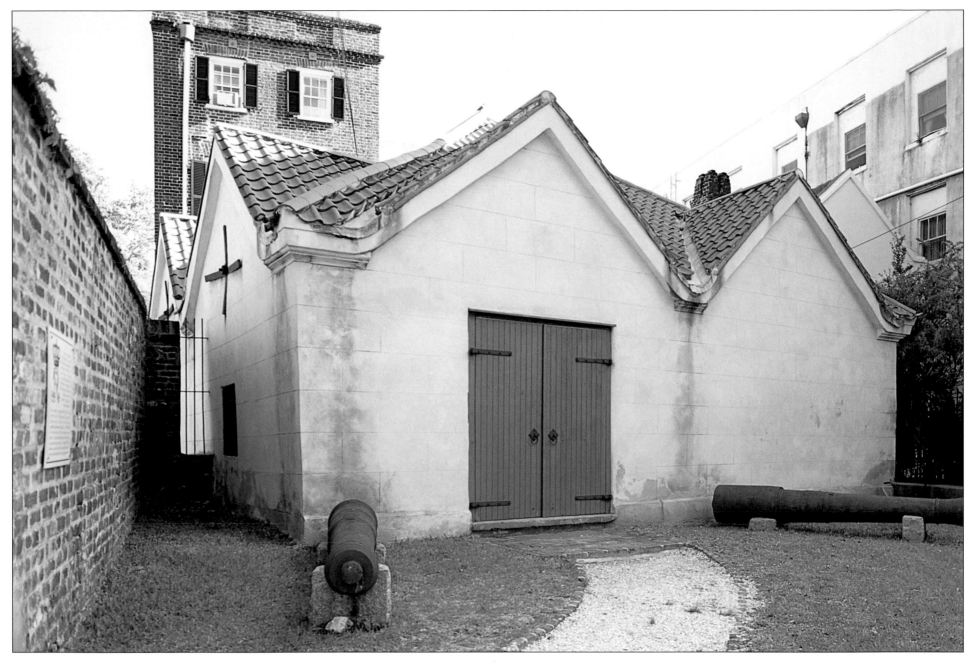

Like many of Charleston's buildings, the Old Powder Magazine was not restored until the twentieth century. Prior to its renovation, it had been used as a print shop and wine cellar for the Manigault family. In 1902, it was purchased by the Colonial Dames Society, which still owns the building today. Funding is scarce, which makes it difficult to keep the building open for the public to visit year-round. The Old Powder Magazine was the first building in Charleston to be preserved as a National Historic Landmark.

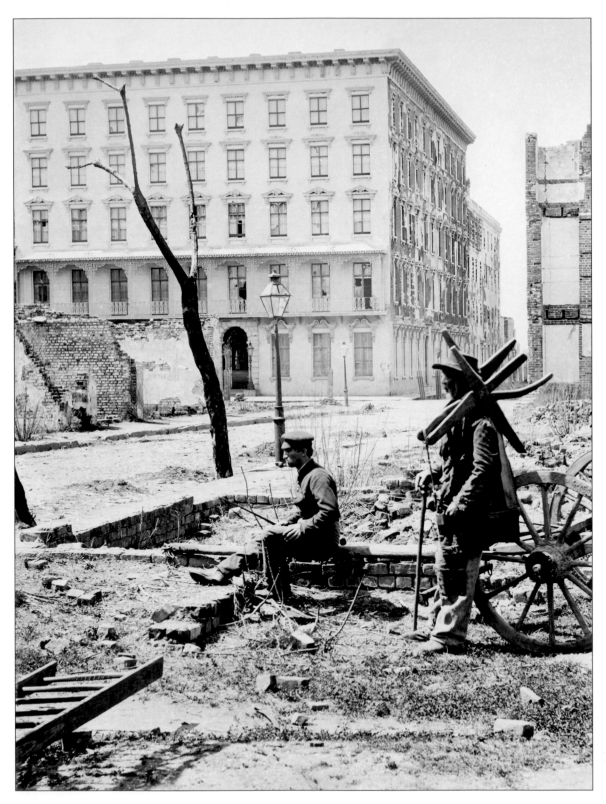

This view, looking west down Queen Street toward Meeting Street, shows a clear image of the devastation that resulted from the 1861 fire and the Union bombardment. Seen here is the Mills House Hotel. Constructed in the 1850s by Otis Mills, the hotel surpassed in elegance and style all of the city's other hostelries. While virtually every other structure visible in this photograph has been destroyed, the fire of 1861 passed to the north of the hotel. The building was saved, in part, by the actions of the hotel staff and those of General Lee, whose own staff assisted by holding wet bed linens and carpets out of the northern windows as the fire passed. Lee and other dignitaries had watched the fire approach from the original balcony on Meeting Street, which is still used today. General Pierre G. T. Beauregard subsequently used the hotel for a time during the war. In 1863, the hotel was closed due to damage from Union shellfire that hit the building at least thirty times.

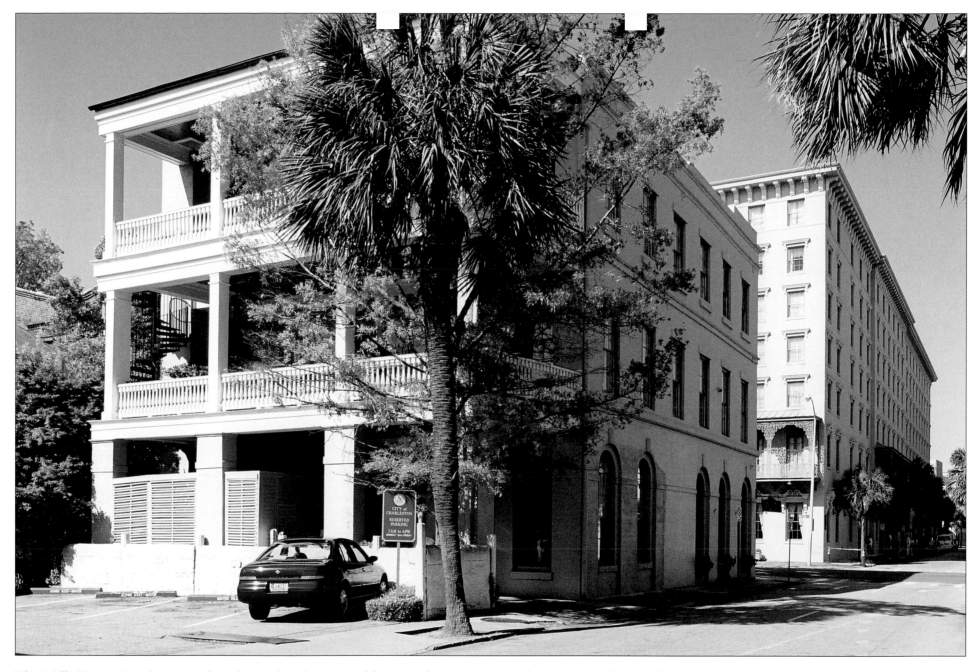

The Mills House Hotel reopened its doors after the war and became the St. John's Hotel in the early twentieth century, at which point it slowly slipped into disrepair. In 1967, a New York banker organized the Charleston Associates with the goal of restoring the hotel. Staggering news came when it was discovered that the building was structurally unsound and would either need to be restored or leveled and reconstructed. The latter option was adopted at a cost of $6 million. Careful attention was paid to reconstruct as close to an exact replica of the original, incorporating the original cast-iron piazza and reproducing the window eyebrows and dental work around the roofline in fiberglass rather than wood.

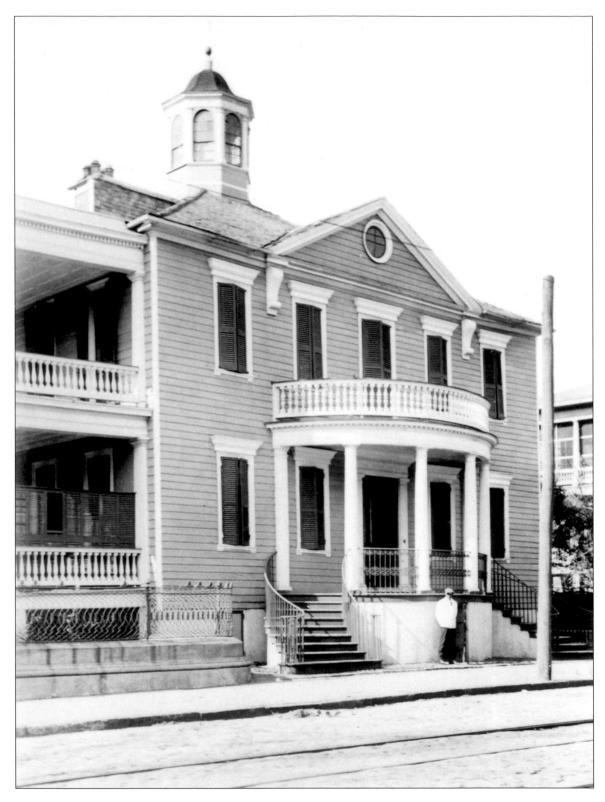

Back on the South Battery is the foot of Meeting Street, the main artery in the city of Charleston. Shown here is the Josiah Smith House, built either just prior to the American Revolution or just afterward, depending on which source one chooses to rely upon. Josiah Smith was a wealthy merchant who lived in Charleston at that time. It was one of the largest double houses built during that era. Incorporating the traditional Charleston "open arm" staircase, the home also has a cupola, meaning that in the early life of this structure, the Smiths probably had a nice view of the waterfront.

The Josiah Smith House was the site of the Charleston Club from 1881 until 1927. The famous social club was known far and wide for its Charleston Club Punch. In 1937, the garden wall was heightened to give its residents more privacy. This residence is a long way from the Josiah Smith Tenant House, located on Charleston's East Side, and one of the last grand homes to be commissioned before the Civil War. Built almost a century later, the Josiah Smith Tenant House is used today as a center helping provide services to address inner-city poverty.

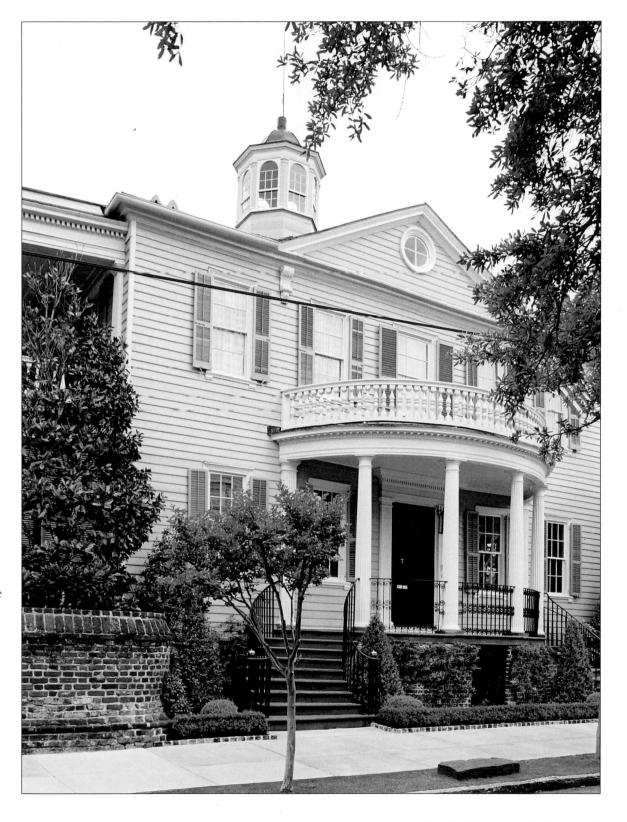

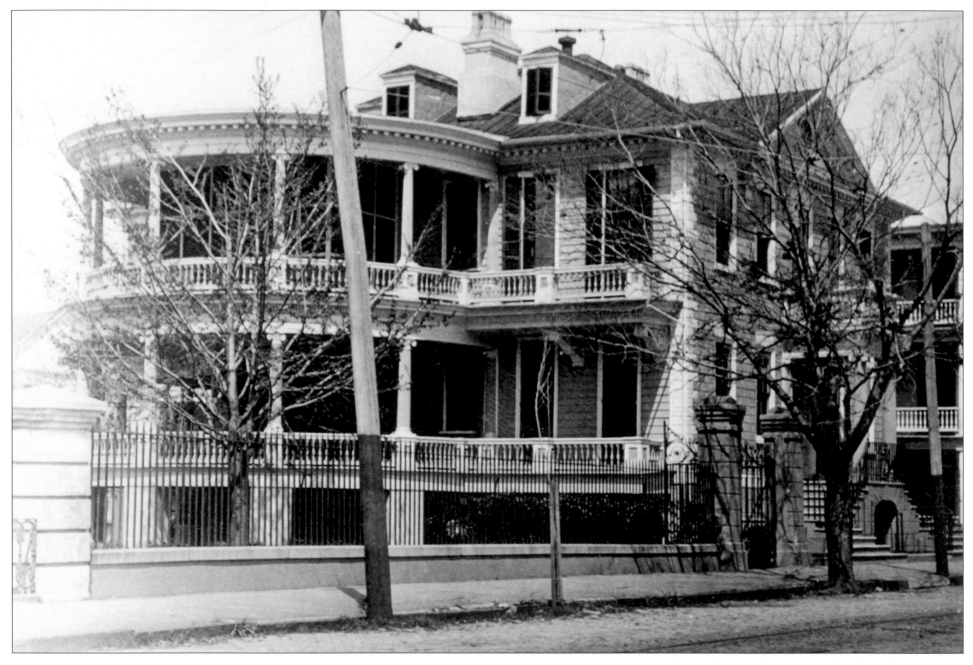

Just a few doors up from the Josiah Smith House is the John Edwards House, built in 1770 by Edwards, who was associated with John Rutledge, a signatory of the United States Constitution, the first president of the Republic of South Carolina, and the state's first governor. The house was similar to that of George Washington's Mount Vernon estate in that its cypress façade was beveled to give it the appearance of being made of stone. During the British occupation of Charleston in 1780, the home became the headquarters of

Admiral Arbuthnot, commander of the British fleet. Edwards, Rutledge, and Josiah Smith were among many Charleston patriots captured by the British and exiled to St. Augustine, Florida. In the nineteenth century, the house was purchased by George W. Williams Jr., son of George Walton Williams, whose imposing home sits just across Meeting Street. George Williams Jr. added the massive semicircular piazzas to the southern side of the house and held ice-cream parties for all the children from the Charleston Orphan House.

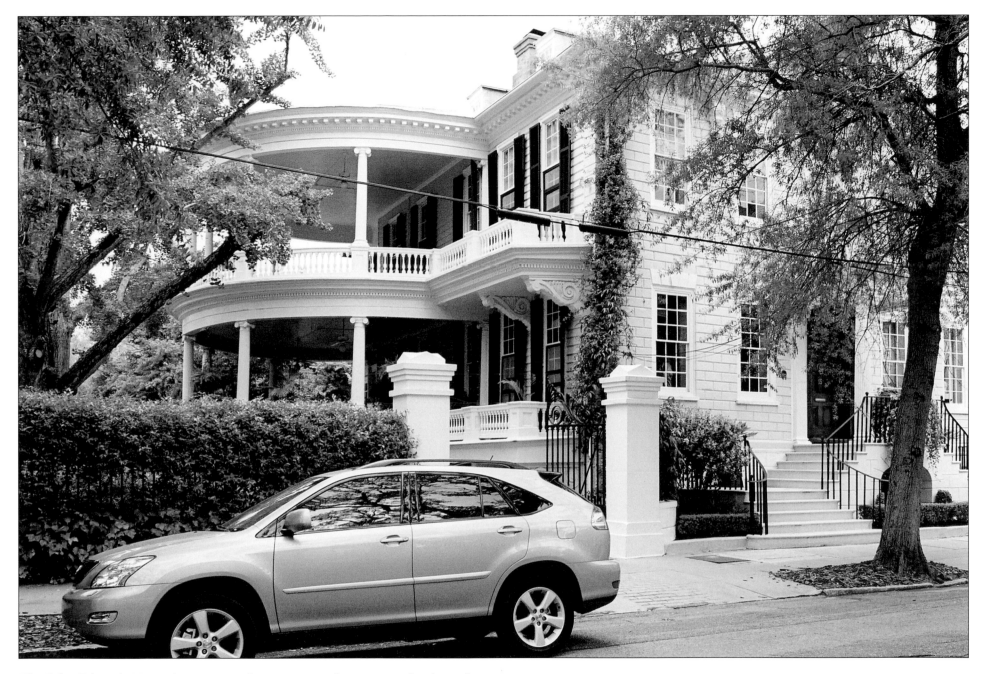

The John Edwards House has remained a private residence since the days of Admiral Arbuthnot. Mr. and Mrs. Glenn Allen, heirs of the original owner, John Edwards, sold it to Charles R. Allen in 1973. The property boasts one of the largest ginkgo biloba trees in the country, while the house is said to possess a bathroom—concealed by a trapdoor—under the house, containing the oldest bathtub in Charleston.

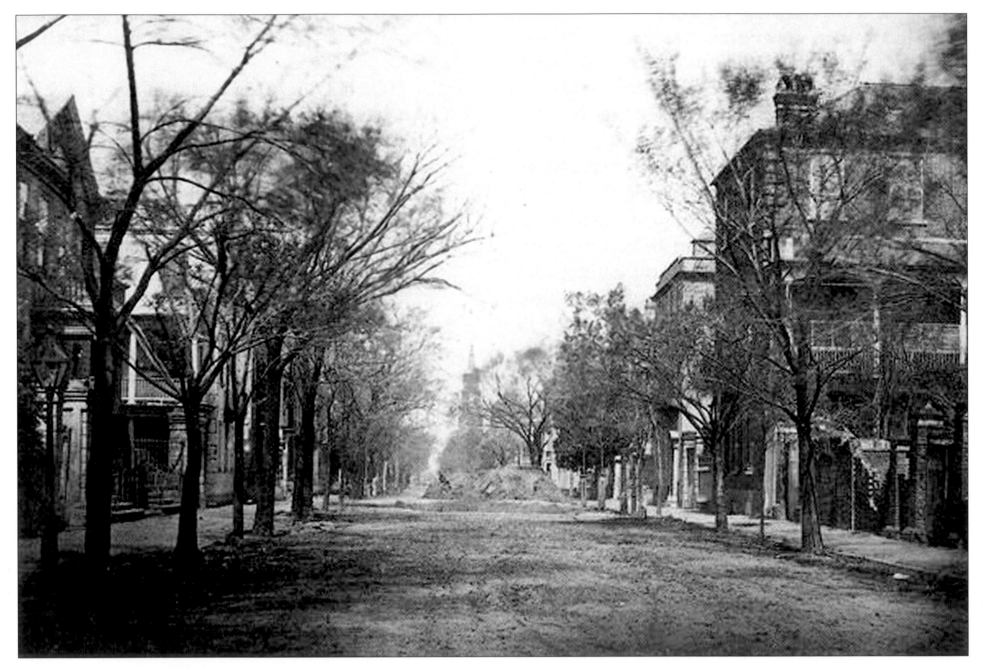

Standing in the middle of Meeting Street, with the John Edwards House on the left, the darkened steeple of St. Michael's is clearly visible in the distance. A mound of earth can be seen piled in the street. This is probably an unfinished earthwork constructed to defend the city should it come under a land-based attack by Union forces. Though the fight never materialized, Confederate officials swore that rather than lose Charleston, the city would be defended from street to street and house to house. In the end, the Confederates decided that Charleston should be evacuated rather than fought for. On the right is a portion of a wall damaged by shellfire. That property was torn down after the war to make room for the large mansion of George W. Williams.

Fortunately for later generations of Charlestonians, preservationists, and visitors, the city was not defended to the death as called for in the Confederate plan. Following the 1886 earthquake, Meeting Street was lined with cable-car tracks, first horse-drawn and then electrified. In the twentieth century, room was made for automobiles and today this section of Meeting Street—where many important eighteenth- and nineteenth-century buildings remain—is continually clogged with tour buses and horse-drawn carriages.

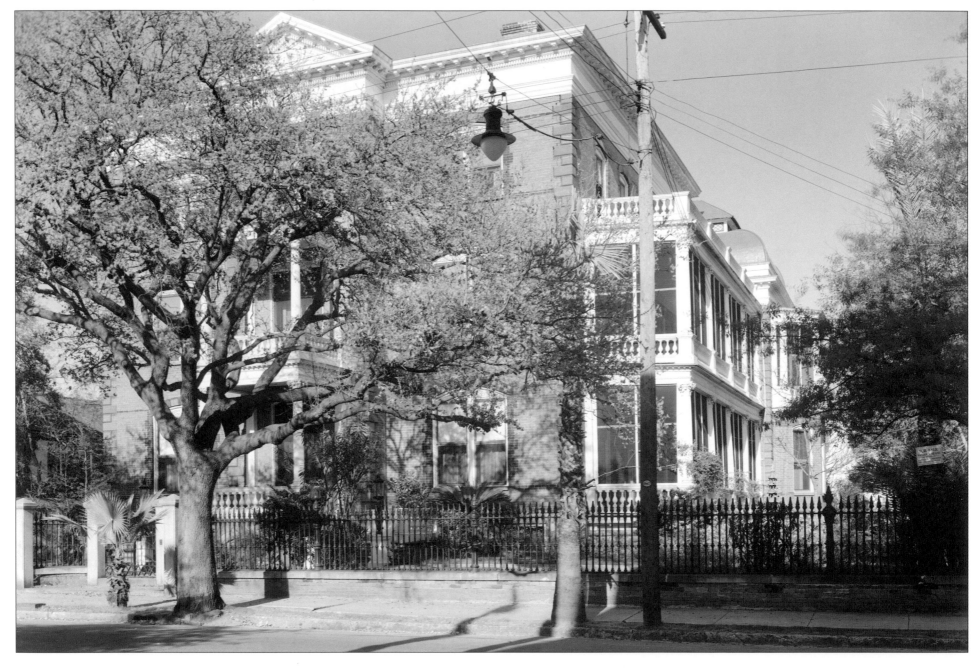

Across the street from the John Edwards House sits the Calhoun Mansion, built eleven years after the Civil War in 1876 by the wealthy merchant and banker George Walton Williams. Boasting nearly 25,000 square feet, the home was referred to as "the handsomest and most complete private residence in the South." This Victorian home is considered one of the most important structures of that style in the eastern United States. Containing twenty-five rooms, the mansion is the largest in the city. One of Williams's daughters married Patrick Calhoun, grandson of the great John C. Calhoun, vice president of the United States from 1825 to 1832, and after Williams's death, the mansion was given to Patrick and his wife.

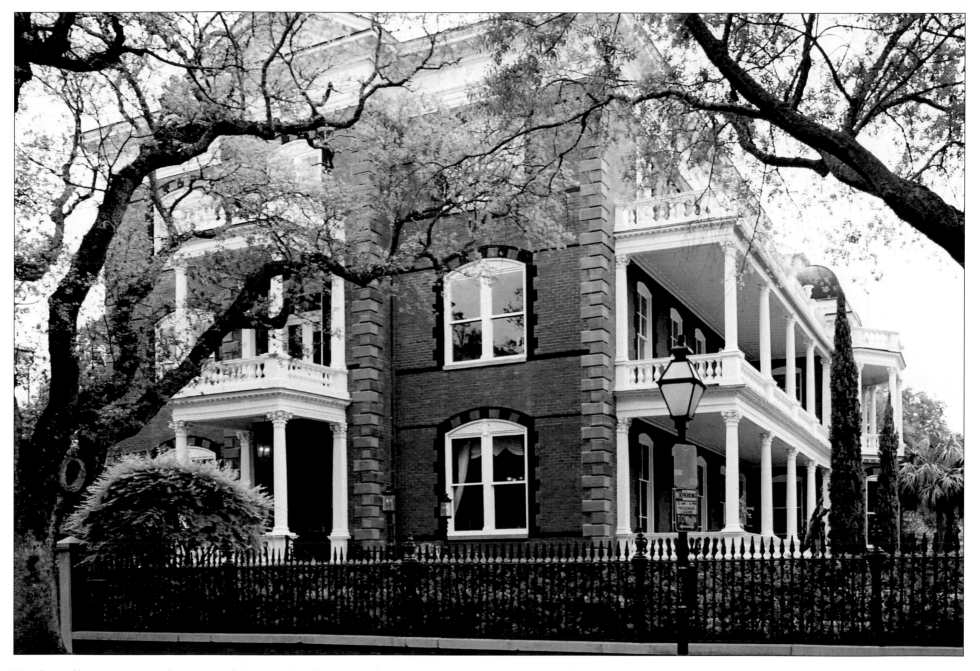

Used as officers' quarters during World War I, the house was later turned into a hotel called the Calhoun Mansion. For decades the mansion slid into a state of neglect until it was thoroughly renovated in the 1970s as a private residence by Gedney Howe, one of Charleston's most reputable attorneys.

The house has luxury apartments in the basement levels, and the upper floors are used as a house museum. In recent years the house has been featured in many travel programs on television, and the location was used for the filming of the television miniseries *North and South* and the film *Scarlet*.

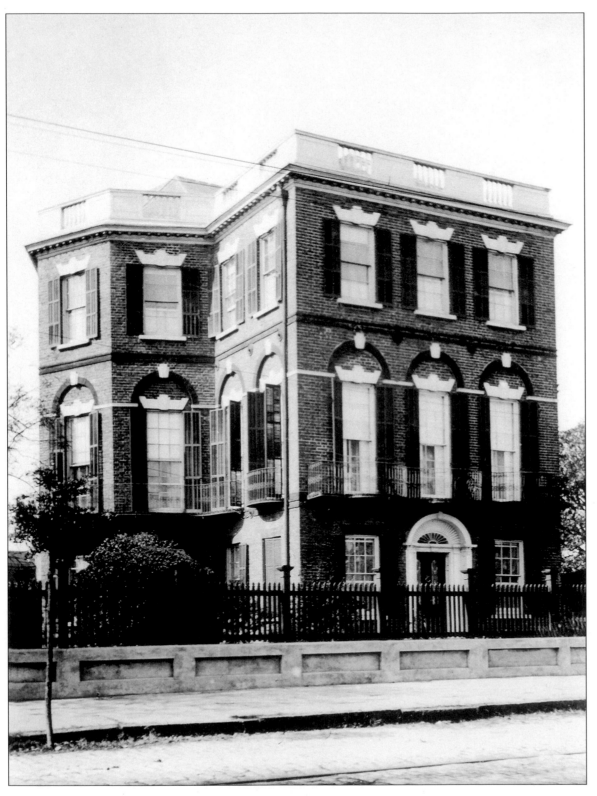

Several blocks up, on the western side of Meeting Street, sits the neoclassical Nathaniel Russell House, built circa 1808 by Russell, a young "Yankee merchant" from Rhode Island. At the age of twenty-seven, Russell moved into the home with his wife, two daughters, and eighteen slaves. Later, Alicia, one of Russell's daughters, married Arthur Middleton, and they used the house as their principal residence. A subsequent owner of the house, Governor R. F. W. Allston, was forced to flee with his family and slaves during the Union bombardment. The magnificent structure contains unusual features, such as a three-story, cantilevered "flying" staircase, which gives it the appearance of having no structural support at all, as well as a wrought-iron balcony surrounding the second story. Also of interest is that the house has three floors, each containing a square, oval, and rectangular room.

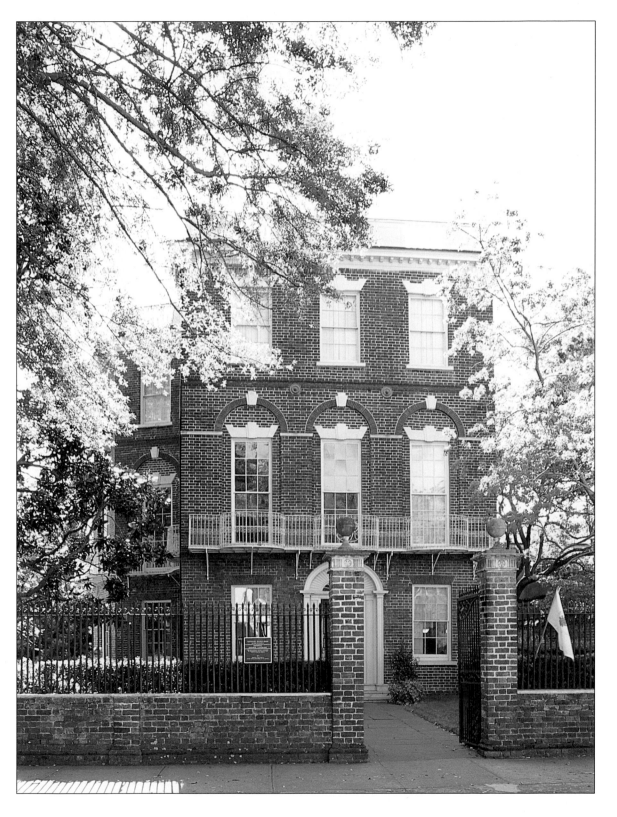

In 1955, the Historic Charleston Foundation acquired the Nathaniel Russell House for $65,000 through locally raised funds, including a $32,500 challenge grant from the Smith-Richardson Foundation. In the early 1990s, the Historic Charleston Foundation announced a $4 million Heritage Campaign. A total of $1.5 million was raised to restore the Russell House to its original architectural distinction, and work began in 1999. Today visitors will find the Russell House to be a faithful reflection of its nineteenth-century self.

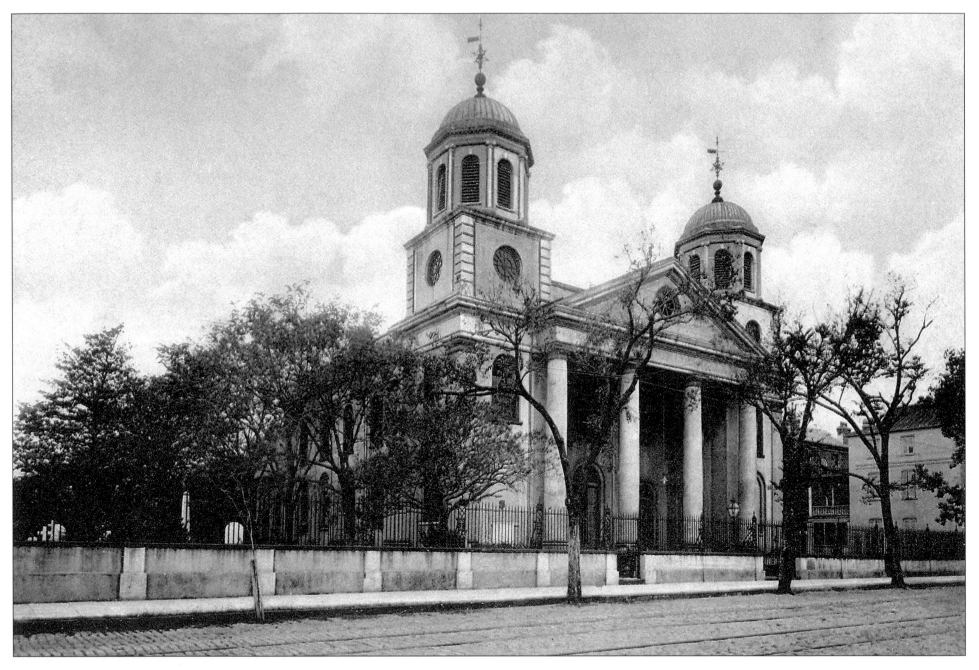

Next door to the Russell House is the First Scots Presbyterian Church, the fifth-oldest church building in the city. The first structure sat on the site of the graveyard, and the present building was built circa 1814. The central portico of the church is ornamented with a stained-glass window containing the great seal of the Church of Scotland. The 1886 earthquake caused considerable damage to the building, requiring many interior alterations.

Though the church has two bell towers, it had only one bell. During the Civil War, First Scots, like many churches in the city, including St. Philip's, donated its bell to the Confederate cause, to be melted down and used to cast artillery. First Scots displays a marble plaque on the outside of the church listing its fallen Confederate parishioners, unlike many churches in the city, which have similar plaques placed inside their structures.

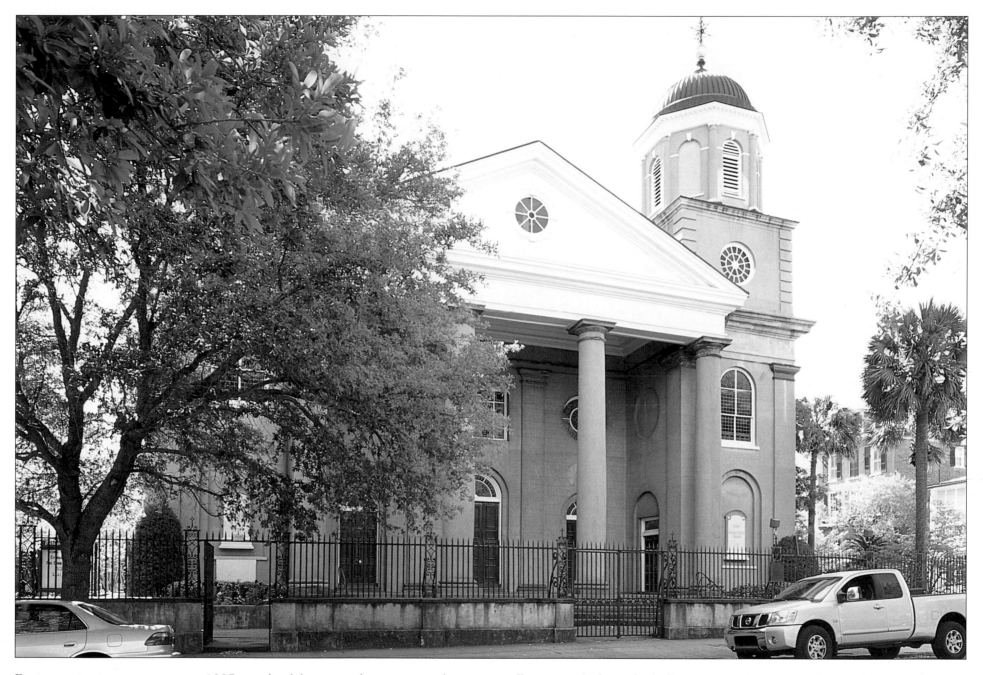

During extensive renovation in 1987, much of the original terra-cotta tile flooring from 1814 was uncovered. Renovation lasted from 1987 to 1988 and cost $2 million. Having given its one bell to the Confederate cause, the 1,500-member congregation purchased a "new" bell to ring in the new millennium. At least the bell was new to First Scots, having been purchased secondhand from a church in England. This new bell had been cast around 1800 and had sounded out across the English countryside in glory of Napoleon's defeat at Waterloo in 1815.

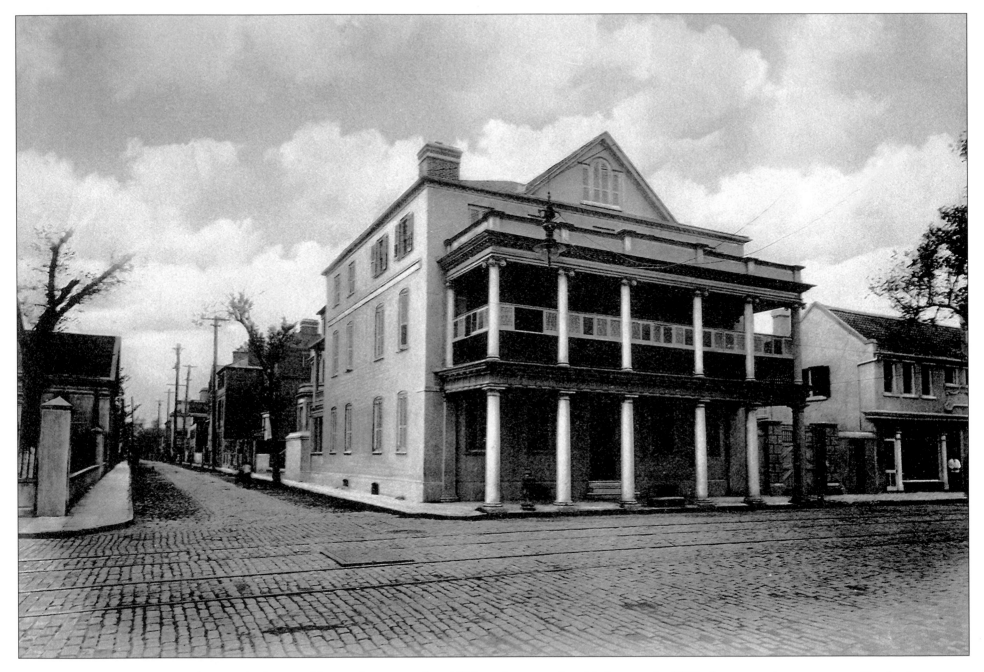

To the north of First Scots is the Branford-Horry House. Constructed in 1750 by Benjamin Savage, the house is a fine example of a symmetrical double house with a central hallway running through it. Savage's niece Elizabeth, who married the wealthy planter William Branford, was given her uncle's town house, including the property next door, on which stood a kitchen house and stable houses. In 1830, the impressive, two-story Greek piazzas extending over the sidewalk and out to Meeting Street were added by Elizabeth's grandson, Elias Horry, who inherited the property in 1801. The kitchen house was torn down, and the property on which the stables sat is now a residence at 61 Meeting Street.

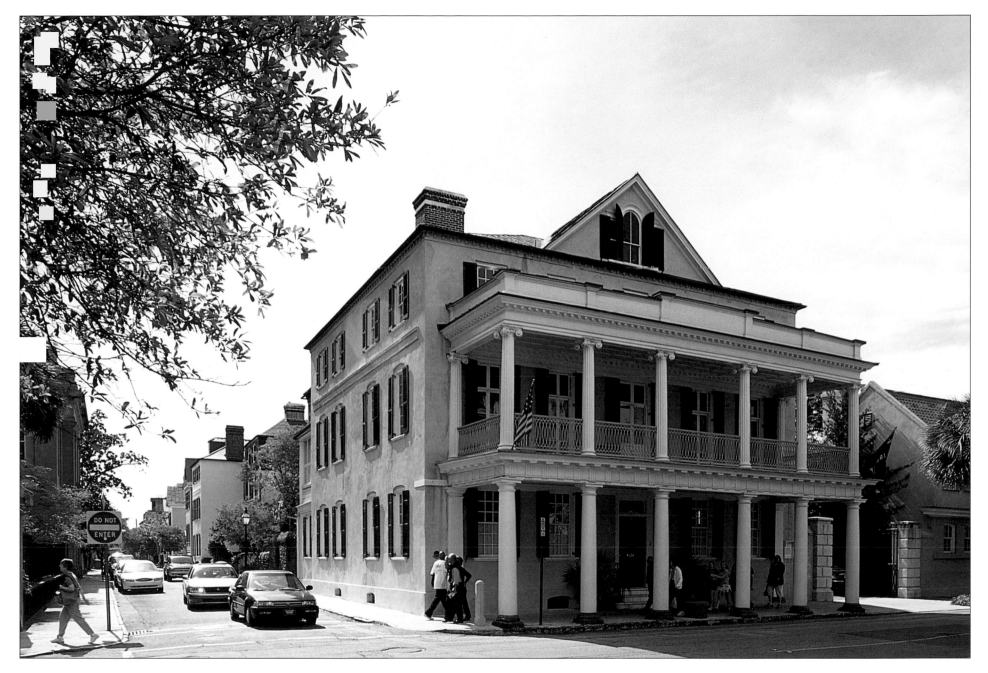

By 1988, the Branford-Horry House had slid into decay and the owner had defaulted on his mortgage, allowing the bank to repossess it. Yet still more damage awaited that year when a motorist collided with an oak tree, palmetto tree, and lamppost before crashing into the columns of the house. One column went crashing through the front door, and another trapped the driver in his car. Still in bad condition, the dilapidated house was loaned to Edward Ball in the 1990s while he wrote his award-winning novel *Slaves in the Family*. The house was subsequently renovated and is a private residence today.

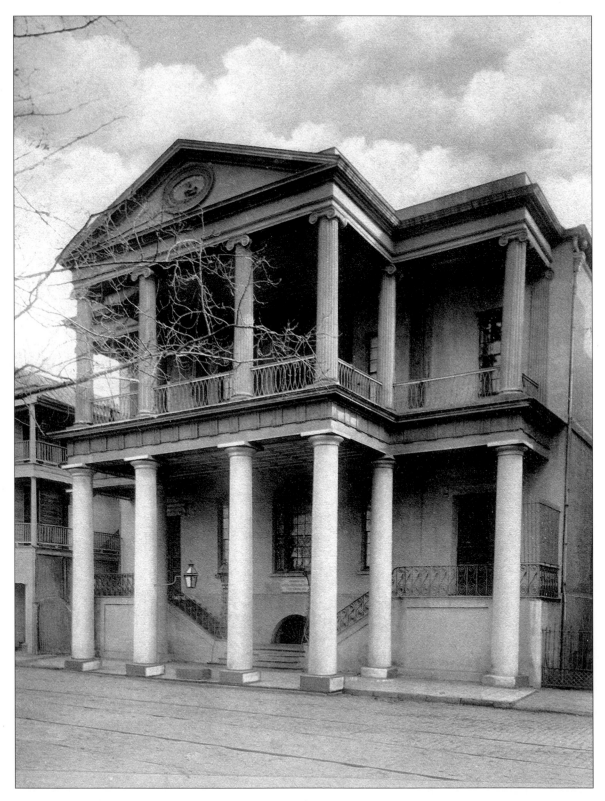

Across Meeting Street and just north of the Branford-Horry House is the 1804 structure known as the South Carolina Society Hall. The building's impressive portico was added in 1830, with the society's seal containing the word *Posteritati* (For Posterity) in the pediment. The South Carolina Society was a fraternal organization established in 1737 by French Huguenot merchants, businessmen, and artisans, who paid dues to aid in "relieving the wants and miseries" of the poor members of the Huguenot community. These regular payments resulted in the society's original name, the Two-Bit Club, that being the standard amount paid by its members. Subsequently, they renamed their club the South Carolina Society. Prior to the construction of their nineteenth-century structure, the Two-Bit Club regularly held their meetings at various taverns around the city. Despite the typical atmosphere of taverns, the club's steward was responsible for making sure all members were sober and remained so during their meetings.

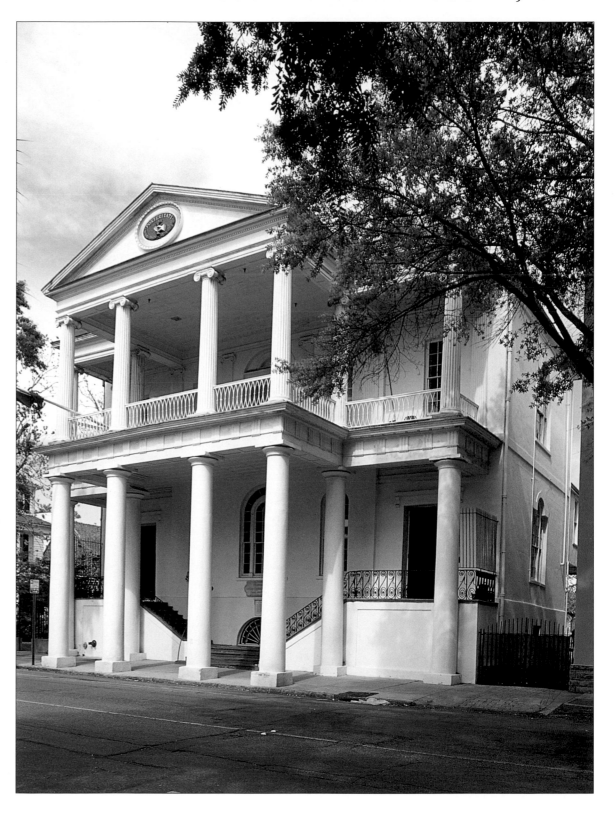

In 1955, the South Carolina Society began offering a scholarship and endowment to the College of Charleston. The seal was removed due to decay, and $6,800 was spent to have a replica made and affixed to the pediment. Indeed, the pediment sits so high—forty feet up—that few noticed the seal was missing. Today the building is used for social gatherings, weddings, and dances. One of the many highlights for today's visitors is that the gas lamps (clearly seen in the previous photograph yet hidden by columns in this modern photograph) are considered to be the oldest pieces of ironwork in the city.

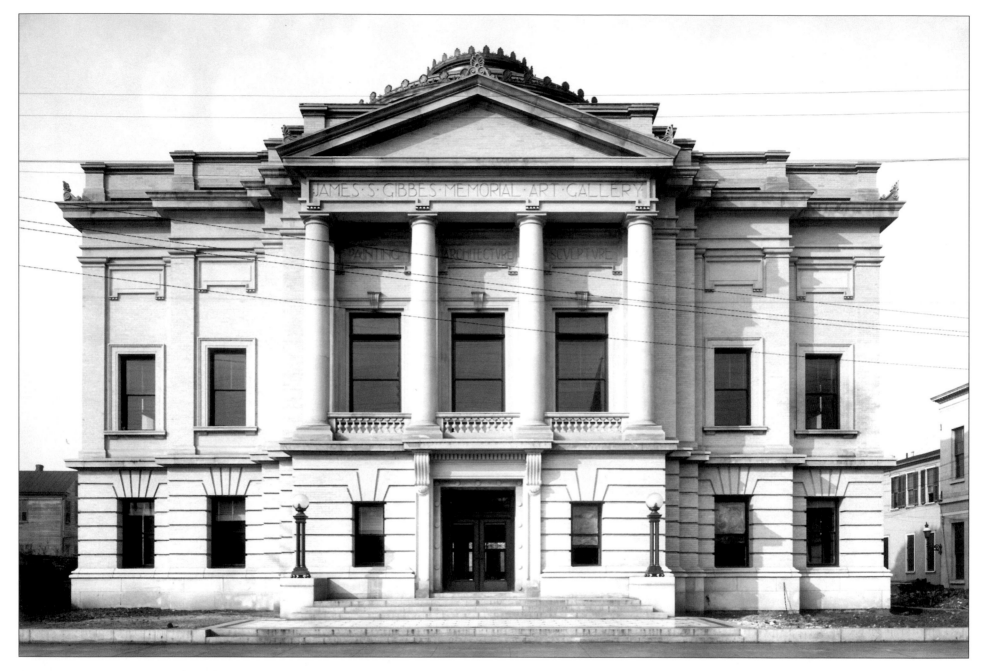

Sitting on Meeting Street, directly in the path of the 1861 fire, is the more modern Gibbes Museum of Art, built in 1904 in the Beaux Arts style. The roots of this museum extend back to 1858, when a group of Charlestonians established the Carolina Art Association. Their goal was to foster an appreciation for the visual arts. The museum was originally staffed by volunteers and offered both exhibits and art classes. In 1932, the museum hired Robert Whitelaw, their first director, who was key to the growth of the museum's collections and its national reputation.

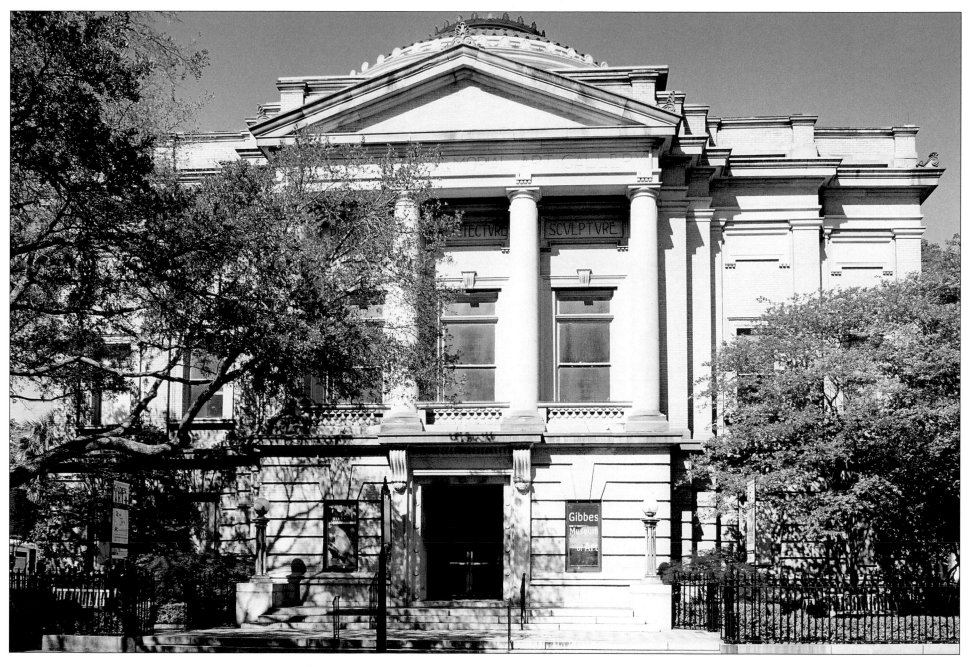

Between 1910 and 1932 the museum gathered, through donations and purchases, a collection that determined its true strength: American art with a Southern perspective. However, this did not prohibit the museum from collecting other styles and hosting traveling exhibits. The Gibbes Museum continues to grow as one of the South's premier museums. Still focusing on Charleston and the South's most famous artists, the Gibbes has not ignored many of this country's most famous artists, from Sol LeWitt and Roy Lichtenstein to Andy Warhol.

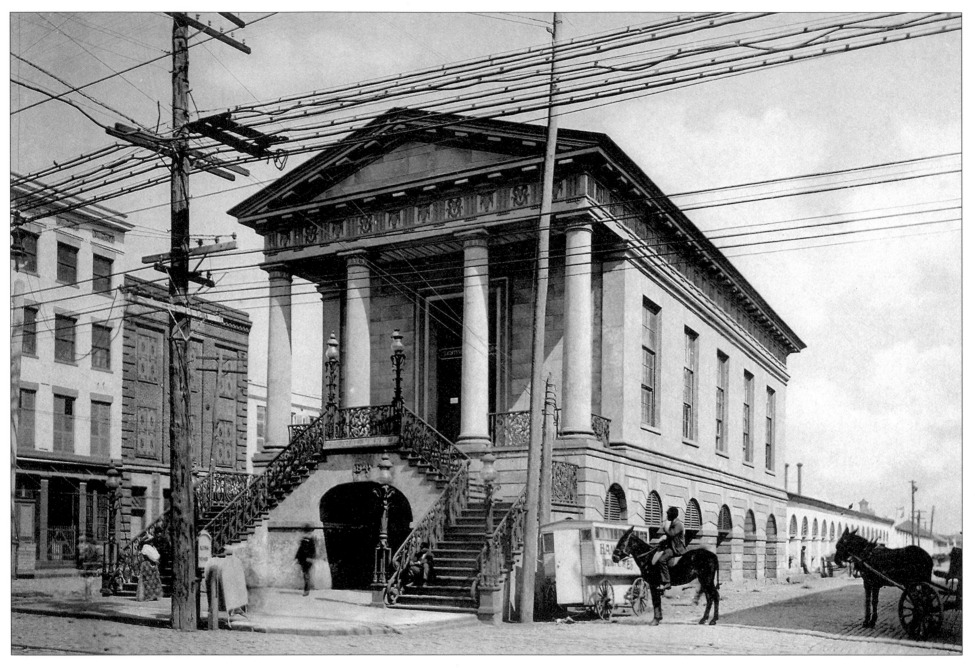

Without question, the most popular site for today's visitors to Charleston is the City Market, where once you could buy beef, poultry, and fish. Now you can purchase anything from Rhett Butler T-shirts to fingernail clippers. Pictured in this late-nineteenth-century photograph is the head of the market, or Market Hall, built in 1841. In the building's stucco frieze, alternating cattle and rams' heads display the fact that this was never a slave market. The market's covered sheds once stretched almost a third of a mile eastward from Meeting Street across East Bay to the Cooper River, until a section of market buildings was destroyed by two tornadoes in one day in 1930. The land on which the market sits was once a tidal creek known as Daniel's Creek, which was filled in. The property was owned by Charles Cotesworth Pinckney, who conveyed the area for a public market with the caveat that the land would revert back to his family if it ever ceased to be in the public domain.

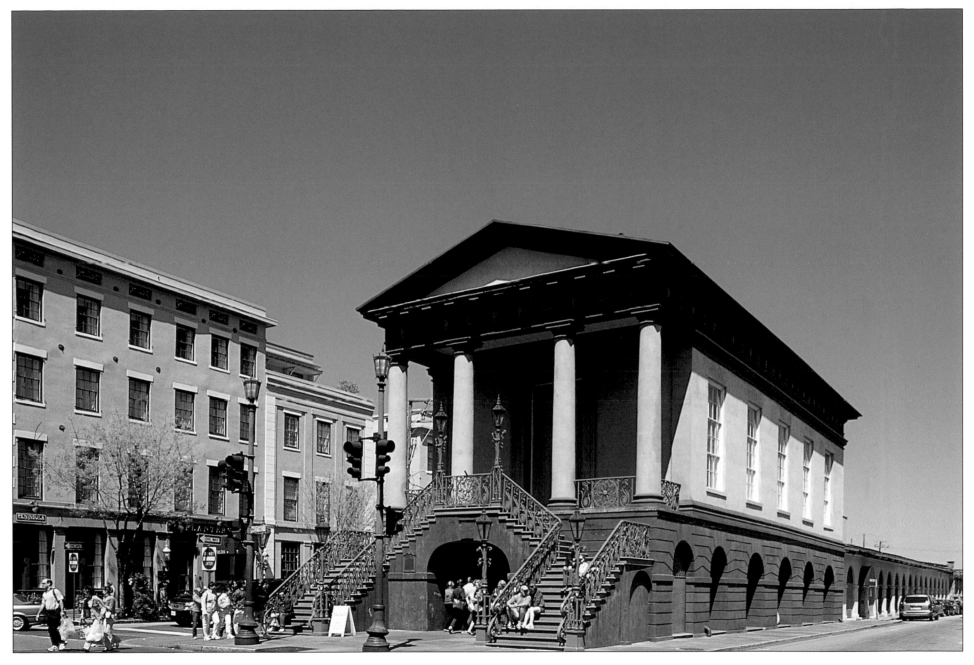

No longer do turkey buzzards walk the Market feasting on the scraps thrown into the streets by butchers. Instead, Market Hall is now one of the central features of Charleston, rejuvenated from its conditions in the 1970s, when one could get tattooed, find "comfortable company," and barhop. Since that period a mere thirty years ago, the Market is now lined with restaurants, shops, and horse-drawn carriage rides. A walk through the central market buildings can take hours as visitors wade through the throng of merchant tables and gift shops. Historic Market Hall has been completely renovated and houses the Confederate Museum, which displays relics and memorabilia of Charleston's gallant citizen soldiers.

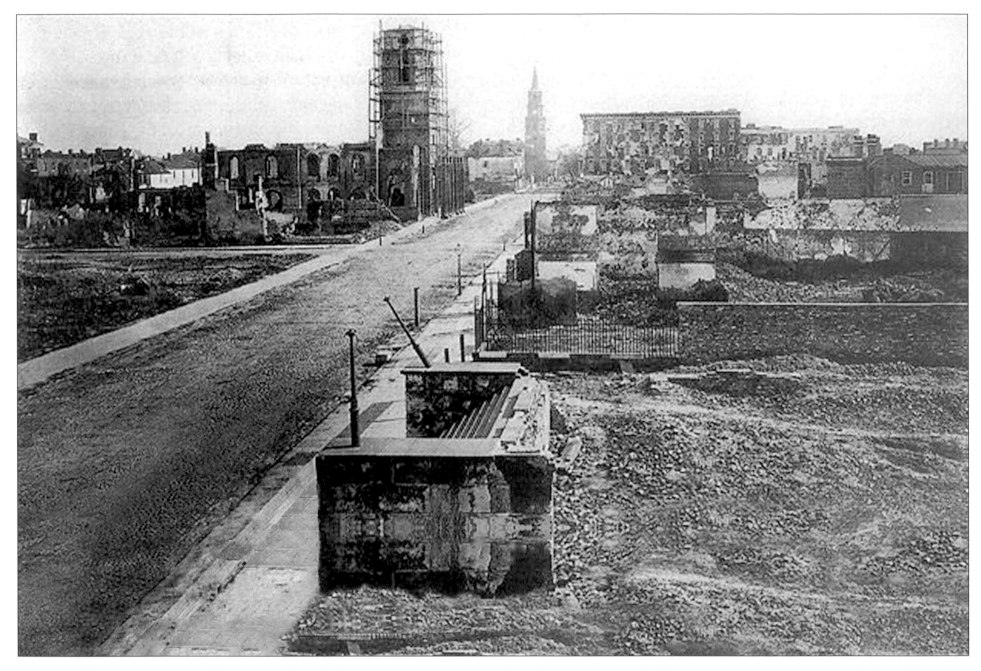

A view of the destruction caused by the 1861 fire, looking south from the City Market. In the foreground, both sides of Meeting Street, once covered with homes and businesses, lay desolate. The three prominent structures in this landscape are, from left to right, the Circular Congregational Church, the darkened steeple of St. Michael's Episcopal Church, and the charred northern face of the Mills House Hotel. The scaffolding covering the steeple of the Circular Congregational Church indicates an attempt to rebuild it. However, this only lasted until the Union shells began to fall throughout the lower two-thirds of the city. At that point work was abandoned. St. Michael's and the Mills House also shut down in 1863. When all was said and done, the Mills House received as many as thirteen direct hits. St. Michael's, the original marker for Union shells, was only hit three times, suffering little damage.

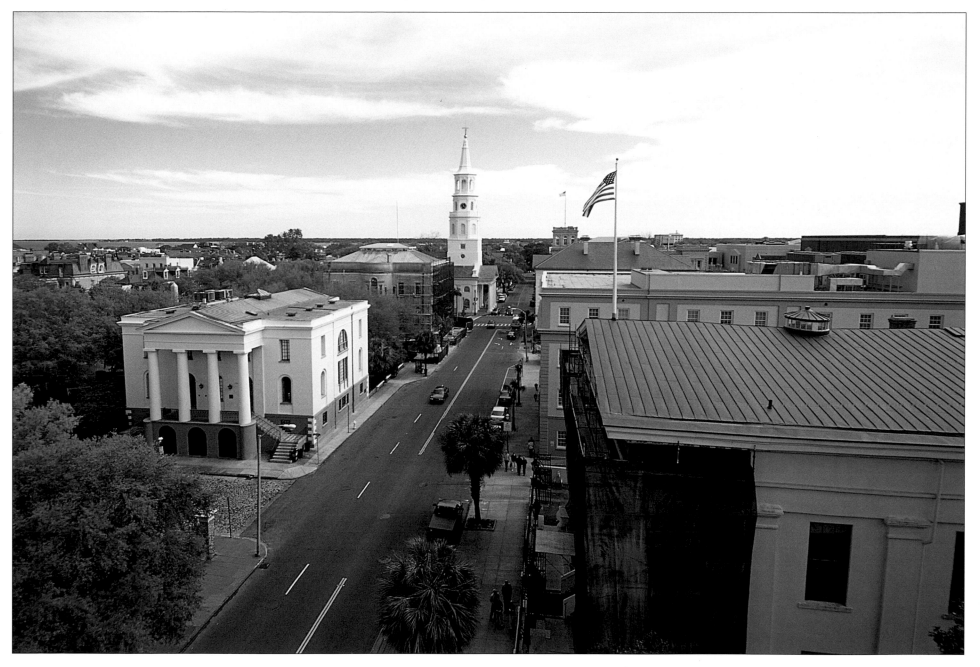

One can no longer see the Circular Church and Mills House Hotel. Sitting atop the site of the abandoned steps (seen in the foreground of the previous photograph) is the Meeting Street Inn, constructed in 1874. From that time until the 1980s, the building served as a brewing company, a restaurant, and stores selling auto parts, dental supplies, liquor, and bicycles. Finally, in 1981, the building was transformed into the thriving Meeting Street Inn. From this building begins a long stretch of banks, parking lots, office buildings, and other hotels.

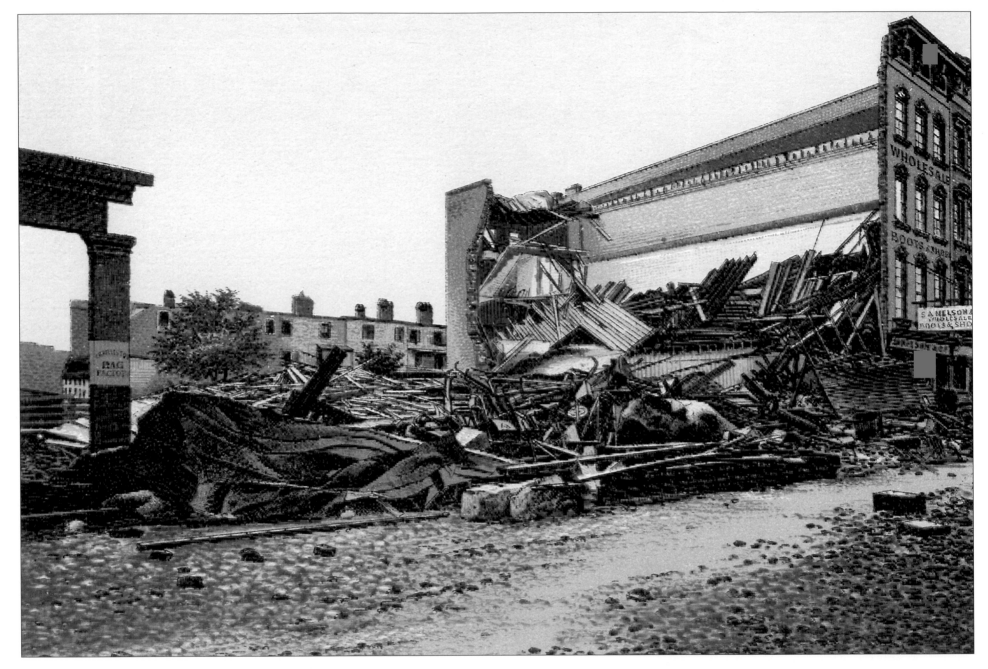

One block north of the City Market, running east from Meeting Street, is the cobbled Hayne Street. Originally named Pearl Street, a city ordinance changed the name to Hayne in 1839 in honor of Robert Y. Hayne, a United States senator, South Carolina governor, and Charleston mayor. This hand-tinted photograph once more illustrates the power of Mother Nature and her unpredictable fury. Once lined with nineteenth-century commercial buildings, this portion of the block lays completely destroyed by the 1886 earthquake. The facade of Nelson's Boots and Shoes remains, and connected just out of sight to the right, the Young America Steam Fire Engine House, established in 1866, remains intact.

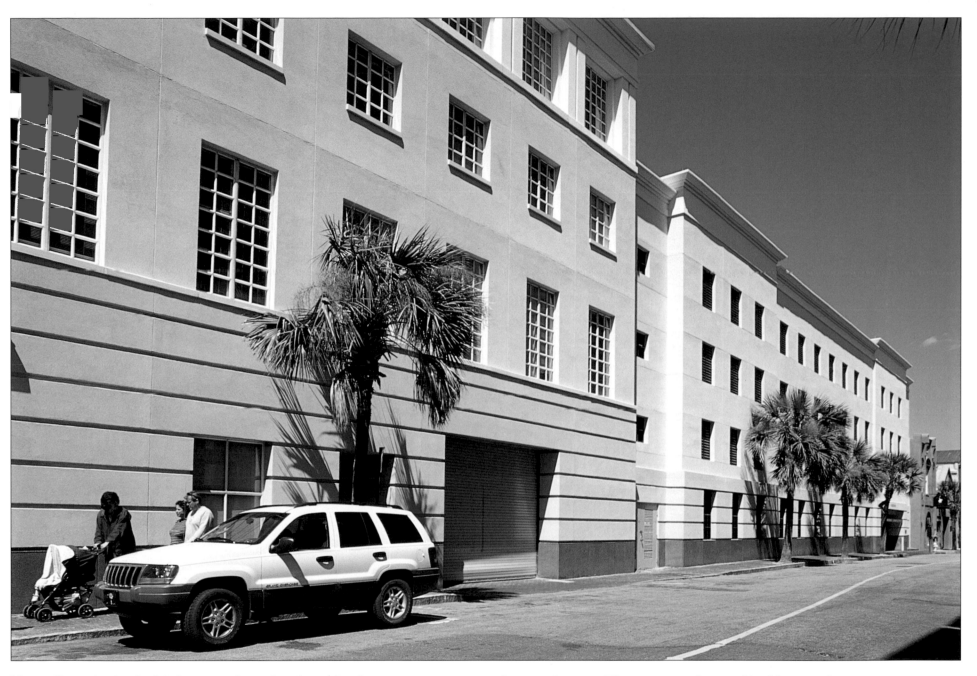

Hayne Street backs the Market as it always has, but it has lost its many commercial and retail outlets. Looking east from Meeting Street, the left-hand side of Hayne Street is lined with large parking garages to accommodate both tourists and employees of the numerous banks and shops in the area. The remaining battered buildings in the previous photograph have been transformed into the popular Hank's Restaurant as well as barns for tourist carriage companies.

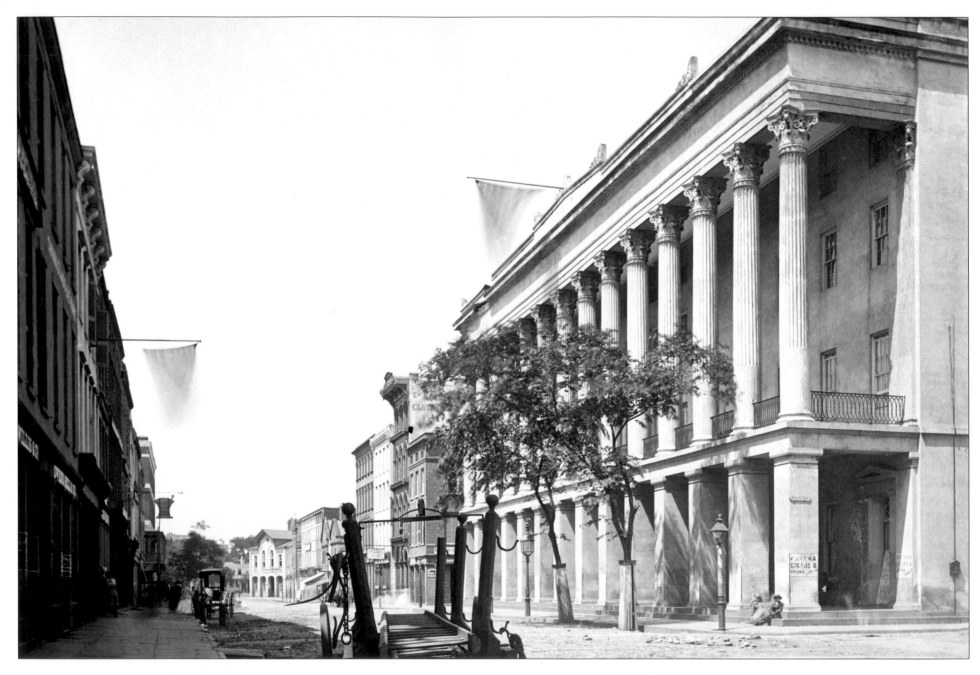

In this postwar photograph stands the majestic Charleston Hotel, at the corner of Meeting and Hayne streets. When it was built in 1839, it was considered one of the most notable hotels in the United States. It was over this hotel that the very first Union shell burst, inaugurating the 545-day bombardment of the city. Its impressive and massive Meeting Street frontage is lined with fluted columns that are topped off with Corinthian capitals.

During the first seven months of 1861, as the war began, Confederate companies and regiments, consisting of Charleston's finest young men, were marched through the streets and drawn up in formation in front of the hotel. Here they were addressed by the mayor and governor and usually presented with their flags, often made by the ladies of Charleston. Notable guests included Daniel Webster and Queen Victoria's daughter Louise.

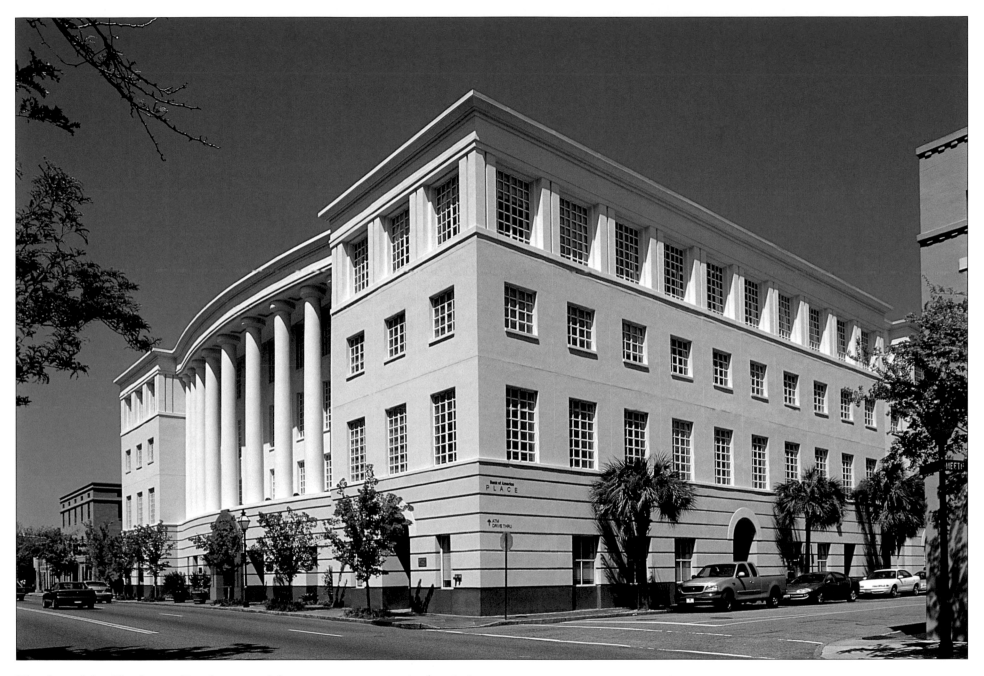

The fate of the Charleston Hotel is one of the most tragic stories in the city's modern history. Above the shouts and efforts of preservationists, the famous Charleston Hotel succumbed to the wrecking ball in the 1960s. In succession, the site housed a motel, then a bank. Today it is the home of the Bank of America. If one stares from a distance and squints one's eyes, the building actually follows the flowing lines of the original hotel.

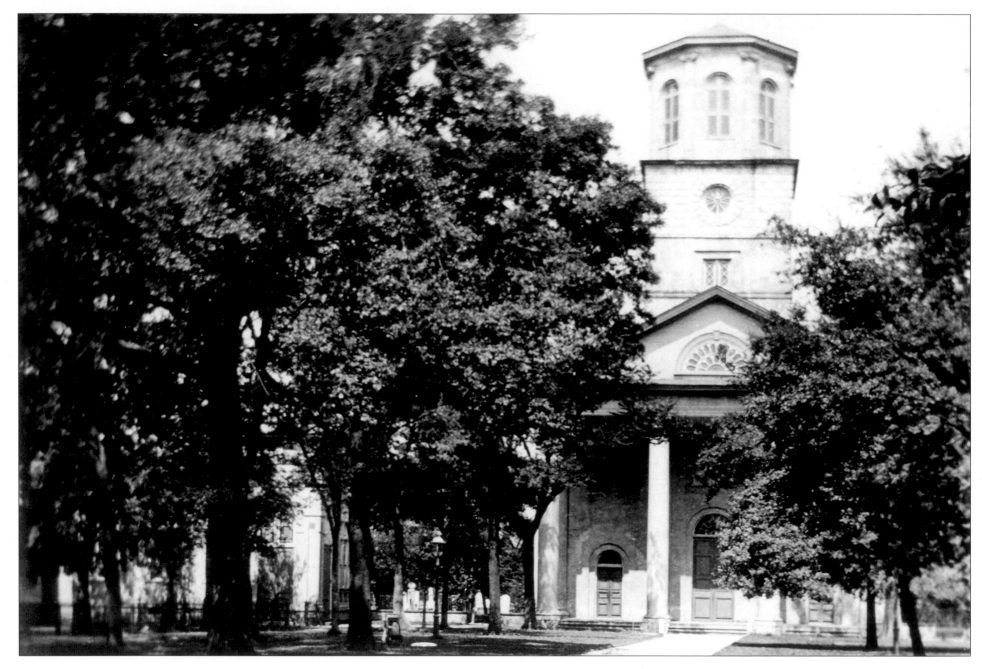

The Second Presbyterian Church spawned from an outgrowth of the congregation of First Scots Presbyterian Church. Oddly, Second Presbyterian is the fourth-oldest church building in the city, while First Scots is the fifth-oldest due to being moved and rebuilt. When Second Presbyterian was constructed in 1809, the structure sat outside of the city limits, facing what is known as Wragg Square, visible in this photograph with the live oaks and magnolia trees. The steeple was intended to be much taller, "a finger pointing upward" to heaven, but it was never completed due to lack of funds. The base of the intended steeple incorporates "bull's-eye" windows and supports an octagonal cupola. As was the case with First Scots and many other churches, Second Presbyterian donated its bell to the Confederate cause, to be melted down for the casting of artillery.

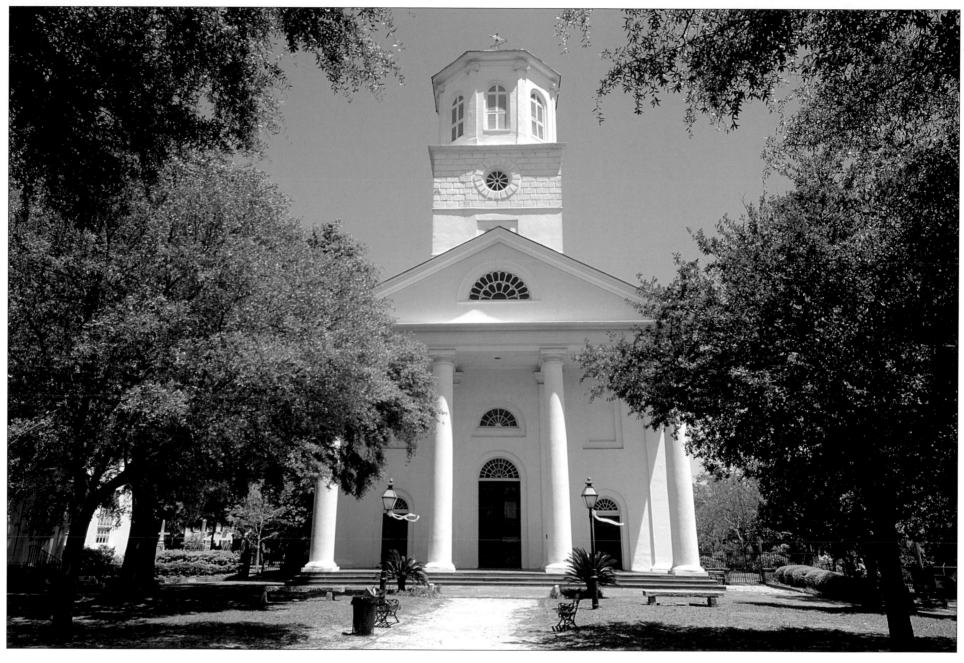

Like its sister church, First Scots, Second Presbyterian remained a "silent" church until the late twentieth century, when new bells were successively added in 1984, 1985, and 1987. In 1989 Hurricane Hugo blew the roof off, costing $1.5 million in damages. The next year, the church had perhaps its worst year when it caught fire after a gas-fire furnace vent was blocked. The result was severe damage to the church's organ, valued at $25,000. That same year, during a Christmas freeze, the fire sprinkler system froze, bursting pipes in the ceiling, which caused a twenty-eight-foot-wide section of the ceiling to fall and crush five pews in the balcony.

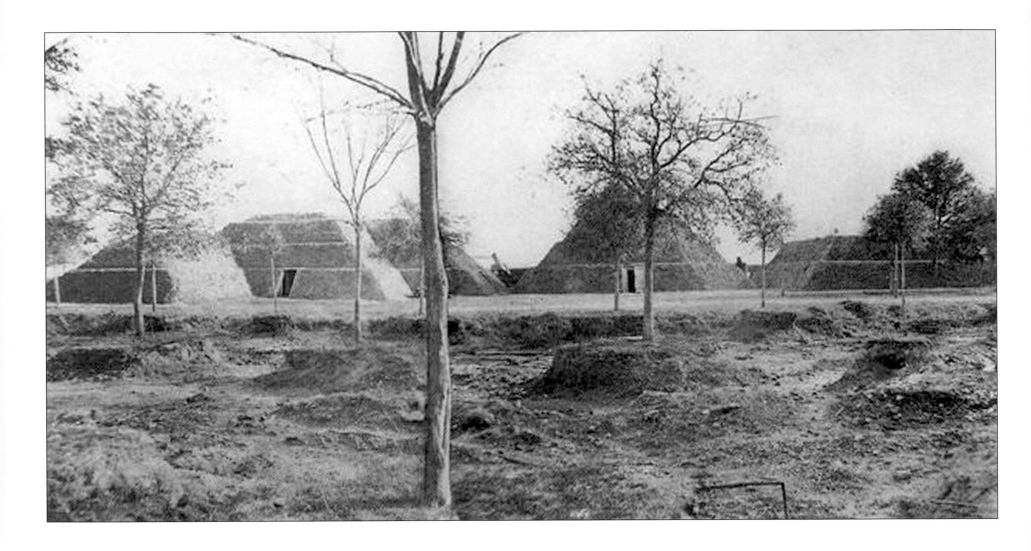

One block west of Meeting Street is King Street, so named because it was the original road, termed the King's Highway, leading from Charles Towne into the hinterland of the new colony. The King's Highway turned east, where it entered the landward side of the walled city over a moat and through the earthen, piked walls and gate into the city. Later, the street ran onward south to what became White Point or the Battery. This view is from just east of the King's Highway, facing south toward the Ashley River. Seen here is the three-gun King Street Battery, which protected James Island, the southern approach to Charleston. The Union forces tried in vain to use this approach in 1862 and 1864; the tales of the British advance across James Island and their eventual capture of the city during the American Revolution still lingered in the minds of Charlestonians, many of whom evacuated the city for the hills of upstate North Carolina.

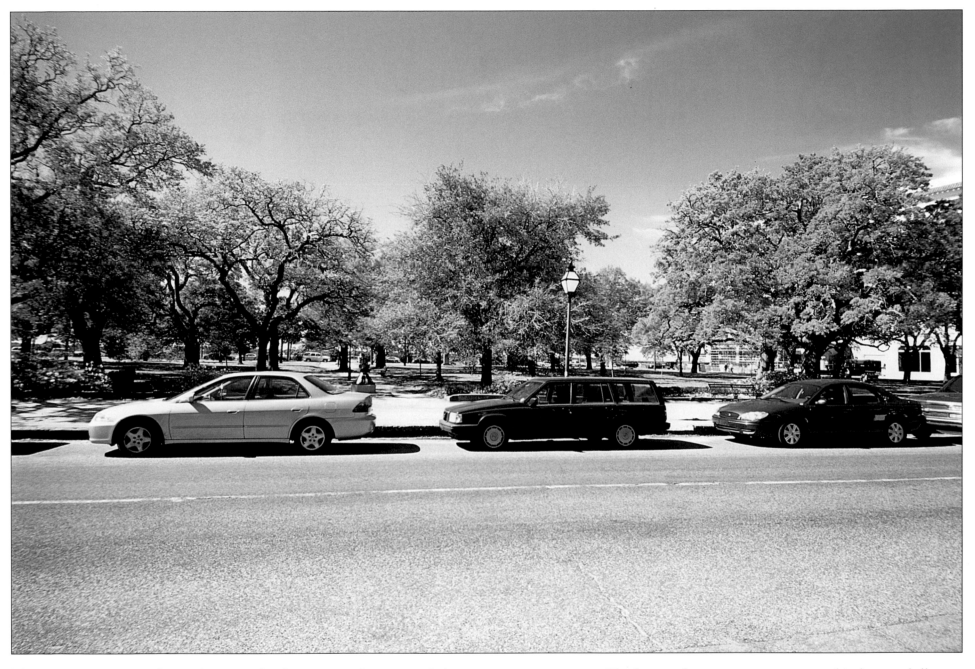

Monuments are scattered over this ground today amongst the trees and along the pathways of the Battery. The Little Angel monument, depicting a little girl playfully dancing, was one of twenty bronze castings distributed throughout the country. Near the Little Angel stands a granite monument in memory to the men of the USS *Amberjack* submarine. Though the boat had no connection to Charleston, the monument was erected in honor of all submariners who died in World War II. A granite shaft nearby commemorates the Charleston-built USS *Hobson*, which sank on April 26, 1952, after colliding with another vessel, the aircraft carrier USS *Wasp*. The *Hobson* sank in four minutes, carrying with her 176 sailors from all over the country.

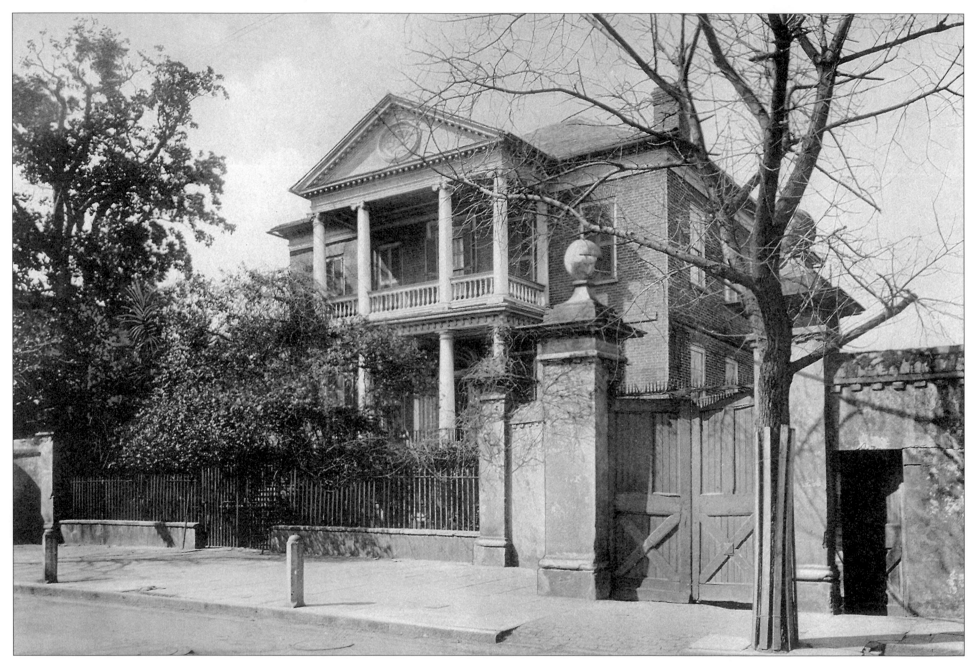

The Miles Brewton House, constructed between 1765 and 1769, is considered to be one of the best examples of the Georgian Palladian architectural style in America. Brewton, an extremely wealthy slave trader, was lost with his family at sea in 1775. Brewton's home was transferred to his sister, Rebecca Brewton Motte, shortly thereafter. During the British occupation of Charles Towne, the home became the headquarters of General Cornwallis. On the mantel is a profile carving believed to be that of General Sir Henry Clinton, overall commander in the Charles Towne theater of British operations. The spiked ironwork topping the gates surrounding the structure is known as *cheveaux-de-frise* (horses of Friesland), used to prevent entrance to the grounds following the thwarted 1822 attempted slave revolt led by Denmark Vessey, a freed slave from the Caribbean. Had the revolt taken place, it would have been the largest in American history. Following the Civil War, the house was again used as a headquarters, this time for Union generals Meade and Hatch.

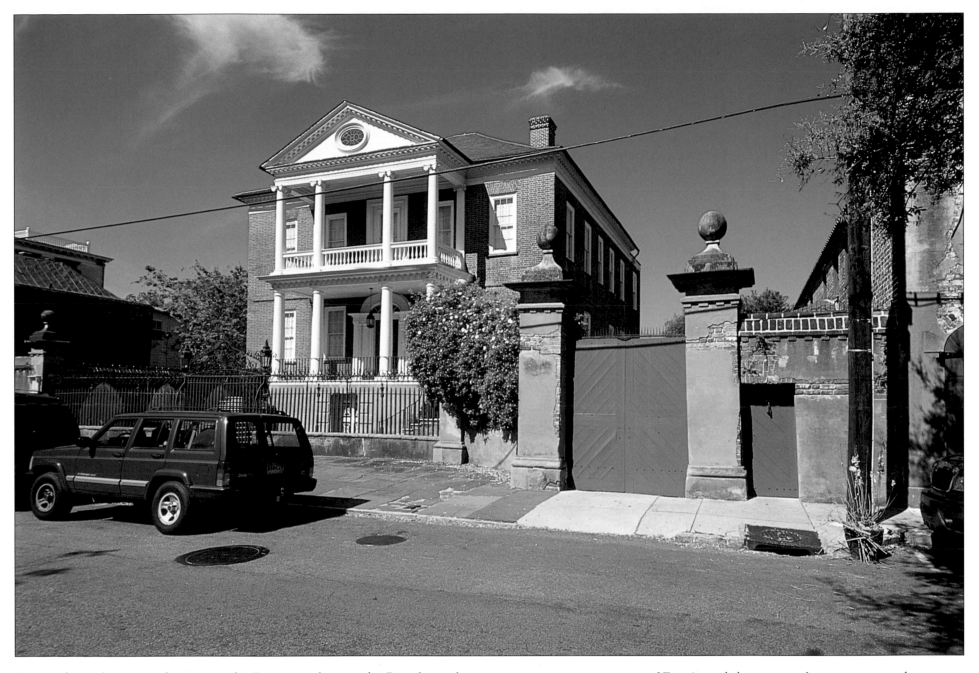

During the early twentieth century, the Brewton relatives, the Pringles and the Frosts, were without the means to repair—let alone maintain—the Miles Brewton House. For years it was owned by Susan Pringle Frost, considered to be the mother of Charleston's modern preservation movement. The outstanding house was designated a National Historic Landmark in 1964 and was purchased by Peter Manigualt in 1987. Manigualt was a lifelong preservationist, a cousin of Frost's, and the owner of an international group of newspaper and broadcasting companies. In 1987 he launched a massive restoration effort, pulling out all the stops with archaeologists, architectural historians, and specialized craftsmen, who by 1991 completed the project after four years of arduous work.

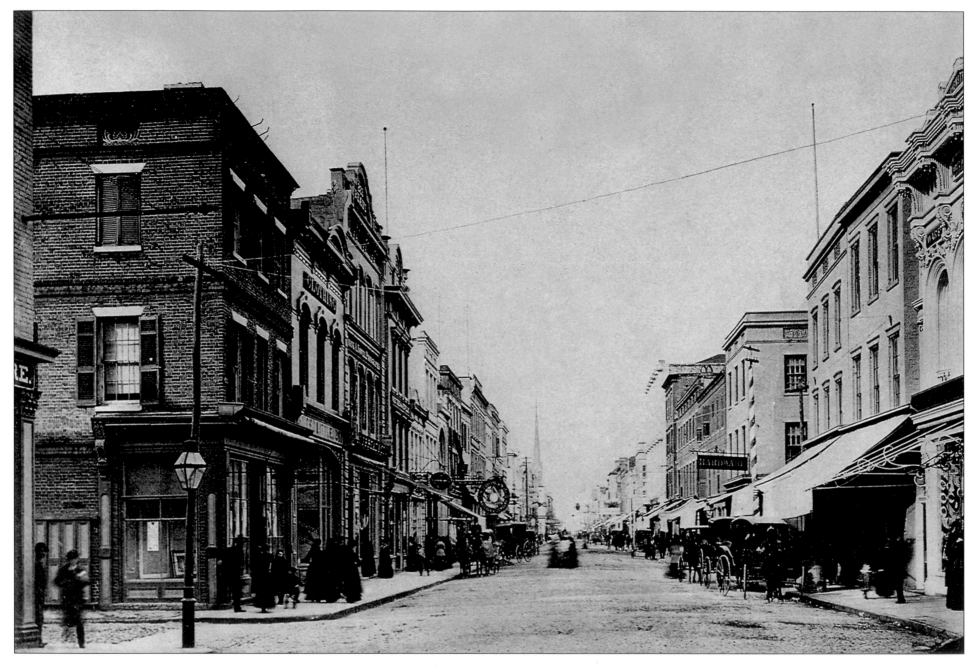

To the left, Beaufain Street terminates at King Street, where this view, looking northward, presents a bustling, vibrant scene in the 1890s. While Charleston was still locked in the throes of disaster and economic depression, many of the city's businessmen and merchants—many of them German—removed their stores and offices to middle and upper King Street, an area less affected by the ravages of war and storms. Though Meeting Street was the central street in the city, King Street had been the main thoroughfare in and out of Charleston since the early eighteenth century. Thus, reestablishing a business there made sense if one wanted to attract customers. On the northern edge of the city, many merchants set up shops with yards and storage sheds behind them, containing everything from flour to horse harnesses.

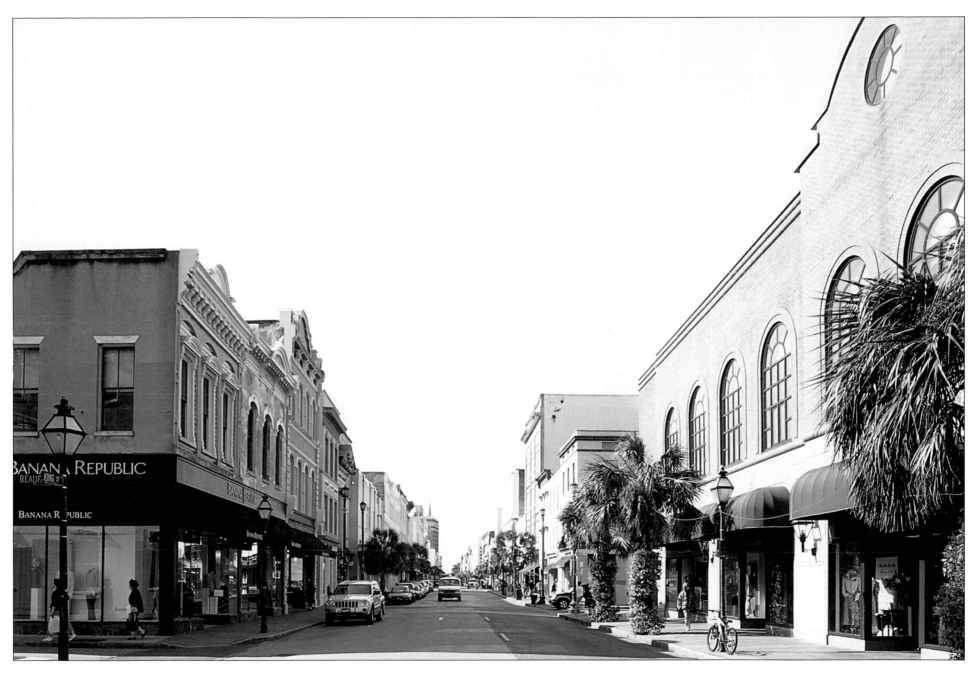

This modern view looking north on King Street shows virtually the same thing as the nineteenth-century view: a busy commercial district. King Street north of the Market is still the retail heart of Charleston, and heads north to the main campus of the College of Charleston. Immediately to the right can be seen a portion of the massive Omni Renaissance Hotel. Constructed during the 1980s, the building also contains numerous shops, boutiques, and fine restaurants.

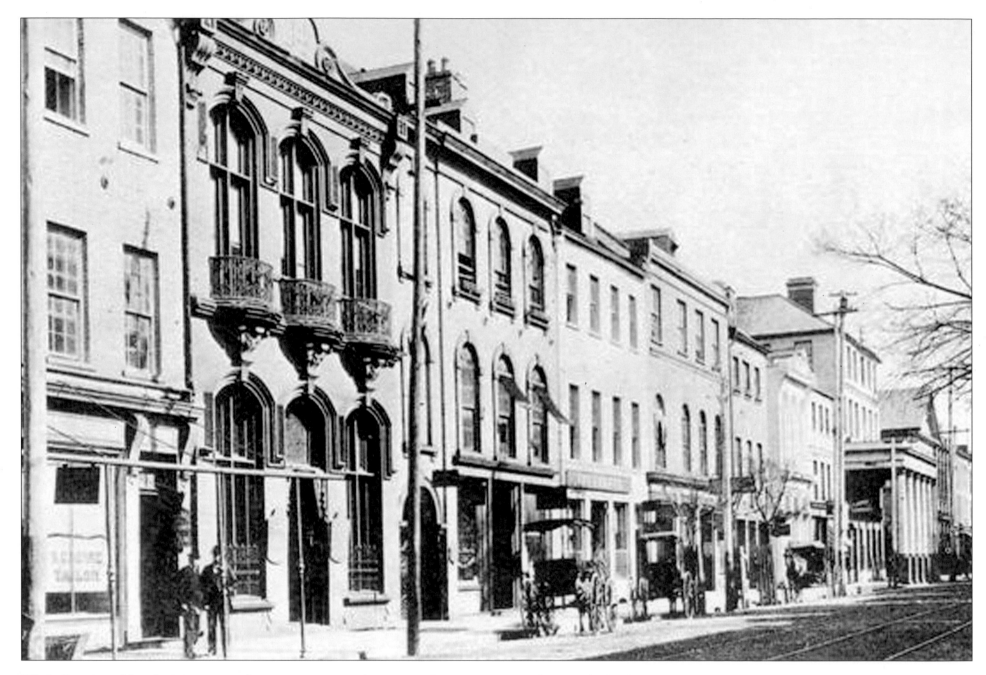

While East Bay, Church, Meeting, and King streets were the principal avenues of the old walled city, running south to north, Broad Street was the main street bisecting the city from east to west. Broad Street was so named because it was nearly one hundred feet wide at its point of origin at the foot of the Old Exchange building. Until the devastation of the Civil War destroyed Charleston's economy, Broad Street east of King Street was the business district. This late-nineteenth-century photograph, taken about midday, shows a less-than-vibrant Broad Street looking east to the Old Exchange, visible in the distance on the far right.

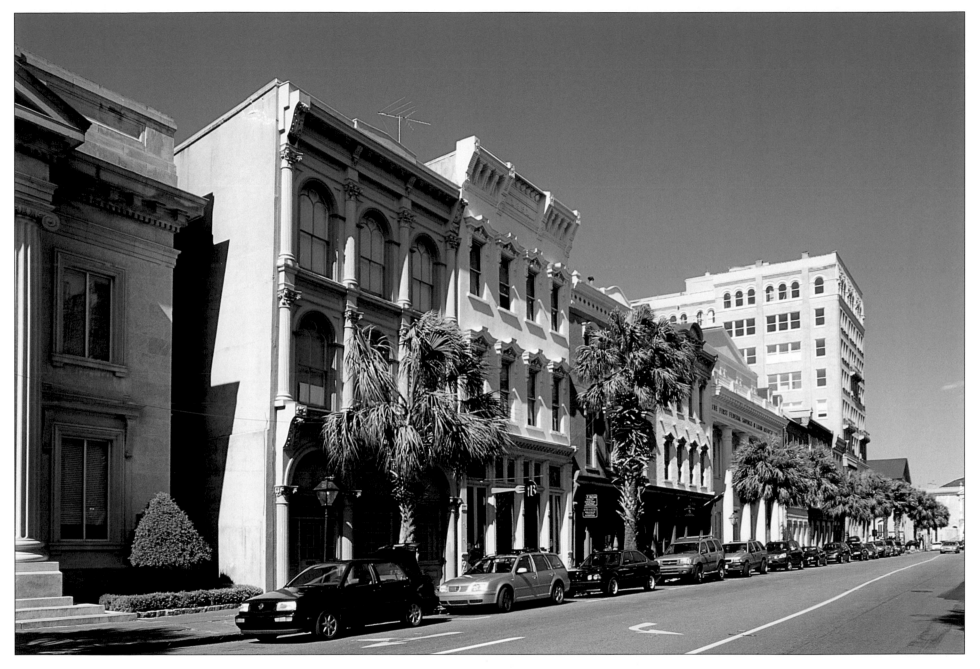

By extreme contrast to the preceding photograph, this Broad Street scene shows a lively modern mixture of law offices, real estate offices, restaurants, and fine art dealers. Another obvious difference is the presence of a "skyscraper" built on the grounds of the 1890s four-story building with a colonnade, seen at the end of the street. Charleston's skyscraper, the People's Bank Building, was built in 1911, and while many viewed it as progressive, others worried it would ruin Charleston's skyline. The bank is long gone and the building is now used for offices and art galleries, but it is still referred to by Charlestonians as "the People's Building."

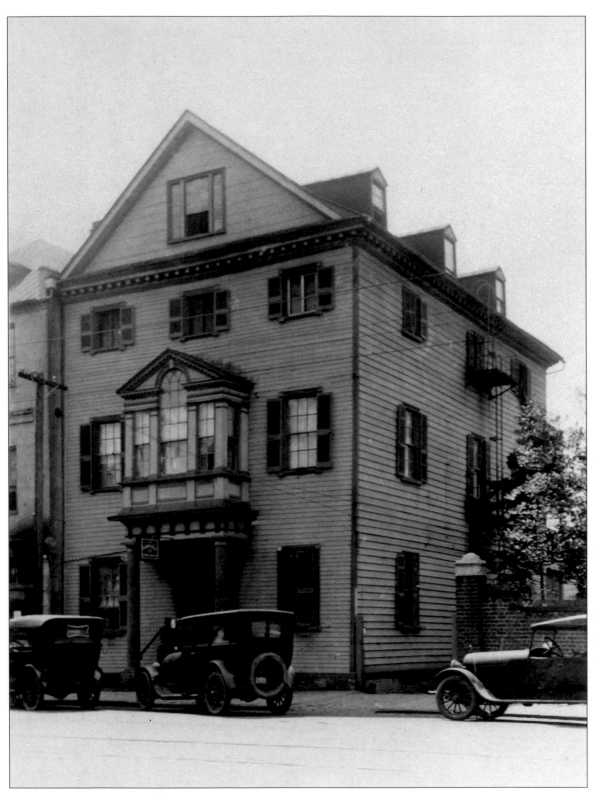

The Jehu Jones Hotel was not just stylistically out of place on Broad Street; the story of its owner is intriguing as well. Jehu Jones was a "free person of color" in Charleston who purchased the mansion of William Burrows at the price of $13,000. In the 1830s, it was considered one of the top three hotels in the city, which is perhaps surprising considering the attitude of most whites toward African Americans in that era. One Charlestonian felt it was "unquestionably the best in the city, few persons of note ever visited Charleston without putting up at Jones', where they found not only the comforts of a private house, but a table spread with every luxury that the country afforded."

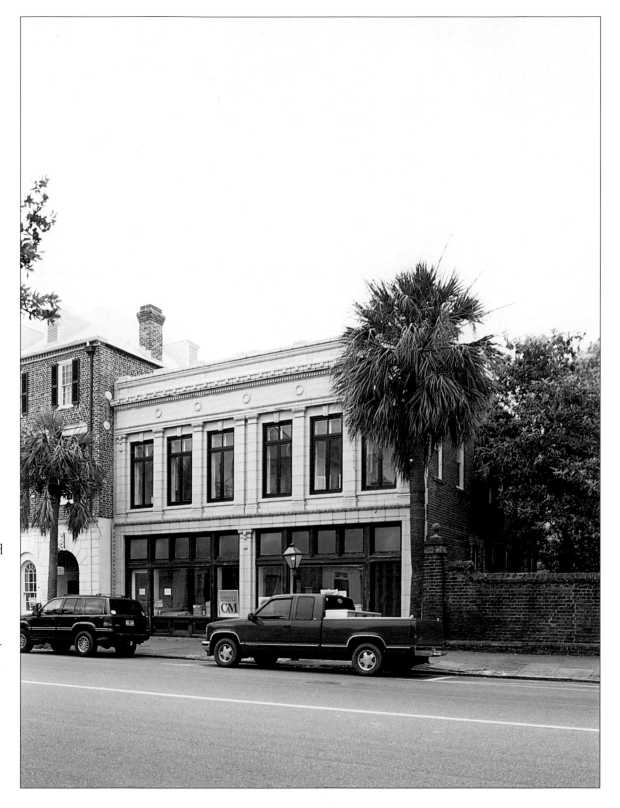

This two-storied masonry building sits on the site of the old Jehu Jones Hotel. In the 1920s, the hotel was privately purchased with the intention of relocating it just north of the city, but the stock market crash of 1929 prevented its reconstruction. The present masonry building, which is very much out of style with its eighteenth- and nineteenth-century neighbors, was built in 1930 as an insurance office. In subsequent years it has served as offices for various businesses and more recently as a series of art galleries. As in many other places in Charleston, the surrounding walls and gates live on, long after the buildings they abutted have been replaced. The brick wall abutting the hotel remains as a locator to the old photo.

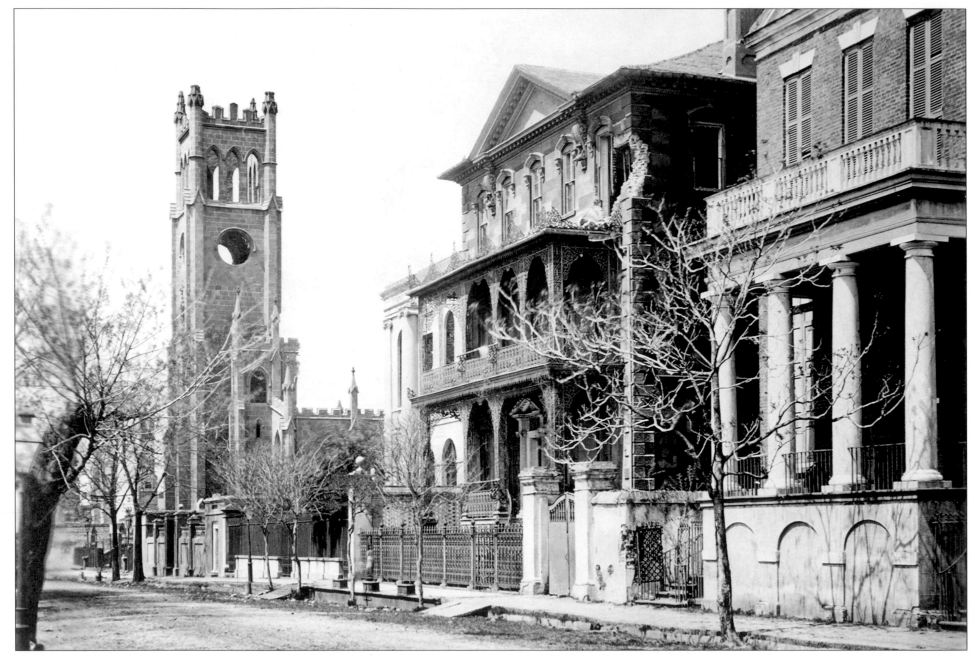

Looking west down Broad Street, Dr. Thomas Gadsden's mansion, also known as the John Rutledge House—Rutledge was a signatory of the United States Constitution—has fallen victim to at least one Union shell. Just to the left of Gadsden's home, St. Andrew's Hall—barely visible, sitting back from Broad Street—and the skeleton of the Cathedral of St. Finbar, along with virtually every building to the west along Broad Street, were razed to the ground. Over 540 acres and hundreds of buildings were destroyed in the 1861 blaze, leaving both the rich and poor homeless and at the mercy of friends and families. Even South Carolina soldiers fighting in Virginia collected what little money they could scrape together and sent it home to help those affected by the fire. As the fire spread across the city, people desperately moved their valuables into St. Finbar's, believing it was invulnerable to fire, only to find that it was just as susceptible as any other building. Ironically, the fire insurance on the cathedral had just expired.

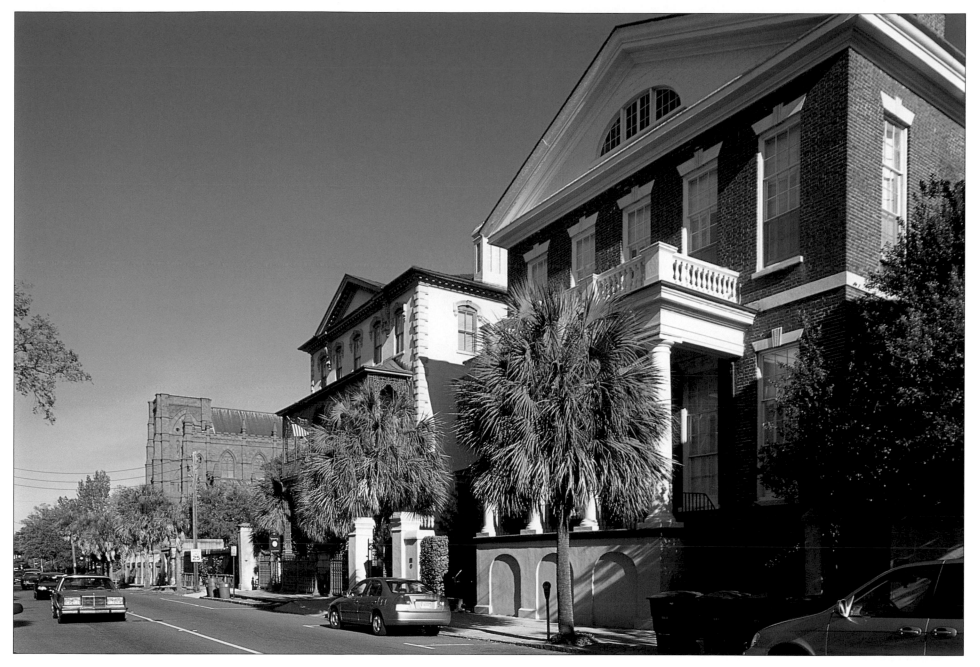

The John Rutledge House remains substantially as it appeared during the Civil War, minus the shell hole, of course. Arthur Barnwell, who acquired the property from Dr. Gadsden's family in 1885, remodeled the interior, installing eight Italian marble mantelpieces from England and parquetry floors of three kinds of wood, copied from European palaces. It is said that the carpenter, Noisette, took eight years to put in the floors. Barnwell sold the property in 1902 to Robert Goodwyn Rhett, who was the mayor of Charleston, president of the People's Bank, and one of the developers of North Charleston. During Rhett's ownership, William Howard Taft, president of the United States from 1909 to 1913, was a weekend guest several times. Tradition says that it was during the Rhetts' residence here that their butler, William Deas, invented she-crab soup.

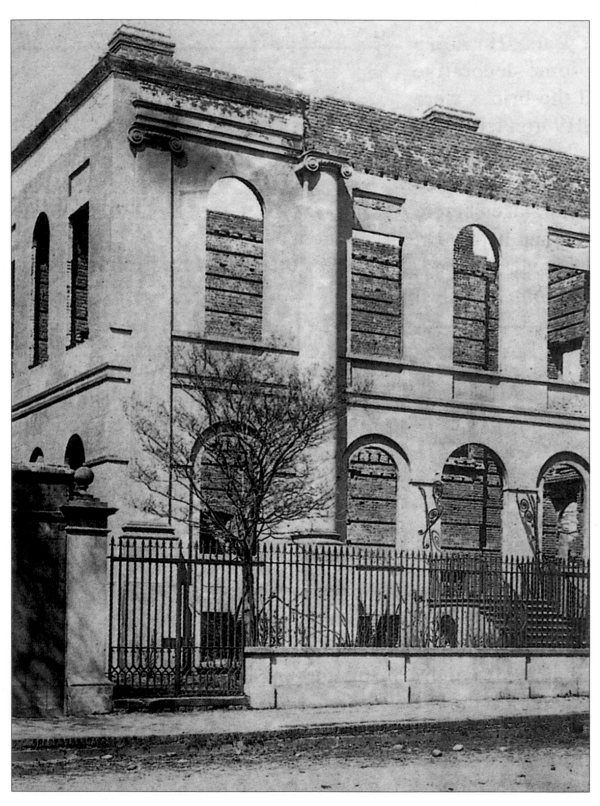

St. Andrew's Hall was destroyed in the 1861 fire, yet in this 1865 photograph the walls are still standing. Later, the building's walls were toppled by the 1886 earthquake. St. Andrew's Hall was built between 1814 and 1815 as a Scottish benevolent society, founded by the city's Scottish contingent and believed to be the oldest of its name in the world. The iron fence and gate of this two-storied brick building were added in 1819. Many galas and grand balls were held here in the period before the Civil War. In addition, the hall received many famous guests, including President James Monroe, Daniel Webster, and the great French leader of American troops during the American Revolution, the Marquis de Lafayette. However, perhaps the most important event in the building's history was when the South Carolina Ordinance of Secession was adopted here and officially signed at Institute Hall, so the citizens could witness the historic event.

Today, the site of the building serves as a parking lot for St. John's Cathedral next door. Like the Jehu Jones Hotel, the only physical reference to the past is the brick gatepost and front wall. However, St. Andrew's Hall is far from forgotten, and there is an annual celebration by Charleston's Scottish descendants, who parade out front in kilts with a suitable skirl and lament from a Scottish bagpiper to mark the occasion.

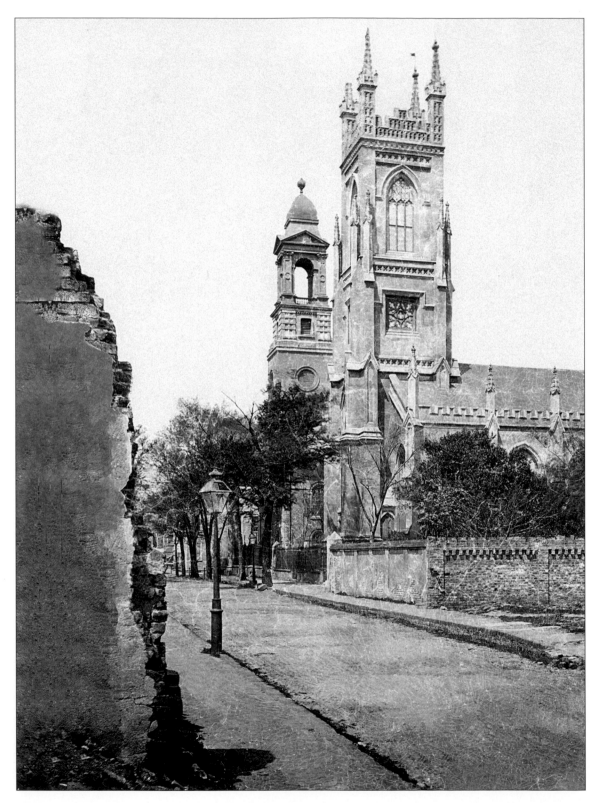

The path of the 1861 fire swelled to its greatest width in the area between the Mills House Hotel and the City Market. However, width meant nothing as the blaze churned south and west across the peninsula. The Gothic church steeple in the center of this image is that of the Unitarian Church, which barely escaped the fire unscathed as the blaze passed from east to west. The vacant lot to the right and the portion of wall to the left are testament to how close the fire came to the Unitarian Church. The construction of the Unitarian Church began in 1772 but was interrupted by the American Revolution, during which time British troops used the unfinished structure as horse stables. The church was completely remodeled in the 1850s, but care was taken to retain the original structure while at the same time completely changing the exterior. To the left of the Unitarian Church is the steeple of St. John's Lutheran Church.

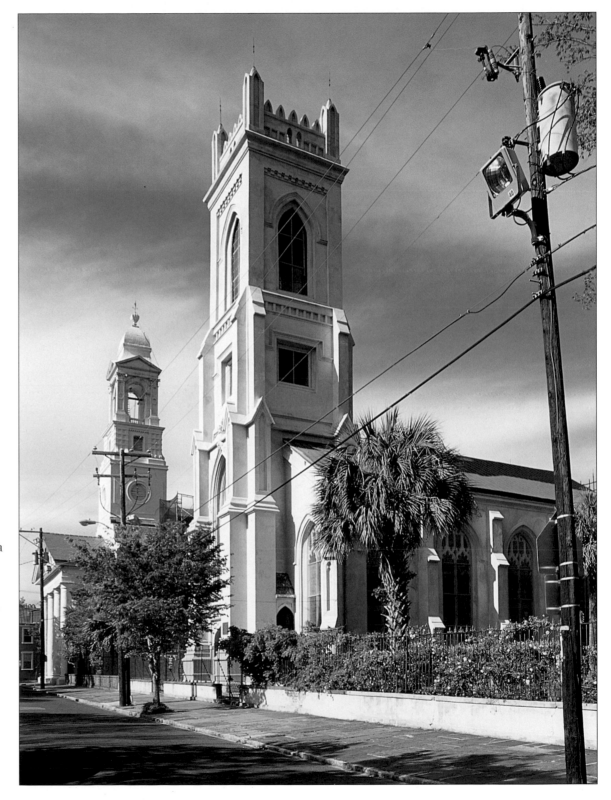

Though the Unitarian Church is the second-oldest surviving church building in Charleston, it has aged well, weathering every major catastrophe to date, including Hurricane Hugo in 1989. In 1915 its Austin Company organ was installed in memory of longtime parishioner Rosa Thompson and was used until the 1980s. After World War II, the family of Major Marion Ryan McCowan, killed in action during the conflict, donated the candelabra and cross. The church was designated a National Historic Landmark in 1974. The Guage Hall annex next door was added in 1998 to provide accommodation for the growing religious educational programs offered by the church.

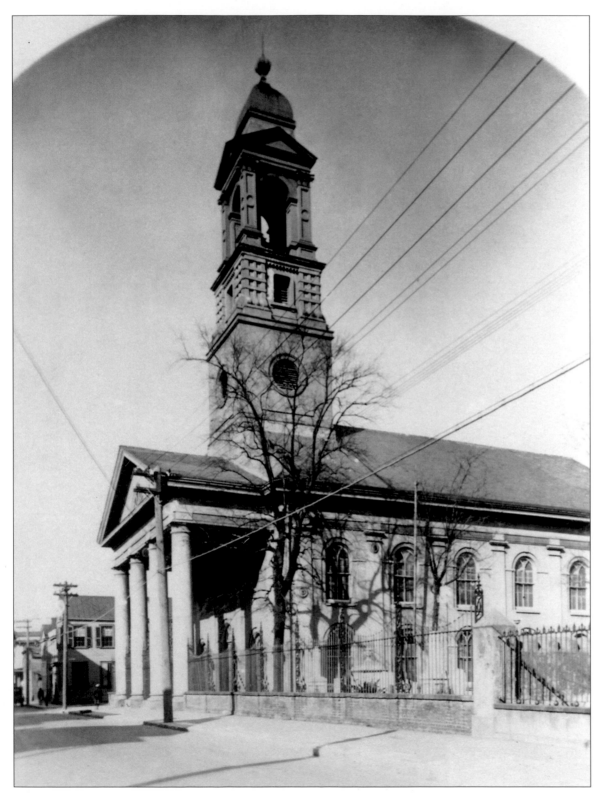

St. John's Lutheran stands proud in this early twentieth-century image. Lutheranism is documented in Charleston's history as far back as the 1730s, but a formal congregation was not organized until 1752. The original wooden church with a gambrel roof sat just behind the present church, which was constructed between 1816 and 1818. When built, the church had no steeple at all, so one was designed to resemble that of St. Michael's. Ultimately, the eighty-foot-tall steeple was built in 1859. During the American Revolution, the Reverend John Nicholas Martin was driven from the city, nearly at the point of a bayonet, for refusing to pray for the king of England. In addition, his property was confiscated. The churchyard and building were struck several times by Union shellfire and severely damaged by both the 1886 earthquake and the hurricane of 1896.

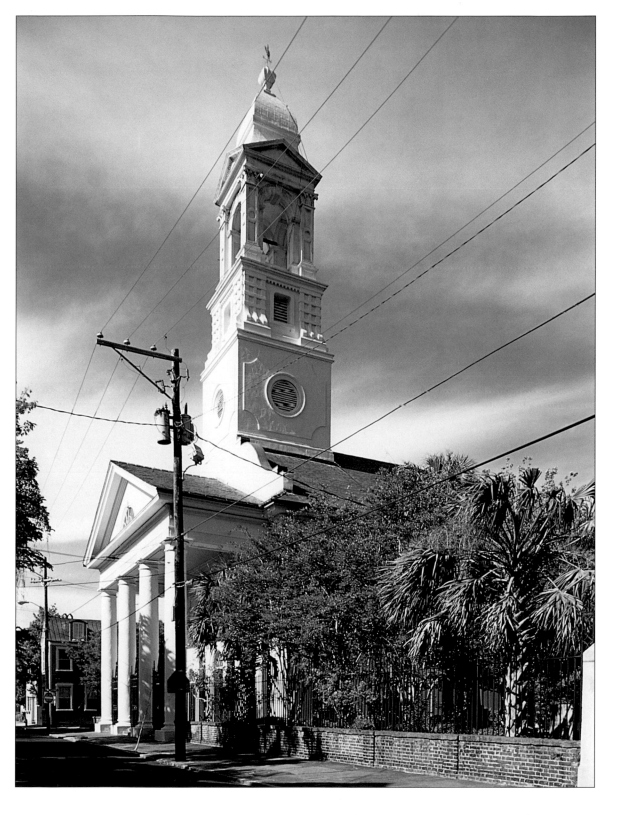

St. John's endured the same nineteenth-century woes as every other building of the era. In 1940, yet another hurricane swirled across Charleston, seriously damaging the church, and like so many times before, the congregation rallied and rebuilt. In 1962, mahogany pew boxes were installed, and in 1965 the present organ followed. Then, of course, in 1989 came Hurricane Hugo, which severely damaged the roof of St. John's, but in doing so it revealed a hidden piece of history. A local Charlestonian was imprudently inspecting the damage and traced the path of a Union shell through the supports to the point where it burst. After 124 years, shell fragments still remained in this time capsule of sorts. The gentleman retrieved a piece of fragment and gave it to the church's minister. A "silent" church since 1862, St. John's received new bells in 1992, cast in France by Paccard-Fonderie de Cloches. The new bells were dedicated on Easter Sunday of that year.

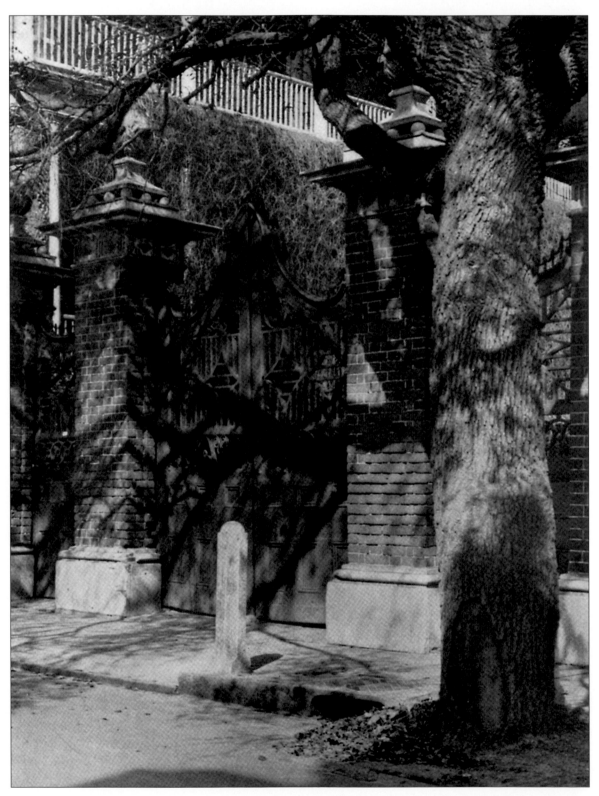

To the south of Broad Street run numerous smaller streets and lanes. Some of these were laid after the Civil War, while some were prewar streets that, unfortunately, fell in the path of the great 1861 fire. Still others survived intact, the fire having passed to the north and west. One of the latter streets is Legare Street, originally known as Johnson's Street after Sir Nathaniel Johnson, an early governor of the province between 1703 and 1709. It was renamed for the Huguenot silversmith Solomon Legare, who owned a large portion of land in the area. Along the southern portion of Legare Street stands the Simmons-Edwards House, built circa 1800, and most noted for its splendid formal entrance gates. Known to most Charlestonians as the Pineapple Gates—the pineapple being the symbol of hospitality— these massive brick gates are topped with stone pineapple finials, which were actually carved to resemble Italian pinecones. Nevertheless, the home is most commonly referred to as the Pineapple Gates House.

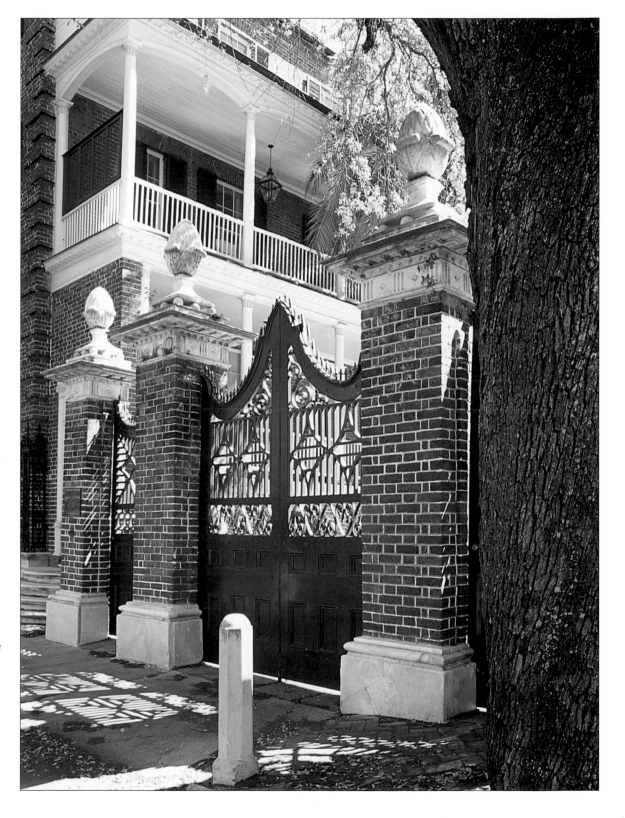

In 1968, the home was purchased by Mr. and Mrs. Norman B. Steveson. Later, in 1987, Thomas R. Bennet Jr. bought the home for $800,000 and then spent $100,000 on restoring the carriage house behind the main structure. In 1989, Bennett sold the home to Mr. and Mrs. William J. Gilliam, who in turn sold it to Andrew Crispo, a noted art and antiques dealer who later filed for bankruptcy in New York. The Pineapple Gates House had to be sold to satisfy creditors' claims. The house is well known as a historic landmark, and at the time of its purchase, it was the most expensive home in Charleston. This stigma attached to the home and prevented its sale for some time. Most recently, the home found a new owner and has been extensively renovated. It is noted by the Library of American Landscape History to be the only one of this particular style in the country.

Further north on Legare Street is the Sword Gates House, built sometime prior to 1810. The large home was the creation of two German merchants, Paul Lorent and Jacob Steinmetz, who connected two large brick and frame structures together with a frame addition. The home appeared on early plans as three separate buildings. Surrounding the house is a massive brick wall with a heavy, wrought-iron gate. This entrance to the property is known as the Sword Gates because each of the two gates contains a broadsword whose points nearly touch when the gates are shut. The elaborate gates, installed in 1850, were made by one of Charleston's most celebrated ironworkers, Christopher Werner, who apparently made them by mistake while making a similar pair for the Guard House, later known as the South Carolina Military College, or the Citadel.

In the early twentieth century, the Sword Gates House, owned by Henry T. Gaud, was sold to a wealthy Charleston attorney who restored the main house and transformed the carriage house and servants' quarters into four rental properties. Later, Mrs. Dorothy B. Shackleford purchased the center portion of the main house along with the gates and gardens. The Gauds retained the brick portion. Shackleford sold the brick portion to E. Graham Reed in 1966, and the brick portion was sold to a notable Charleston physician. Today the three sections of the house serve as three different homes, with three apartments on two separate lots.

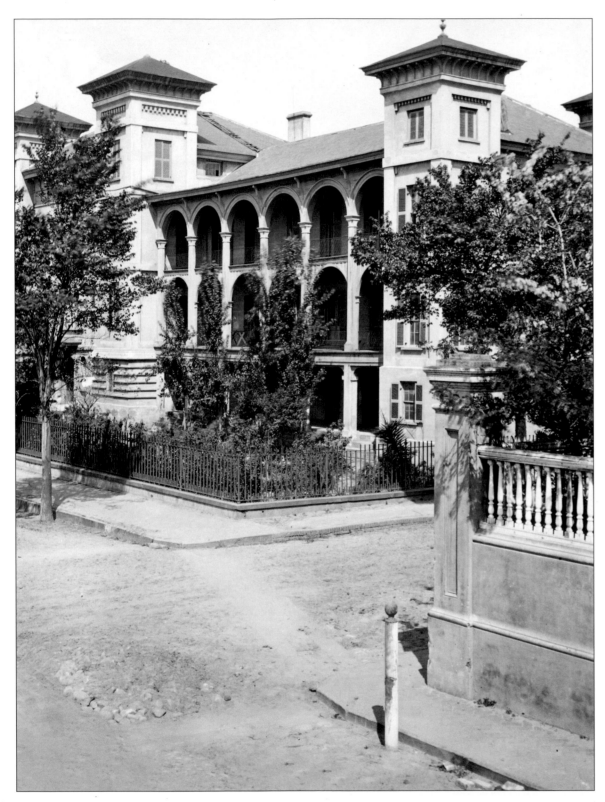

Roper Hospital was built in 1852 and had a large central section with arcaded wings on both sides. The son of Colonel Thomas Roper died without a child to receive his wealth, so his legacy of $30,000 was used to build Roper Hospital, Charleston's first public hospital. Located on Queen Street, one block north and parallel to Broad Street, the hospital was saved from the 1861 fire when Confederate authorities destroyed fourteen homes in order to create a firebreak. It worked and thus saved the entire block around the hospital, including the old city jail. The hospital was also used to hold Union prisoners of war. Many prisoners wrote home of the fine accommodation they had at Roper, being able to lounge comfortably on the piazzas of either wing. Likewise, many Confederates envied the prisoners, feeling that they were treated too generously. The comfortable wings were destroyed in the 1886 earthquake.

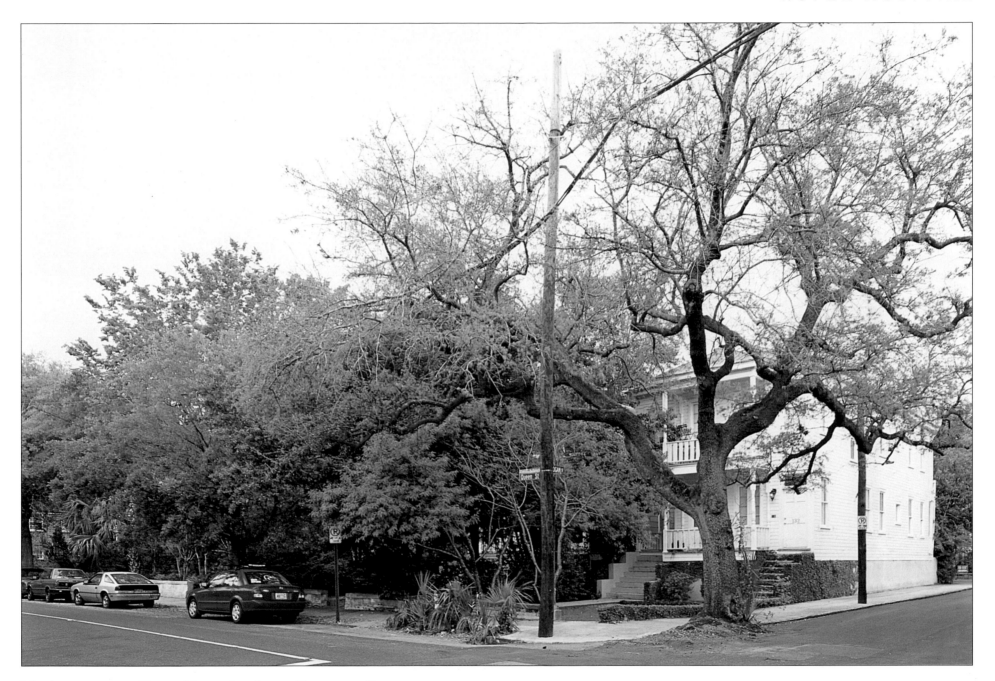

The last remnant of Roper Hospital is the small stucco wall running in front of a row of rental houses. The 1886 earthquake severely damaged the building, though the central tower held fast. The hospital relocated north to Calhoun and Lucas streets in 1904, and the two wings of the old hospital were torn down in 1911. The central tower was finally demolished when Hurricane Hugo sacked the structure.

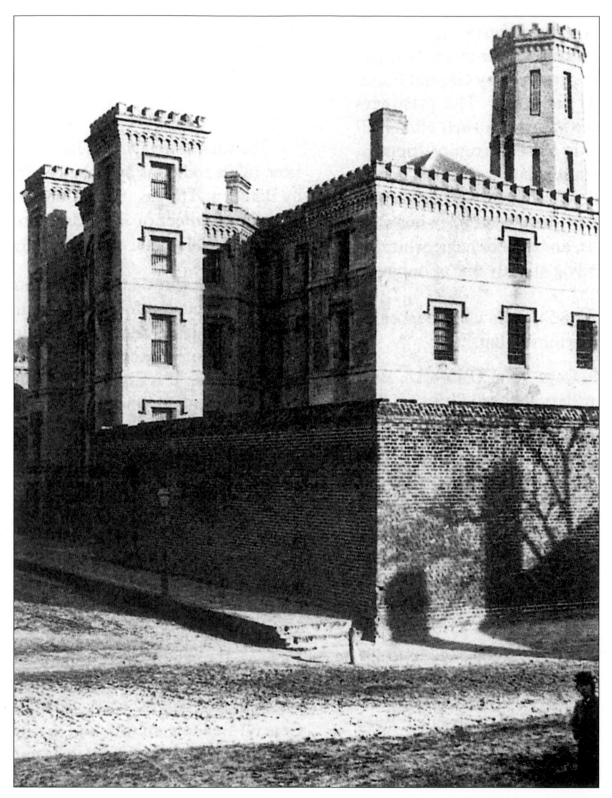

Behind Roper Hospital stands what looks like a medieval castle, constructed in 1802. The wings were added later in 1855, although improvements were made in the 1820s by Robert Mills. Mills designed the wings of "fireproof construction," designed to contain one-man cells, but his wings were removed and replaced with an octagonal tower. As with the Old Slave Mart on Chalmers Street, all black seamen, regardless of national origin, were held here while their ships were in port. Many Union prisoners were also held here during the war, including perhaps the most famous, a number of soldiers of the Fifty-fourth Massachusetts, the first all-free black regiment in the war. Their stay was less than comfortable, while the Confederate and South Carolina authorities debated whether or not to hang them or exchange them for Confederate prisoners held in the North, one of whom was the son of General Robert E. Lee.

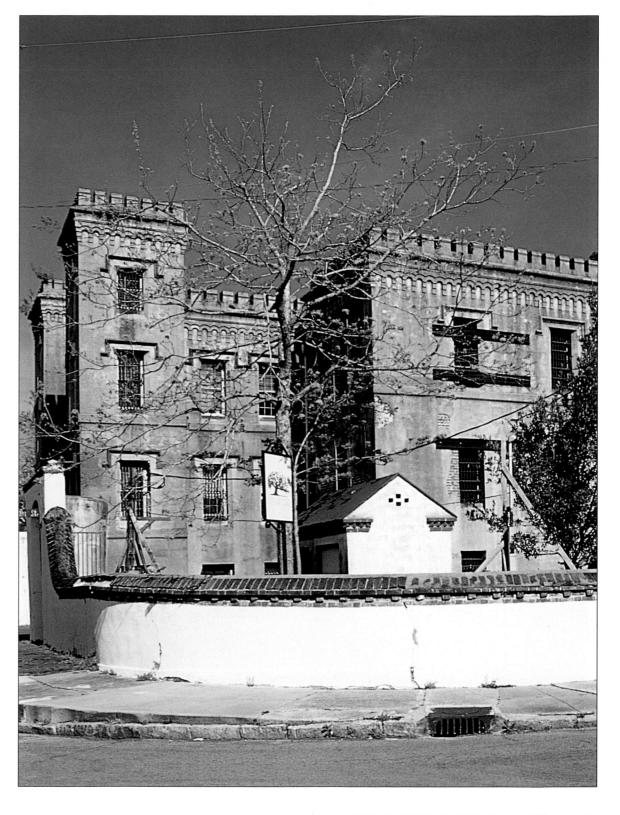

The old city jail held offenders from its construction in 1802 until 1939. At that time, it was purchased to become part of the Robert Mills Manor Project. The building lay vacant for many years until the 1980s, when it became a museum. Subsequently, the city took it over and used it for miscellaneous storage purposes. In recent years, the School of the Building Arts has taken on the task of renovating the jail as a facility to train students in the ancient arts of building, from stonework to wrought iron.

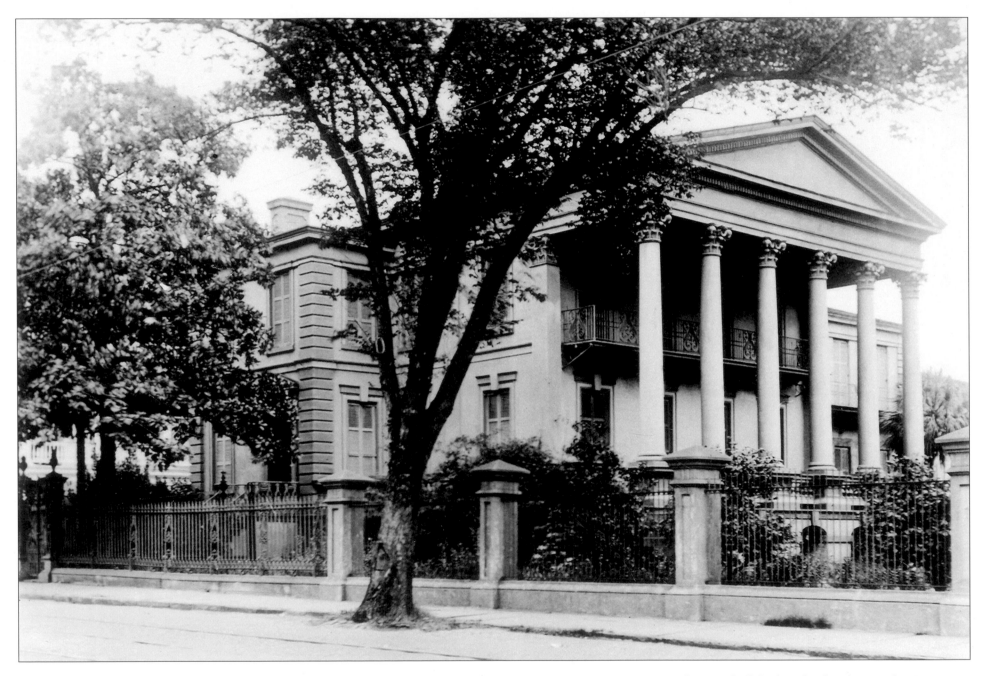

In 1849, Rutledge Avenue—named after Charleston's great patriot John Rutledge—was built, running north from the western end of Broad Street, across the marshy waters of a pond. Rutledge Avenue had been laid out as one of the original streets on the western side of the peninsula, in an area known as Harleston Village, which claims to have contained the first golf course in America. Moving north on Rutledge to where it intersects Montague Street is an imposing house known as the Jenkins-Mikell House,

built around 1853 by Isaac Jenkins Mikell for his third wife, Martha Pope. Mikell was a millionaire cotton planter on Edisto Island, south of Charleston. Immediately following the war, Mikell sold the house for just over $22,000 due to the depressed postwar economy. Most consider the outstanding features of this house as being the six massive columns, made of cypress rather than marble and topped off with rams' head capitals.

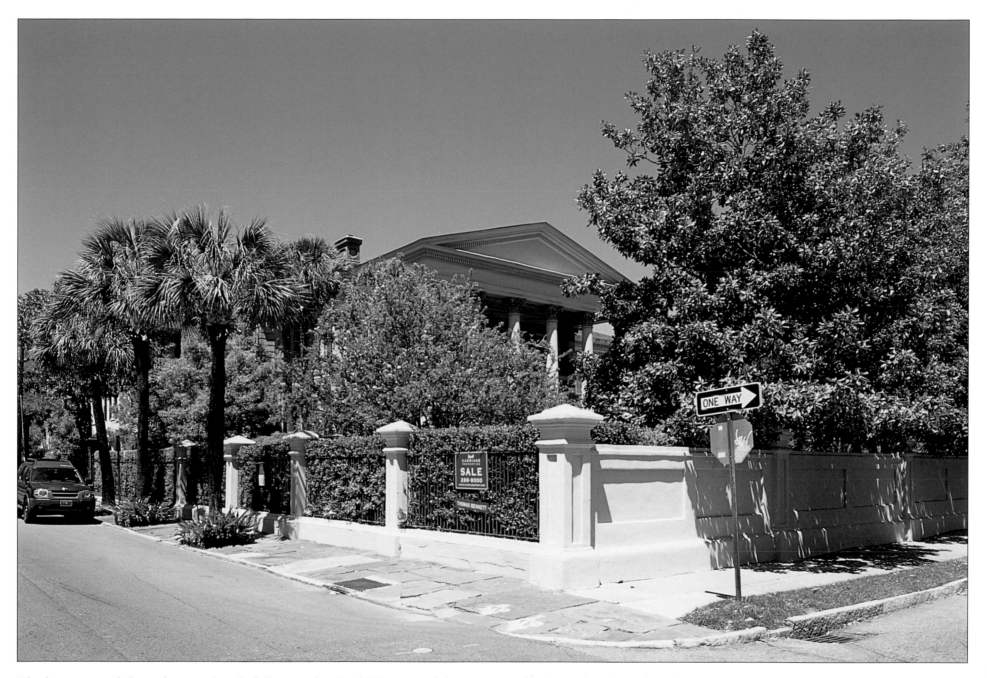

The house passed through many hands following the Civil War, one of the last owners being Mayor John Ficken. The house served as the Charleston Free Library from 1935 until 1960. In 1962, owing to its size and that of its spacious grounds, the home seemed destined for destruction. Salvation came in the form of modern-day plantation owners, Mr. and Mrs. Charles H. Woodward from Philadelphia, who handsomely renovated the structure. The Woodwards divided the building into apartments, and it is now a private residence.

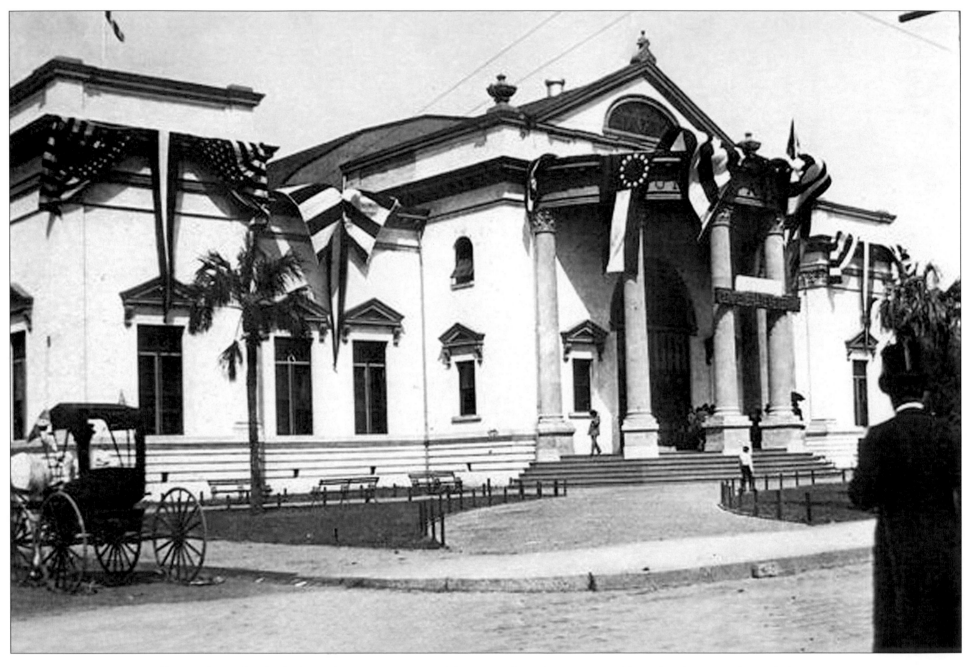

Cannon Park was originally a mill pond, which, like a large percentage of the Charleston Peninsula, was eventually filled in to create more land. The park was named after Daniel Cannon, who had established sawmills in the area. By the end of the nineteenth century, it was used as the site of the Thompson Auditorium, hastily built in only ninety days in order to accommodate the influx of surviving soldiers for the United Confederate Veterans reunion. Until the early twentieth century, the large seating hall continued to serve conventions. In 1907, the building officially became the Charleston Museum, taking in some extensive collections, which for a long time had been housed in the cramped upper levels of Randolph Hall at the College of Charleston.

Appearing to be a Minoan ruin, these columns are all that remain of the Thompson Auditorium. The auditorium served as the Charleston Museum until 1980. A short time afterward, the building, to the eyes of many Charlestonians, "conveniently" burned to the ground the same year a new museum complex was finished on upper Meeting Street at a cost of $6 million. Cannon Park now occupies the site.

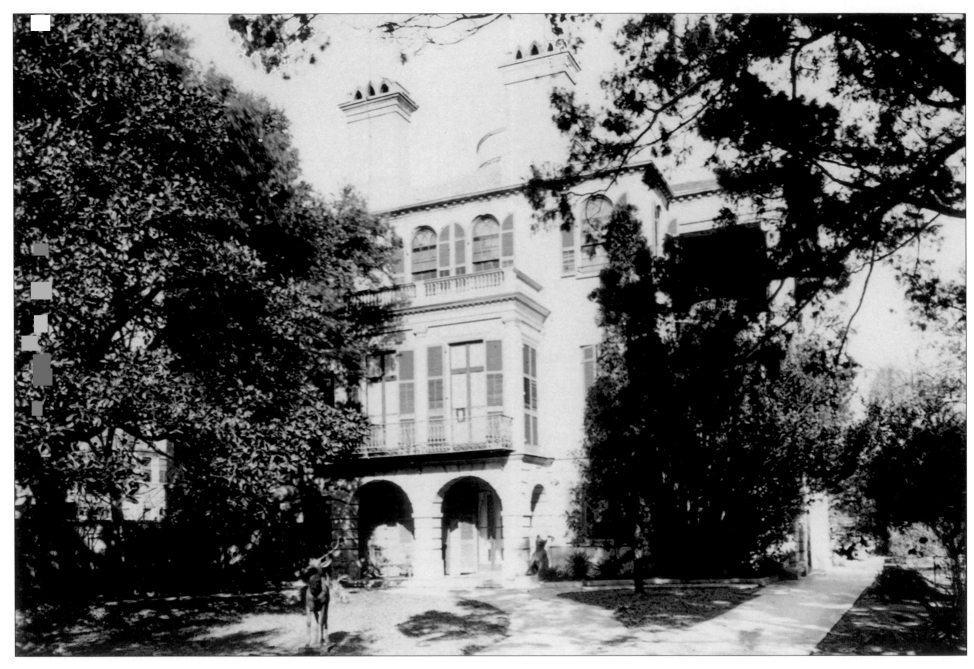

Although the exact dates of construction and the architect of the McBee House are unknown, the building probably dates to around 1816 and most attribute it to William Jay, an English architect. When built, the home sat on an island surrounded by marshland, with a clear view of the Ashley River along the peninsula's western side. Just after the Civil War, the property was purchased by George A. Trenholm, one of the wealthiest men in America and the largest blockade runner in the Confederacy. In 1864, he was appointed secretary of the treasury in Confederate president Jefferson Davis's cabinet. Though the house was damaged by the 1886 earthquake, it was quickly repaired, and in 1909 it was purchased by Mary Vardrine McBee, who turned the house into the Ashley Hall Girls' School, which remains a girls' preparatory school to this day.

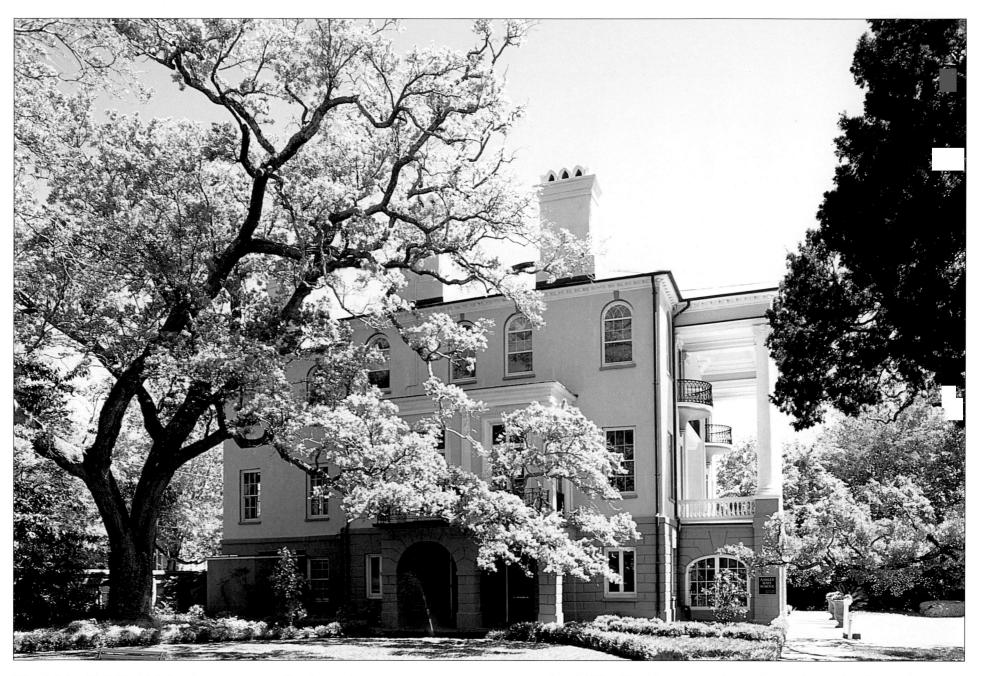

The Ashley Hall Girls' School remains virtually identical in appearance as when Mrs. McBee owned the building and surrounding property. The only exception is that the area under the recital hall was converted into the school's dining room. In 1988, major interior restoration was carried out in memorial to Mildred Muldrow, an early graduate of the school. Another notable alumna is Barbara Bush. In 1989, the damage caused by Hurricane Hugo required that some of the surrounding buildings be torn down, rebuilt, and combined with the Martha Rivers Ingram Center for the Arts.

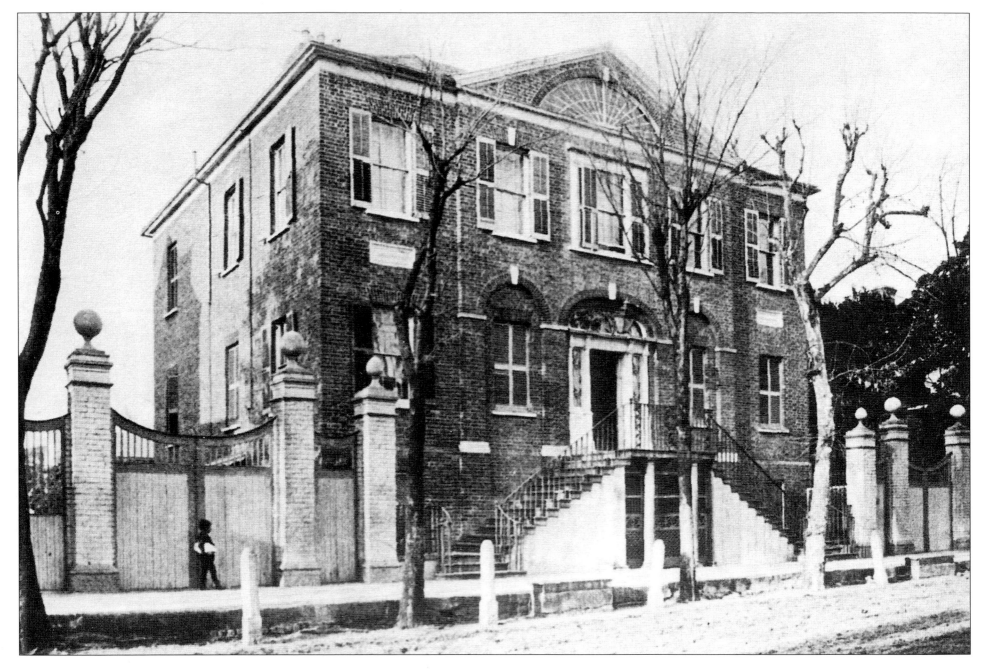

Further east in Harleston Village, on Bull Street, sits the William Blacklock House, built in 1800. Blacklock was a wealthy English merchant who at one time held a partnership in a large importing and exporting company on East Bay Street. He also once held a position on the building committee for the First National Bank, which eventually failed, and the building became Charleston's city hall. Built in a style reminiscent of Georgian Palladian, similar to the Miles Brewton House, the building has a sloping double staircase but incorporates largely Neoclassical elements. The date of completion is engraved in stone beneath the staircase. Blacklock, though a merchant, chose to build his home on what was considered to be the northern edge of town, far from the mercantile districts but virtually next door to the College of Charleston.

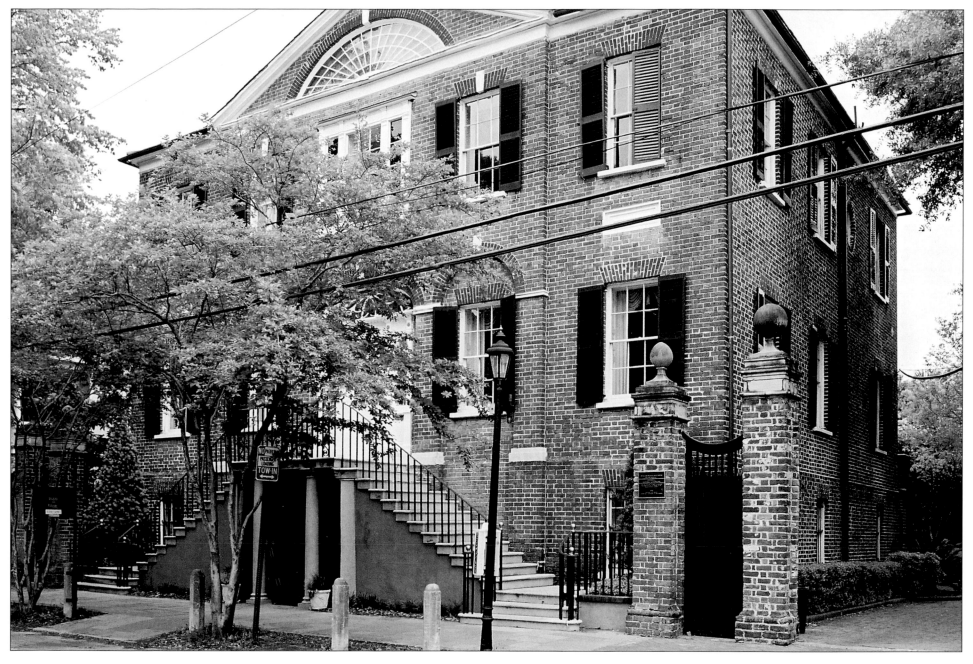

Like so many other architecturally important structures in Charleston, the Blacklock House (shown here from the right to avoid the trees lining the sidewalk) was slated for demolition many times in the twentieth century. Indeed, in 1958 a permit for demolition was obtained. Ultimately, the College of Charleston Foundation acquired the house in 1971 through the generous help of Richard Jenrette, the same man who purchased and renovated the William Roper House along East Battery. In 1974, the house was designated a National Historic Landmark, and today the home is used by the college for receptions, weddings, and various department meetings.

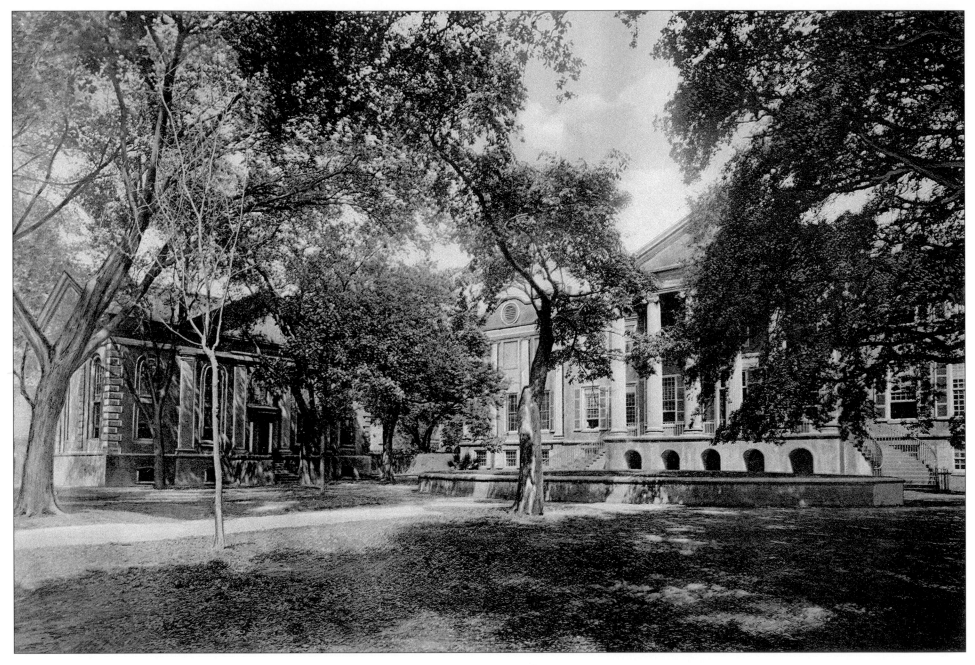

To the east, hardly more than a hundred feet away from the Blacklock House, is the campus of the College of Charleston, the oldest municipal college in the country. Established in 1785 by an act of the general assembly, the college opened in 1790. Prior to the Revolution, young Charlestonian men were often sent to college in the northeastern colonies or in Europe; thus, a college was not considered a necessity in Charleston. The main thoroughfare through the campus, then and now, is George Street, and the main campus grounds contained only three main buildings. The principal structure on the grounds was Harrison Randolph Hall, completed in 1828 and designed by William Strickland from Philadelphia. The six-columned portico and wings were added in 1850. The second most important structure on the small campus was Towell Library, and lastly there was the Porter's Lodge, through which students and instructors had to pass to enter the grounds. The lodge also acted as the home for the groundskeeper.

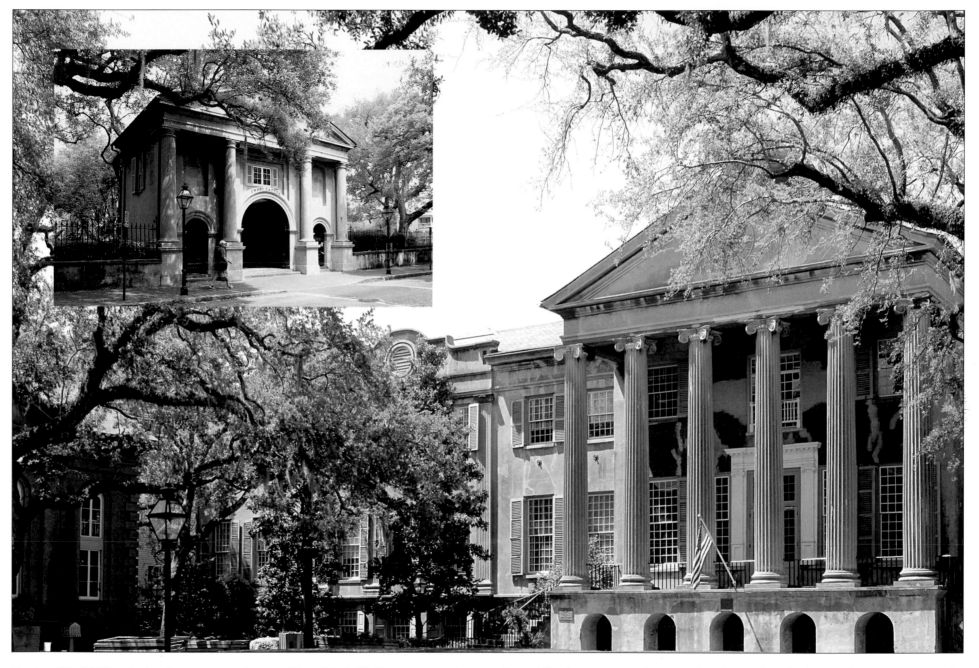

During World War I, the dormitory and part of Randolph Hall were turned into military barracks, and resumed their academic function when hostilities ceased. The South Carolina State College system incorporated the College of Charleston in 1970, enabling the college to begin serving a much broader region. Whereas the first class conducted at the college contained about a dozen Charlestonian students, today the student body numbers approximately 9,800 students, 70 percent of whom are South Carolinians; other students come from the other forty-nine states and from sixty-five foreign countries. The inset photograph shows the Porter's Lodge today.

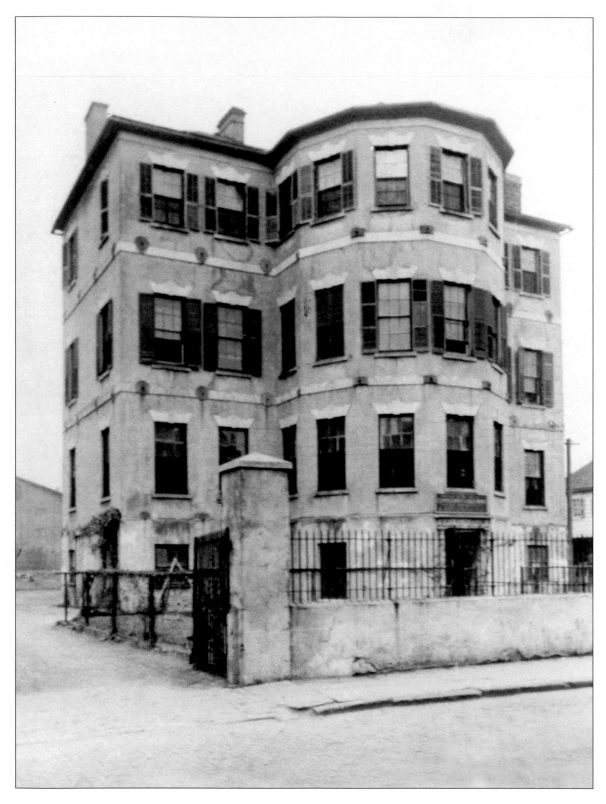

The Middleton-Pinckney House, about three blocks east on George Street from the main campus of the College of Charleston, was completed around 1799. Francis Motte Middleton began construction of the home with her second husband, Major General Thomas Pinckney. Pinckney had played a key role in the American defense of Charles Towne in 1780. One of his artillery batteries overlooked the Cooper River and pounded—relentlessly and with some success—the vessels of the British Admiral Marriot Arbuthnot. Following the fall of Charles Towne, Pinckney and many other prominent civilian and military figures took the oath of allegiance to the British Crown.

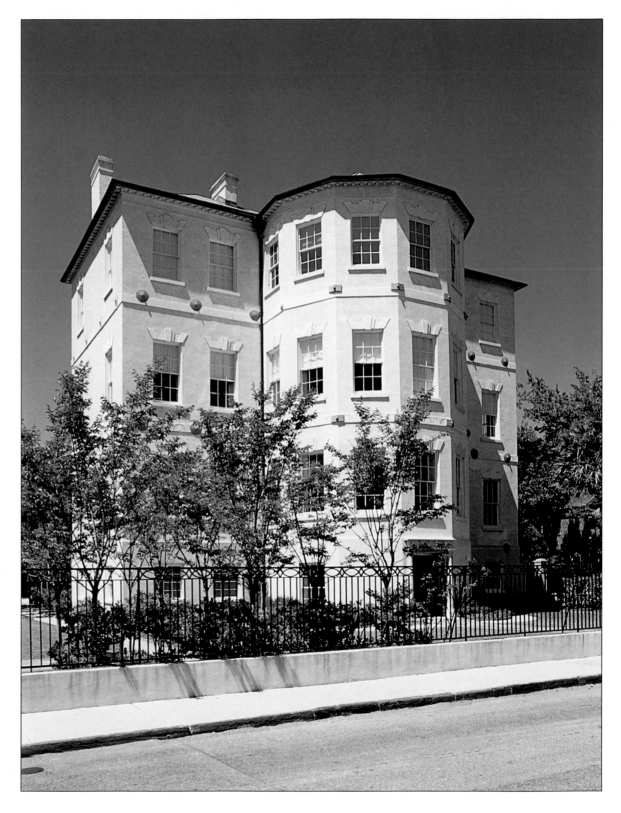

The Middleton-Pinckney House maintains its architectural integrity to this day. Surviving the upheavals of the late nineteenth century, in 1917 the house became the headquarters for the city waterworks. It served in that capacity until 1983. In 1987, it was converted into the offices of the Charleston Symphony Orchestra, Spoleto Arts Festival (with ticket office), and the Cultural Affairs Department.

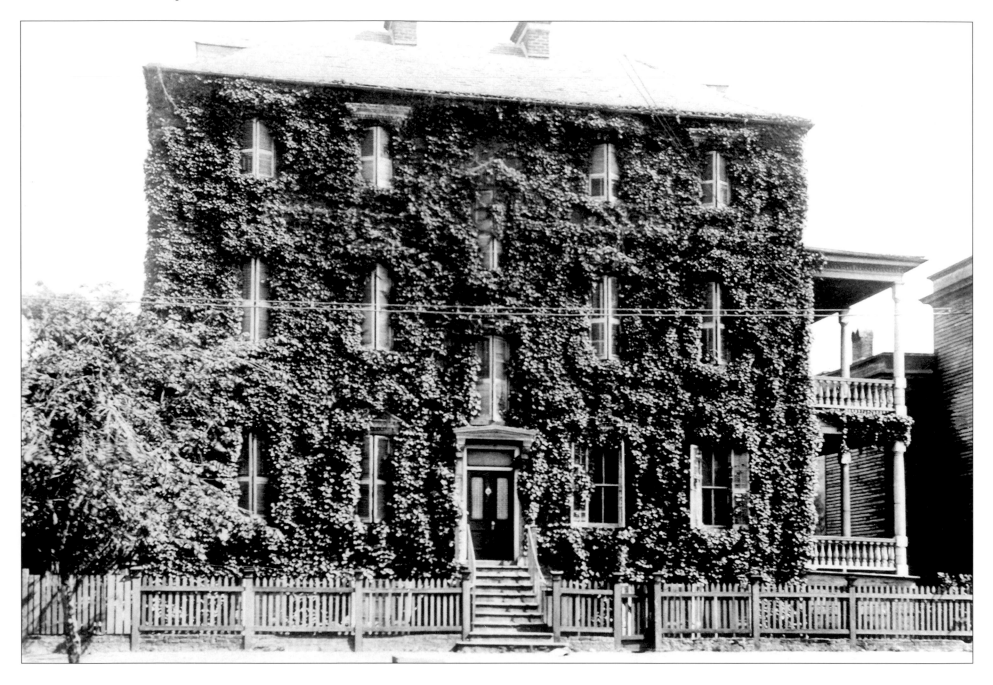

A few blocks from the Middleton-Pinckney House is Ansonborough, Charleston's first suburb, lying just north of the area known as the Old Walled City. It was named after George Anson, captain of a British warship sent to patrol the Carolina waters for pirates. According to popular tradition, the young Anson won a sixty-four-acre tract of land just north of the city, stretching out to the Cooper River, in a card game. Slave trader Henry

Laurens, a president of the Continental Congress, owned considerable property in the area. Captured in the Revolution, Laurens was the only Colonial prisoner to be held in the Tower of London and was ultimately exchanged for General Cornwallis after the siege of Yorktown in 1781. The James Jervey House at 55 Laurens Street is one of the few remaining eighteenth-century structures in Ansonborough that survived the fire of 1838.

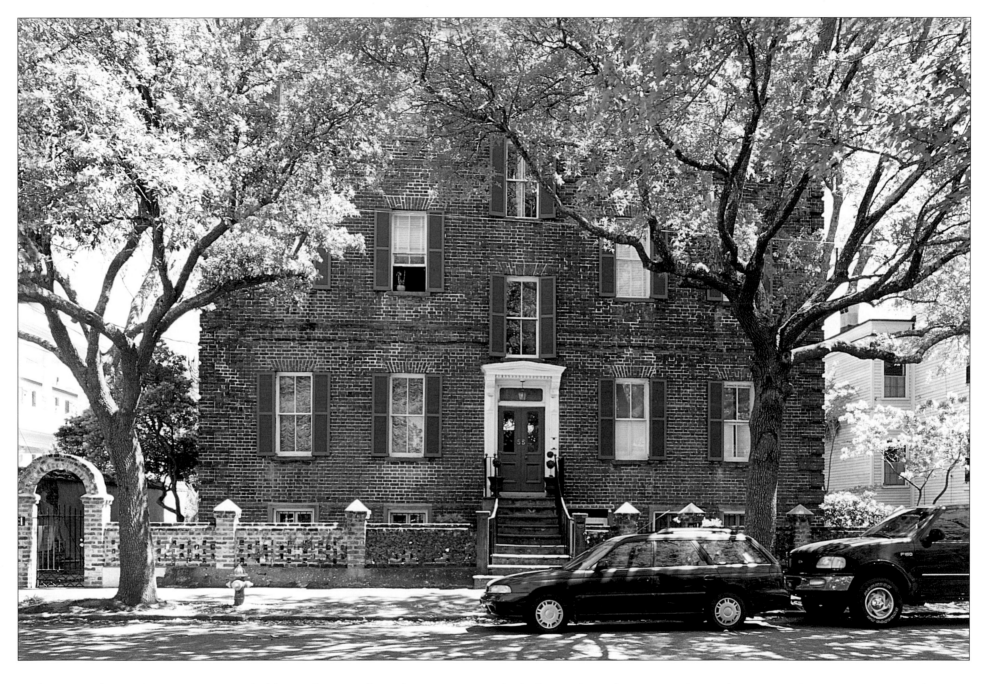

Today Ansonborough remains a quiet, hidden architectural jewel in Charleston's historic district—and perhaps the residents like it that way. The James Jervey House—Jervey was the clerk of the District Court of South Carolina who authorized the production of *Recollections*, a tribute to Revolutionary war hero Francis Marion—appears just as it did when it was built, but without the vines and growth covering the structure. A simple apartment complex today, the Jervey House fronts a half block south of the Gaillard Municipal Auditorium, the county library, and is just a few blocks away from the new South Carolina Aquarium.

This public park was originally referred to as Citadel Square for the Citadel Military Academy, seen here in the background. Following the attempted Denmark Vessey slave insurrection in 1822, the area became a muster and drilling ground for the state militia and subsequently a state arsenal. Several times each year, the Charleston brigade of state militia were required to drill here, and when the Civil War broke out, the cadets acted as drill instructors for these less-than-professional soldiers as well as raw recruits. When the war ended, occupying Union troops were quartered here, and the college did not reopen until 1882.

In 1922, the Citadel was relocated to Hampton Park along the western side of the peninsula, overlooking the Ashley River. The old building in Marion Square had two wings added on either side of the central structure in the 1950s and was used for decades for various purposes, such as extra office space for city and county departments. Gutted in the mid-1990s, the building is currently the Embassy Suites Hotel. Sadly, this chunk of tabby—a concretelike material made from mixing oyster shells and lime—is all that remains of the Horn Work, the principal bastion in the American defensive line during the British siege in 1780. This monument to the American defense sits today in Marion Square, named after the patriot Francis Marion.

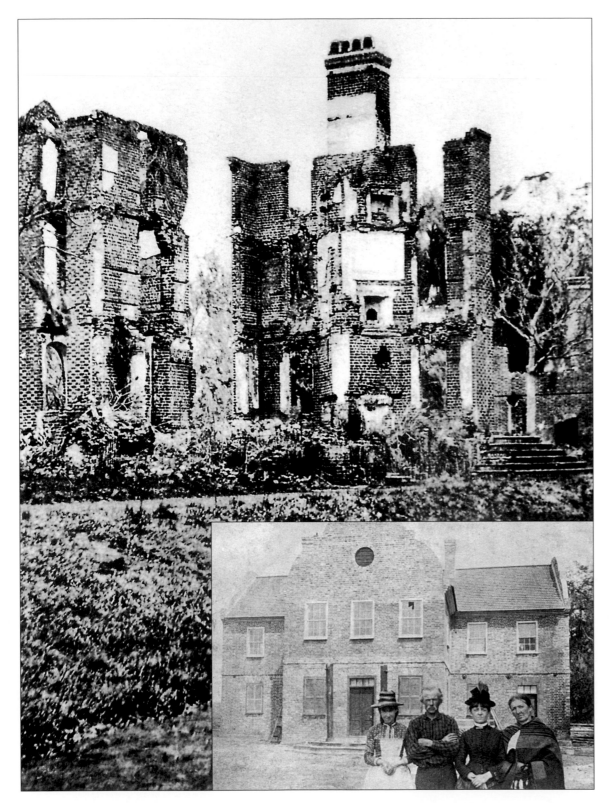

About fifteen miles outside of Charleston, along the Ashley River, lay the grounds of the expansive Middleton Place plantation. First settled in the late seventeenth century, Middleton Place was acquired through marriage by Henry Middleton in 1741. The family laid out extensive gardens surrounding the main house that year. In this rare and previously unpublished photograph, one can see what devastation accompanies war. Immediately following the occupation of Charleston, on February 22, 1865, a detachment of the Fifty-sixth New York Regiment occupied Middleton Place. The troops ransacked and burned the main house and flanking buildings, leaving the ground strewn with family treasures. When William Middleton returned to the property, he restored the less severely damaged south flank between 1869 and 1870 to be his family residence (inset). The remaining ghostly walls of the other two dwellings were toppled by the 1886 earthquake.

The gardens of the great house lay overgrown and neglected until the property was inherited by J. J. Pringle Smith in 1916. He set about restoring the gardens to their eighteenth-century form. His acclaimed restoration work garnered national attention, and the Garden Club of America awarded Middleton Place its Bulkley Medal in 1941. In 1974, Smith's heirs established the Middleton Place Foundation, which now owns and operates this National Historic Landmark. The grounds were reopened to the public in 1975. Today it is a thriving restoration of eighteenth- and nineteenth-century plantation life, attracting visitors from all over the world.

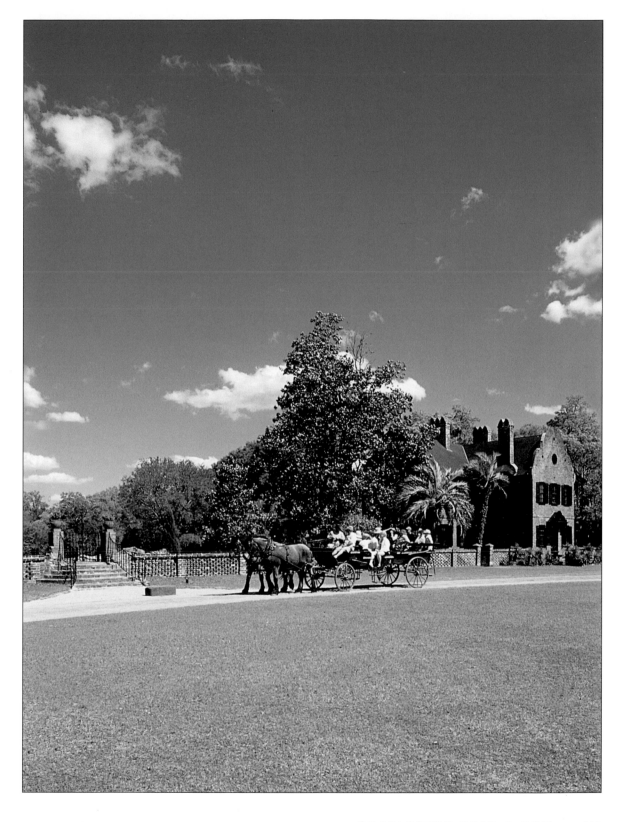

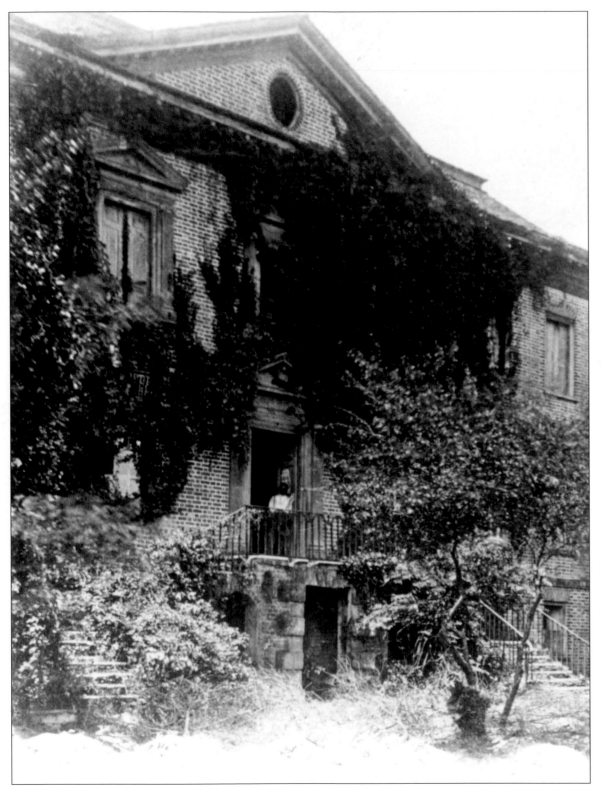

Just downstream from Middleton Place is the Drayton Hall Plantation, which was established around 1738 by the twenty-three-year-old John Drayton. Drayton Hall remains the oldest standing Georgian Palladian plantation house in the country, as well as the oldest plantation in America open to the public. The building served as the headquarters for the British Army, and it was from Drayton that British troops crossed the Ashley River to besiege Charleston from the north. In this rare post–Civil War photograph, we see the Ashley River side of the home disheveled and covered with vines and other growth. Unlike Middleton Place, Drayton Hall survived the war intact. There are two theories as to how this happened. One theory is that although Thomas Drayton became a brigadier general in the Confederate Army, his brother Percival remained in the Union Navy and commanded Admiral Farragut's flagship in the assault on Mobile Bay in 1864. It was to Percival Drayton that Farragut shouted "Damned the torpedoes, full speed ahead!" The second theory has it that the Drayton family placed a sign at the entrance to their plantation stating that it was quarantined due to fever. In either event, Drayton Hall remains standing today.

Though occupied throughout the remainder of the nineteenth and early twentieth centuries, by the 1970s Drayton Hall stood neglected and overrun with weeds. At that time the home was still in the possession of the Drayton family, who turned the structure over to the National Trust for Historic Preservation. Still without running water, electric lighting, or central heating, the preserved house extends to its guests a sense of timelessness and continuity. Its mere existence proves its strength against the tests of time. Drayton Hall is open to the public and specializes in educational tours for students.

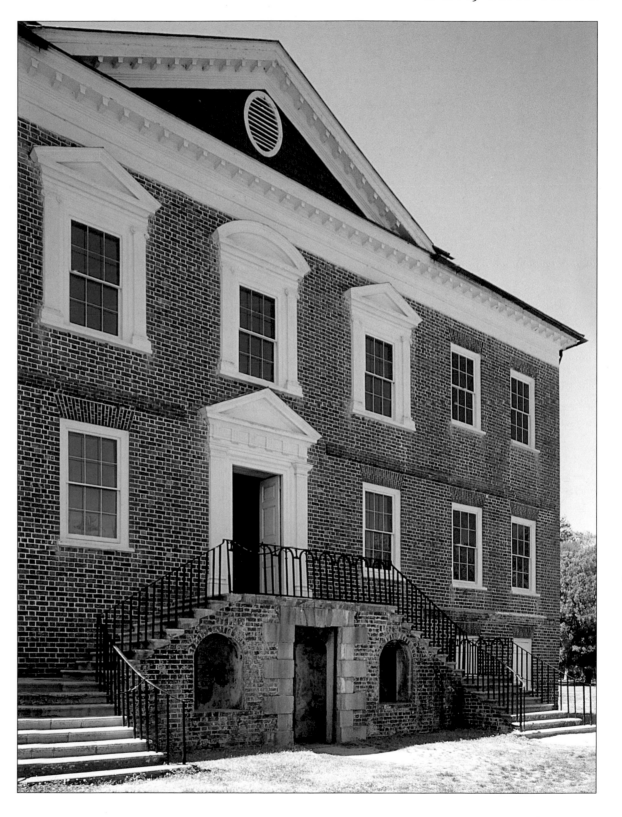

INDEX